ALL
about techniques in
DRAWING

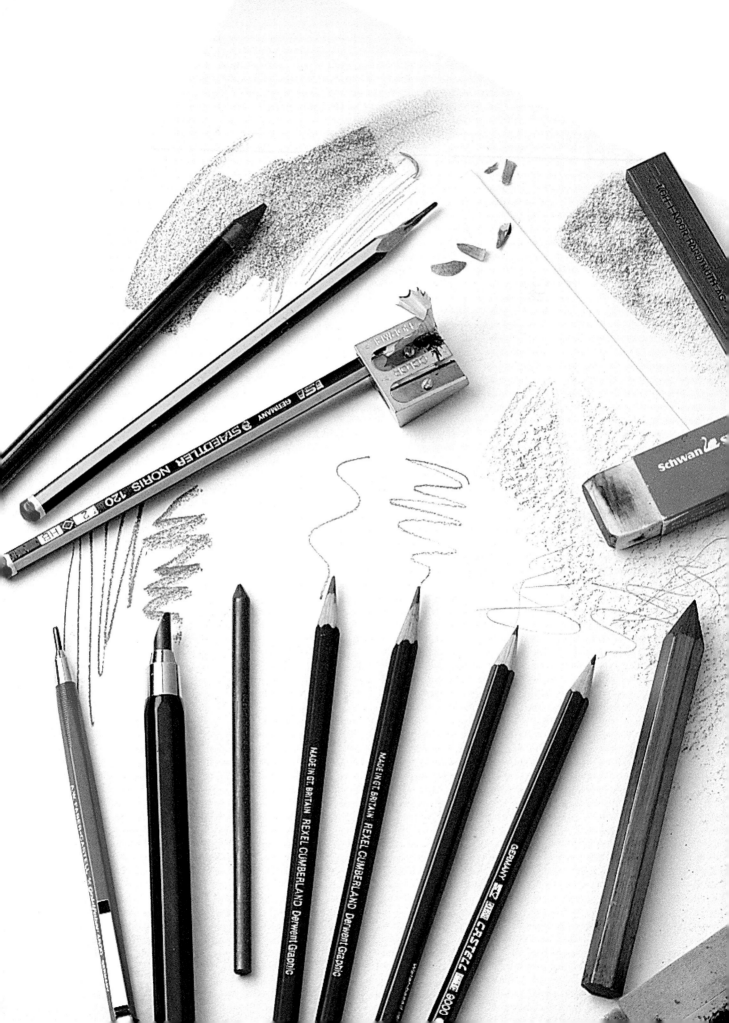

ALL
about techniques in
DRAWING

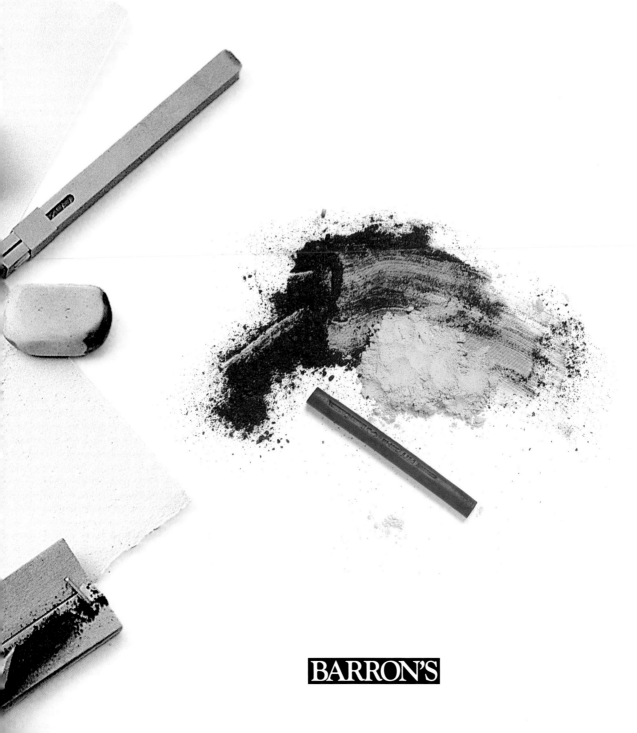

BARRON'S

Contents

Preface 5

MATERIALS AND TOOLS 6
Graphite 6
Colored Pencils 8
Charcoal 10
Pastel and Similar Media 12
Ink 16
Other Media 18
Brushes 22
Drawing Papers 24
Other Supports 28
Complementary Material 30

GRAPHITE 34
Graphite Techniques 34
Value and Modeling 38
Perspective 42
The Value of the Line 44
The Sketch 46
Drawing with a Range of Grays 48

COLORED PENCILS 52
Colored Pencil Techniques 52
Color by Strokes 58
Color Drawings 60
Drawing and Color Ranges 62

CHARCOAL 66
Drawing with Charcoal 66
Blending and Strokes 68
Modeling 70
Surfaces 72
Seascape 78
Still Life 82

PASTEL AND SIMILAR MEDIA 86
Drawing with Pastel 86
Drawing with Sanguine 88
Drawing with Chalk 90
Still Life 92
Landscape 96

INK 100
Drawing with Ink 100
Drawing with a Reed Pen 102
Highlighting with a Nib 106
Combined Techniques: Ink and Gouache 108
Nib and Colored Ink 110

WET TECHNIQUES 114
Wet Techniques 114
Sketching with a Brush 116
A Monochrome Wash 118
Combined Dry-Wet Techniques 122

DRAWING WITH WAX CRAYONS 126
Oil-Based Media 126
Drawing with White and Black Wax Crayons 128
Colored Wax Crayons 132

FELT-TIP PENS 134
Drawing with Felt-tip Pens 134
A Sketched Figure 136
A Full-Color Drawing 138

Topic Finder 142

It is possible to paint with watercolors without ever having painted with oils, but no artistic medium can be used properly if one has not mastered the basics of drawing. Oil and watercolor are painting media, whereas drawing is not as easy to classify.

A drawing is considered to be anything that is created with lines of a single color. But this definition omits a host of works of all styles and periods that are created by combining various tones of chalk and pencil or by means of shading. Nonetheless, such works are included in the drawing sections of the world's most important museums. In fact, no one thinks of works created in colored pencil or India ink, or a sketch drawn in pastel or with colored markers as paintings. They are all types of drawings. In the same token, a drawing cannot be defined according to the support used. It is true that most drawings are done on paper, but there are countless examples of drawings on wood, canvas, metal, or even stone. Drawing knows no boundaries because, to a greater or lesser degree, it forms an essential part of all artistic media.

This book has been compiled to provide the reader with a wide range of drawing possibilities, based on experience and common sense rather than theoretical principles. This does not imply that this book is in any way less rigorous. We believe that by laying down rigid rules on the subject we would limit its potential. Throughout the pages of this book, the reader is introduced to the broadest and most up-to-date range of drawing techniques and materials. Given that we could fill a volume of this size on each one of the techniques included, priority has been given to media such as pencil and charcoal, which are accepted by a wide range of artists.

The comparatively shorter sections dedicated to other media, ranging from India ink to the latest combined media techniques, in no way signifies that they are less important than the most commonly used media. All the techniques shown in this book are given the attention and detail required to be of use for both the novice and the professional. The extensive variety of media and tools available to today's artists (which increase day by day) are covered virtually in their entirety in the first section of the book, and are accompanied by information about their characteristics and usage. This section provides the reader with an exhaustive guide of the drawing materials, from the most conventional to the latest innovations available on the market. The next section offers numerous practical demonstrations, divided into subsections for each basic technique, its thematic possibilities, as well as specific procedures used with each drawing medium. The advice included with each one of the graphic examples provides the reader with useful guidelines to follow that can be immediately applied to his or her own work.

No book can expect to cover everything in such a vast subject as the one dealt with here. The practical nature of this work renders it the most thorough and accessible compendium designed for professional artists, fine arts students, and amateur artists.

David Sanmiguel

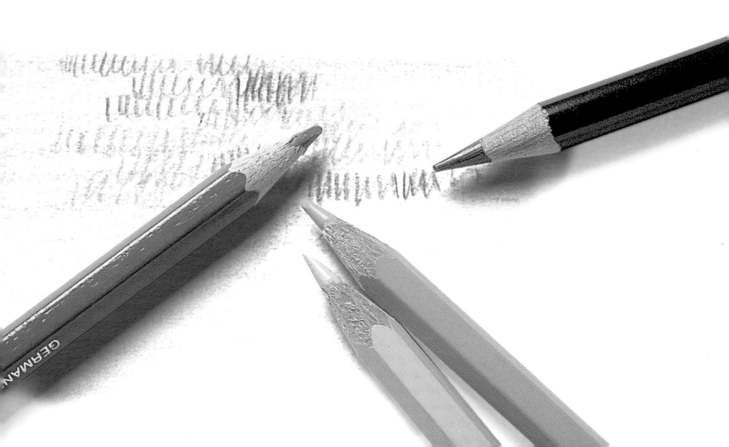

Graphite

Graphite is the substance from which the lead inside pencils are made. It is the simplest and cleanest drawing medium. Pencil drawings can be done on any type of surface and, because graphite is a greasy medium, they are very durable and do not require the application of a final fixative, though this may be advisable in certain cases. Pencil can be used to produce line drawings and works built up by shading. Its leaden gray color is always the same in any type of graphite, the only variation being its intensity: lighter in the hard type of graphite and darker in the softer type. Graphite can be combined with other drawing media in the same work, provided they are compatible with its greasy nature.

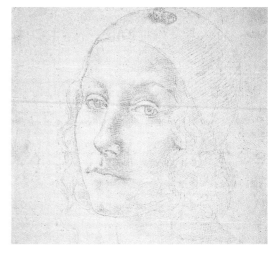

Perugino (1445–1523), Maid's Head. *British Museum, London. A drawing made with a silver lead. Metal leads (lead, gold, or silver) are the forerunners of the modern graphite pencil.*

COMPOSITION

Graphite is crystallized carbon, present in natural deposits but also obtained artificially. It is a greasy substance with metallic reflections. Graphite pencils are also known as *lead pencils*. This name comes from the metal nibs that were used as drawing instruments before the discovery of graphite. These nibs were made from gold, copper, silver (all three producing brown lines), or lead (gray lines). Lines could be drawn very accurately using this substance and the tone would sometimes become darker as a result of the oxidation of the metal in contact with the air. This technique required a suitable surface: paper primed with bone dust and glue on which corrections could not be made.

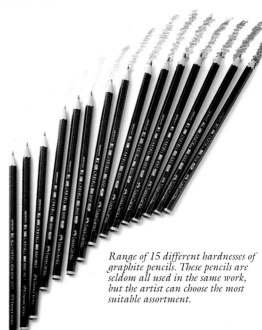

Range of 15 different hardnesses of graphite pencils. These pencils are seldom all used in the same work, but the artist can choose the most suitable assortment.

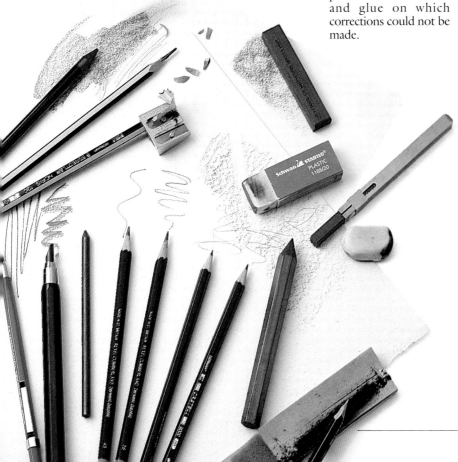

ORIGINS

The first graphite deposits were discovered in 1654, in Cumberland, England. This substance eventually came to replace all the metal nibs used in Europe, which were more expensive and awkward to use. Graphite in lead form as it is known today was an invention of Nicolas-Jacques Conté (who named his discovery after himself), toward the end of the eighteenth century. This new material was a mixture of powdered natural graphite and clay, which was then fired in the shape of a lead pencil and sheathed in a cedar wood cylinder. By varying the firing time, a wide variety of solid tones could be obtained. This is still the type of graphite used by today's artists.

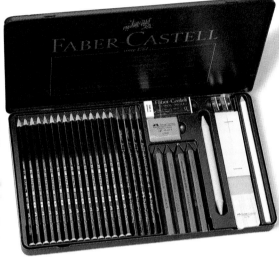

Pencil and graphite case by Faber-Castell. This set includes a complete range of quality pencils and graphite sticks that can be adapted to the requirements of most draftsmen.

HARDNESS AND QUALITIES

The different intensities of the lines drawn with a graphite pencil depend on their hardness: The softer the lead, the darker and more intense the line. In superior quality assortments of pencils (the major brands, such as Faber-Castell, Staedtler, Rexel, Koh-i-Noor) there are some 19 different degrees of hardness. These grades are specified by an alphanumerical indication marked on the tip of the pencil. The letters B and H indicate their respective degrees of hardness (B for soft pencils and H for hard pencils). The B category contains 8 different hardnesses, from B up to 8B (the softest). The H category ranges from hardness H up to 9H (the hardest). Between these two categories there are the HB and F lines, which are of average hardness and suitable for writing.

Out of this entire range, the most commonly used for drawing are the average hardnesses (B, 2B). For quick sketches and notes, the natural lead to choose is the softest, such as 4B and 5B. Hard leads are more suitable for planning elaborate drawings and for the preliminary shading, while the softest are used to emphasize the darkest areas.

GRAPHITE IN LEADS

The same degrees of hardness used for pencils are also used for graphite leads, which are sold loose. These leads are of different thicknesses (from 1/2 to 5 mm) and are inserted into a mechanical pencil. Many artists prefer these varieties because it saves having to sharpen pencils. Those artists who use these leads generally use only one hardness (usually 2B or 3B) for making sketches or preparatory drawings.

GRAPHITE IN STICKS

Graphite in stick form can be used for large-scale works that require large shaded areas. Some of these sticks are pencil shaped and the tips can be sharpened; they are coated in plastic to prevent the artist from getting smudged hands while drawing.

Artists use the stick forms for sketches because they produce strong, thick lines. Most of the thicker types do not have a tip and are designed for drawing with the edge, in a similar way to chalk or pastel sticks.

WATERCOLOR GRAPHITE

Watercolor graphite is a recent development that includes a small amount of gum arabic in its composition, which makes it soluble in water. The quality of its lines is exactly the same as those of normal soft graphite.

Lines and shading produced with this type of graphite can be retouched with a brush, blending the lines and creating different tones, which are lighter as more water is added.

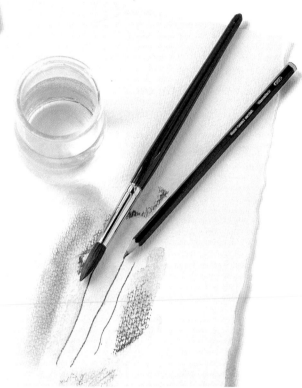

Watercolor graphite is soluble in water to produce lines and areas that are then blended with a brush.

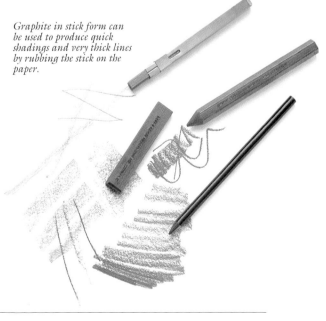

Graphite in stick form can be used to produce quick shadings and very thick lines by rubbing the stick on the paper.

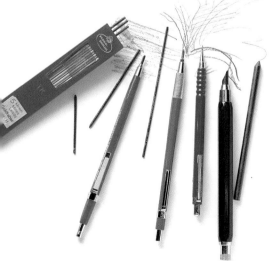

Graphite in leads of different thicknesses saves the artist the trouble of sharpening the pencil. There are different degrees of hardness for each thickness.

Colored Pencils

Despite their childlike associations, colored pencils have great potential as a drawing medium. Their colored lines define forms and color at the same time, with a delicacy and subtlety that other media are incapable of achieving. Combining and mixing colors with pencils requires a special process and technique. In addition, colored pencils can also be an interesting complement in mixed-media techniques, that is, combined with other drawing methods.

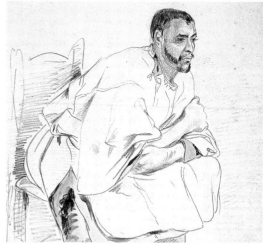

Eugène Delacroix (1798–1863), Seated Moor, *1814. Private collection.*

COMPOSITION

The leads of colored pencils are composed of pigments bound together with a claylike substance called kaolin, which is then mixed with wax. The pigments are the same ones used to produce color in all the other pictorial methods (watercolor, oil, pastel, and so on). But colored pencils have less covering power than these other methods because kaolin, necessary for sharpening and adding resistance to the lead, prevents the pigment from extending freely on the paper. Thus the pencils can produce only colored lines.

CHARACTERISTICS

The essential characteristic of colored pencils is their ease of use and immediacy. They are used in exactly the same way as graphite pencils, though their finish is much less greasy than graphite, which is softer and more satiny. They do not require any accessories or equipment other than paper and the pencils themselves. This is a medium suited to small format works, as the intensity of the tone and the covering power is much less than other media. The advantage of these characteristics is that highly detailed and elaborate work can be drawn, the marks are long-lasting, and the colors are inalterable.

Mixing colors is rather difficult with colored pencils because, once the color has been drawn, it cannot be altered unless it is erased. For this reason, manufacturers offer very wide ranges of colors so the artist can find the exact tone needed without having to resort to color mixtures.

Professional ranges of colored pencils produce quality work, comparable to that of any other drawing medium.

VARIETIES AND PRESENTATIONS

Colored pencils for school use are generally sold in cases containing 8 or 12 colors. They are very limited in range and are not usually sold loose. Major colored pencil manufacturers such as the Swiss company Caran d'Ache, the English companies Rexel Cumberland or Berol, the German companies Faber-Castell or Schwan, or the U.S. company Prismacolor offer multiple assortments. Everything from cases containing 12 colors to deluxe cases containing all the different tones that appear on the manufacturers' color charts: 72 in the case of Rexel Cumberland, 100 Faber-Castell, or 120 Caran d'Ache. All these pencils can be bought loose after consulting the manufacturers' catalogues.

Some manufacturers offer pencils with two different hardnesses. Hard pencils are most

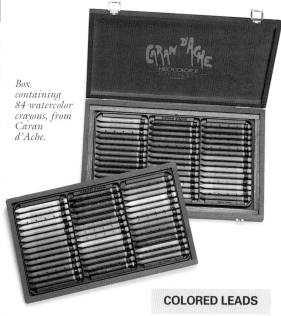

Box containing 84 watercolor crayons, from Caran d'Ache.

Assortment of 120 colors from Caran d'Ache, which come in three trays inside a wooden box.

suited to works of a professional standard, as they can be made sharper and remain sharper longer; semi-hard pencils (there are no truly soft-colored pencils) are handy for covering rather large areas with a uniform color.

COLORED LEADS

Most major manufacturers sell aquarelle or watercolor crayons in their entire range of colors. Because they are in the form of bars or sticks, they can be used on works of a larger scale than usual. Faber-Castell makes fine color leads, 0.5 mm thick, to be used in mechanical pencils. The advantage of these leads is that they produce a fine, even line that conventional pencils could draw only if kept constantly sharp. These leads come in cases of 10 and cover a range of 17 colors.

WATERCOLOR PENCILS

Some major manufacturers offer a special variety of colored pencils that are water soluble. The techniques for using these pencils are exactly the same as for conventional pencils. The difference is that the color can be spread out by applying water with a brush. This almost completely removes the lines from the paper to produce a result similar to a watercolor, although it lacks the latter's brilliance and luminosity.

QUALITIES

The quality of colored pencils depends on the quality and quantity of the pigments used in their composition. School-quality pencils use low-quality pigments and a smaller amount of pigments than the higher quality ranges, and a little wax is usually added to conceal their lower covering power.

High-quality pencils produce opaque, intensely colored marks that are slightly earthy. They can be sharpened to a very pointed tip and the cedarwood used to sheath the lead is soft, yet resistant at the same time.

The lines drawn by watercolor pencils can be blended to produce a finish similar to that of true watercolor.

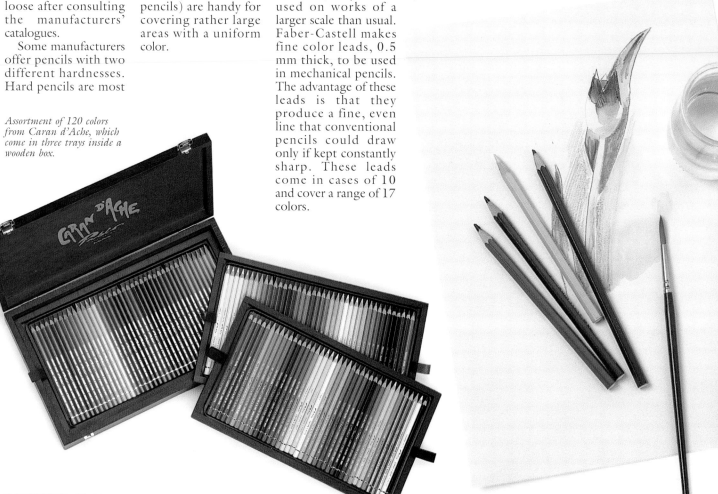

Charcoal

Together with the graphite pencil, charcoal is the most widely used drawing medium. It is extremely pure and direct and highly versatile, and it offers great creative potential. As with pencils, charcoal drawing requires no auxiliary media; unlike pencils, the results are more pictorial and spontaneous, and can be achieved on all types of formats, from small works to large-scale compositions.

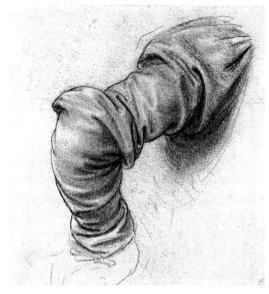

Leonardo da Vinci (1452–1519), Study for the Right Arm of Saint Peter, 1503. Windsor Castle Library.

COMPOSITION

Charcoal sticks, known as vine charcoal, are thin, knot-free twigs of willow, lime, or walnut that have been specially selected and then burnt. The size and thickness of the twigs determines the size and thickness of the final charcoal sticks, which are more expensive the thicker they are. It is becoming increasingly difficult to find charcoal produced by the traditional method; many are now made from powdered willow charcoal, which is compressed in molds to imitate the irregularity of natural twigs. The quality of these sticks is virtually identical to traditional ones, with the added advantage that they do not contain any of the small, hard, crystallized lumps that can occasionally be found in burnt twigs.

VARIETIES AND PRESENTATION

Charcoal is sold in different thicknesses, from thin sticks barely 2 mm in diameter up to sizes almost 3/4 inch (2 cm) in diameter. The price depends on the thickness, while the quality of the charcoal depends on selecting the finest twigs, which should be as straight as possible and free of knots and completely and evenly carbonized. The major brands such as Koh-i-Noor (Austrian), Grumbacher (American), or Lefranc (French) sell high-quality charcoal in all thicknesses, both loose and in boxes containing 25 to 40 sticks. Certain firms, such as Taker (Spanish), sheathe half the stick in aluminum foil so it can be held without staining the fingers.

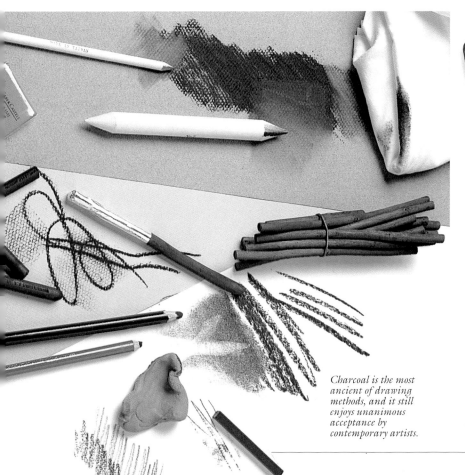

Charcoal is the most ancient of drawing methods, and it still enjoys unanimous acceptance by contemporary artists.

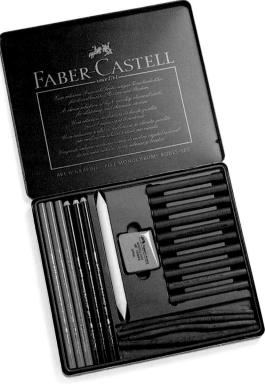

Charcoal pencil case, charcoal, stump, and compressed charcoal sticks from Faber-Castell.

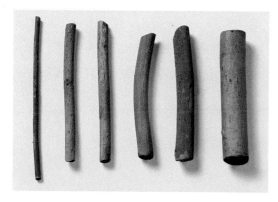

Charcoal sticks are sold in different sizes to suit different formats and styles. Here are six examples, ranging from 1/12 inch to 3/4 inch (2 mm to 2 cm) in diameter.

Natural charcoal is not cheap, so be wary of offers that are too low-priced as they usually consist of charcoal of such low quality as to be virtually useless. Recently, however, press-molded charcoal sticks made from powdered charcoal have appeared on the market. They are of excellent quality and considerably less expensive than traditional charcoal sticks.

COMPRESSED CHARCOAL & BINDER

Faber-Castell manufactures special compressed and bound charcoal sticks with a certain clay content under the name "Pitt." These sticks are standard sized, 1/4 inch (7 or 8 mm) in diameter, and are an intermediate medium between pastel and charcoal. They produce lines that are darker, denser, and more velvety than traditional charcoal, and come in three different hardnesses. The softest produces a tone of black that is so deep that it can only be compared to those of pastel black (made from pigment, not charcoal). This type of charcoal can be used in the same way as traditional charcoal, but because it is denser, it is not as easy to blend or erase.

CHARCOAL PENCILS

Some manufacturers, such as Conté or Koh-i-Noor, offer charcoal pencils, slightly bound to make them consistent and able to be sharpened. They are very useful for small format works that require fine uniform lines. These pencils are generally used together with conventional charcoal sticks.

Charcoal pencils can be used alone or together with charcoal sticks.

CHARACTERISTICS

Charcoal is dry to the touch, leaving a very dark gray, almost black, matte finish. It is made of fine carbonized particles, enabling it to be applied directly to a surface (generally paper) and allowing all kinds of blending and gradations of different grays. The result of a drawing made with charcoal depends greatly on the type of paper that is used. The rougher the paper, the more intense the lines, because more particles will be embedded in the irregularities of the sheet of paper. Charcoal is a totally natural product, one that does not incorporate any binding agents to give it cohesion. Thus, it is necessary to apply a fixative to the drawing so that the particles do not loosen over time.

POWDERED CHARCOAL

Some artists like to use powdered charcoal to create subtle blends and gradations in large-format works. The most common application is to rub some over the paper with a finger or with a piece of cotton. Powdered charcoal is sold in jars, although the artist can make it by grinding fragments of charcoal sticks so fine that they can no longer be used for drawing.

Powdered charcoal is used in large-scale works that require softly blended areas. The powder can be applied directly by hand or with cotton.

Compressed charcoal sticks are made from powdered charcoal that has been finely ground, bound, and mixed with clay. It produces very intense and velvety lines.

ORIGINS

Charcoal is simply burnt plant matter and dates back to the very origins of art. Cave paintings were made using powdered plant charcoal (slightly bound with saliva, probably) as the main pictorial medium, and their survival to the present day is the best sign of the permanence and unchanging nature of this drawing medium. Since then, charcoal has been a universal drawing medium for both sketches and finished works.

Pastel and Similar Media

Pastel and its derivatives are pictorial methods and drawing media. They all use the same method to achieve their effect: bound colored sticks are rubbed on paper to produce lines and patches of color. They can, to a certain extent, be blended and mixed. They are also direct media that are simple to use and, like charcoal, have no drying time and can be superimposed and blended in many different ways. Also, as with charcoal, the final result of the work depends to a large extent on the type of surface the artist has chosen and its roughness.

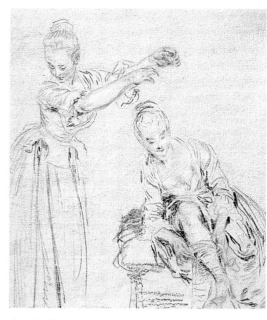

Antoine Watteau (1684–1721), Two Studies of the Female Figure, *1716. Private collection.*

PASTEL, A DRAWING MEDIUM

The discussion as to whether pastel should be considered a drawing medium or a painting technique is a moot one, as both points of view are based on good arguments and no definite conclusion could ever be reached.

Historically speaking, the background to pastel has been its use as a drawing medium. During the Renaissance, artists would use colored sticks to enhance sketches that were never conceived or displayed as paintings. Toward the end of the seventeenth century, pastel consolidated its position as a pictorial medium thanks to the works of the great portrait painters of the court, and many artists since that time have used this medium on the same footing as the other pictorial media. Artists now use all types of pastels to enrich their drawings while maintaining their essential drawing quality either by making great use of lines or of patches of color within a limited range that is more tonal in nature than chromatic.

This book cannot expect to cover all the pictorial potential of pastel, yet neither can it ignore its enormous potential as a drawing or painting medium. The aim of this work is not to impose limits on the artist, for it is up to each artist to decide where his capacity as a draftsman ends and his work as a painter begins.

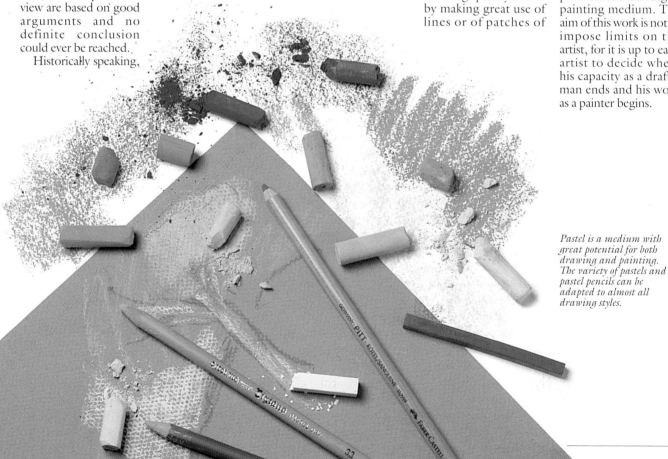

Pastel is a medium with great potential for both drawing and painting. The variety of pastels and pastel pencils can be adapted to almost all drawing styles.

COMPOSITION

Pastels are composed of pigments bound together with gum arabic. The hardness of the sticks depends on the amount of gum arabic included in the mixture. In top-quality pastels, the amount of gum arabic is very low, meaning they crumble easily. This allows manufacturers to sell pastels of varying hardnesses. Low-quality pastels include a certain amount of plaster, which makes the colors less opaque and less intense. Chalk has a similar composition but it is harder because it contains a substance similar to plaster.

Soft pastels are those with the largest proportion of pigment; that is, they are of higher quality and are manufactured in cylindrical sticks that crumble easily when rubbed on the paper, leaving behind an opaque, intense color. They go a long way, as the large amount of pigment they contain can be applied with one's fingers on the surface of the paper. Manufacturers such as the prestigious French company Sennelier produce a total of 525 different colors made from top-quality pigments. The aim of such a wide range is to reduce the need for mixing colors, a technique that is never recommended when dealing with pastel. Both this brand and Schmincke (German) or Talens (Dutch) manufacture soft pastels with pure colors and an enormous range of intermediate tones, which originate from these pigments and are mixed with white pigment. Thus the artist does not have to use pure white to lighten a tone.

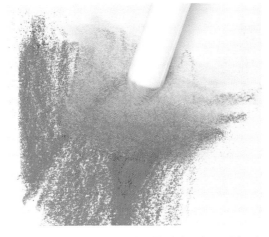

Pastel becomes more opaque when blended as the particles of pigment penetrate into the grain of the paper, covering it entirely.

CHARACTERISTICS

Of all pictorial media, pastel is the closest to pure color, without the use of any element other than pigment. It can, therefore, produce deeper, more saturated colors than other pictorial media. The colors have a dense, velvety quality and need a fixative to be applied to make them durable.

As a drawing medium, soft pastels are too brittle for drawing lines that require a certain uniformity. Artists generally choose harder pastels or sticks of chalk for most of their colored drawings.

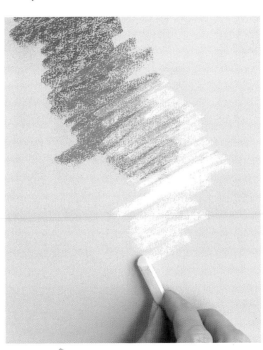

Pastel can be used to superimpose tones and, to a certain extent, to mix colors. The wide variety of hues available, however, makes most of these color mixtures unnecessary.

ORIGINS

Chalk is a form of soft limestone of organic origin that is white or gray. It was during the fifteenth century in Italy that artists began to use powdered chalk, bound and molded into stick shape to allow them to include white highlights in their charcoal or blackstone drawings (clay slate) on colored paper. White chalk was mixed with different iron oxides to obtain brick red chalk (known as sanguine), sepia, sienna, or ochre.

The first pastel colors appeared at the start of the sixteenth century. They were made from bound pigments without any chalk, and were softer than chalk sticks. Today, there is virtually no difference between chalks and hard pastels.

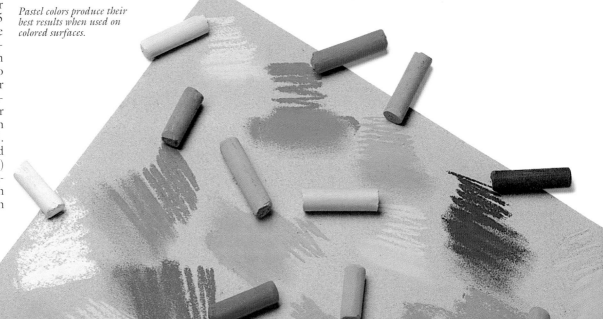

Pastel colors produce their best results when used on colored surfaces.

VARIETY AND PRESENTATION

Every firm sells boxes and assortments of all kinds. Some manufacturers sell soft and hard types of the same colors; this is the case of Talens and its Rembrandt and Van Gogh assortments, which are soft and hard, respectively. Also worth noting among the hard varieties are the square, not cylindrically shaped, sticks manufactured by Faber-Castell.

WATERCOLOR PASTELS

Watercolor pastels, like certain varieties of colored pencils, can be dissolved in water with the help of a brush to produce results that are halfway between pastel and watercolor. They are generally of medium quality and are sold in small ranges, both in stick and pencil form. They can be used as a complement to pastels to create blends of color in particular areas of the work.

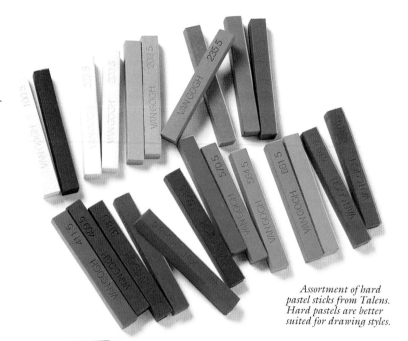

Assortment of hard pastel sticks from Talens. Hard pastels are better suited for drawing styles.

PASTEL PENCILS

As their name suggests, pastel pencils are pastel sticks in pencil form and sheathed in cedarwood, just like an ordinary pencil. They are very useful for an artist accustomed to working with pencils; the handling and consistency of these hard-type pastels make them similar to working with graphite or colored pencils. Their drawback is that they are difficult to sharpen, since they are softer than colored pencils. They are presented in boxes containing twelve colors and can also be bought loose.

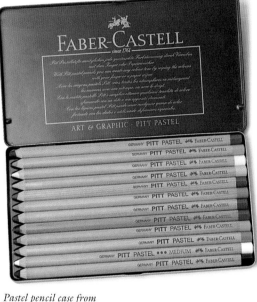

Pastel pencil case from Faber-Castell.

TYPES OF BOXES

Large assortments of high-quality pastels usually come in wooden boxes with one or more trays for easier use, conservation, and transport. There are many smaller assortments that are more economical and come in cardboard boxes, fitted into foam compartments to protect them from blows. Some manufacturers offer special assortments for portraits, landscapes, and seascapes, which contain the colors most commonly used for these subjects. All these boxes and cases can be useful even when all the pastels have been used up and replaced by others, even those taken from different ranges.

Pastel pencils, which produce finer, more accurate lines than sticks, can be used alone or together with the latter.

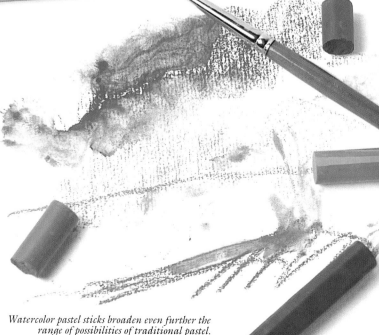

Watercolor pastel sticks broaden even further the range of possibilities of traditional pastel.

Range of gray chalks from Conté, specially designed for monochrome shaded drawings.

SPECIAL ASSORTMENTS

Conté and Faber-Castell sell special assortments for draftsmen, which come in metal cases with small compartments; they contain graphite pencils in four or five different hardnesses; a range of chalks in gray; and colored sticks, chalk pencils, charcoal pencils, compressed charcoal sticks, and natural charcoal. These cases tell us more about the tradition of drawing than about the needs of professional draftsmen: They are really a collection of traditional drawing media that artists generally buy individually, based on their own experience.

A selection of gray and bluish tones (applicable, for example, to a seascape) taken from a pastel assortment sold by the German company Schmincke.

CHALKS

Chalks are relatively hard sticks that are suitable for line-based work and gentle blending. The abundant, varied supply of all types of pastels makes it difficult to distinguish them from chalks. In fact, most manufacturers include chalk in stick form in their assortments of hard pastels. Strictly speaking, chalk colors are limited to white, black, sepia, and sanguine (iron oxide). These four colors possess a perfect tonal balance that makes them specially suited for all types of almost monochrome drawing and harmonic gradations. The French company Conté, together with Faber-Castell and Koh-i-Noor, sell cases of chalks occasionally accompanied by sienna

SANGUINE

Within the group of chalks, sanguine stands out as having its own personality. This is a brick-red colored type of chalk that has been a favorite of many artists. The warmth of its tone and the beautiful results when used on colored paper make it a drawing medium in its own right. Sanguine chalk can be used for line drawing as well as all types of blending. It lends itself to a more delicate style of work than charcoal, and produces less dynamic yet melodious results. The traditional sanguine sticks can be complemented with sanguine pencils, which make for easier line drawing and shading. Many artists use stumps or blending pencils to obtain all the potential of sanguine's characteristic softness.

CONTÉ CRAYONS

This type of crayon, which has been used by artists all over the world for almost 200 years, deserves special mention. Conté was the first to introduce graphite to the European continent and the first to combine it with clay to intensify its tones. Conté crayons produce an unmistakable mark: sharp, precise lines of an

and a range of neutral grays, both in stick and pencil form, and as leads for mechanical pencils.

The wide range of pastel colors allows the artist to select the harmonic tones best suited to the subject.

intense black, which combine the advantages of graphite pencils, charcoal's potential for large formats, and the tonal strength of chalk. They can also be combined with the above media for works that require softened highlights. Conté crayons are currently manufactured in four different hardnesses and in leads for mechanical pencils. This is why the Conté crayon, despite the many imitations that flood the market, is still the favorite medium for many great artists.

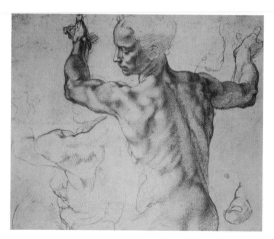

Michelangelo (1475–1564), Study of a Male Figure. Metropolitan Museum of Art, New York. A masterpiece of drawing, in sanguine.

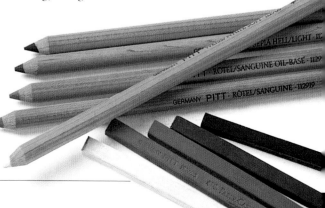

The traditional tones of chalk come in both stick and pencil form.

Ink

Ink is one of the oldest drawing media, used by Chinese artists almost 2,500 years ago. It is one of the most versatile drawing media that exist. It is excellent for both minute, detailed work and for sketches with lines or patches applied with a brush. Used alone or together with other techniques, it has unrivaled graphic strength and quality and can be diluted in water to obtain the most varied pictorial effects.

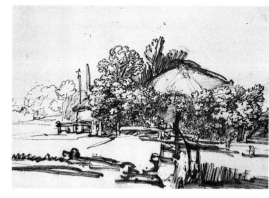

Rembrandt Van Rijn (1606–1669), Figure Surrounded by Trees, *1614. Dresden Museum.*

COMPOSITION

Conventional India ink (also called Chinese ink), white or black, is made from pigments dispersed in a water solution and a special binder called shellac. It is highly adherent on most types of paper and, when dry, is insoluble in water. Modern colored inks for drawing and illustrating have the same composition as India ink except that they contain colorings instead of pigments. Other versions of colored inks use gum arabic as a binder, which keeps them soluble after drying. Colored inks do not produce very permanent colors, so it is necessary to protect them with special fixatives; even so, it is inadvisable to leave such works exposed to direct light for too long, because the colors will eventually fade.

REEDS

The reed is a very rudimentary instrument but one that many artists favor precisely because of its rather primitive effects and its use in sketches or works that do not call for accuracy or detail. Different types are sold, but an artist can make his own from a dry bamboo cane, cut in a bevel at one end and with a long slit starting at the vertex of the bevel. Depending on the shape of the tip (sharp or flat), the lines will be thicker or thinner.

The reed is a wonderful drawing instrument that produces spontaneous works of great tonal wealth.

A traditional India ink drawing kit containing a brush, ink tablet, water, and stone for dissolving the ink.

INK IN TABLET FORM

India ink can also be bought in tablet form. This is the original, solid form of the ink used in the Far East. The tablet is dissolved in distilled water by rubbing it on a special pan made from rough stone until the right consistency is obtained. The basic tool for this traditional process is the brush.

Whether pen, reed, or brush are used, ink drawings are always highly attractive.

ORIGINS

In the western hemisphere, the use of ink dates back to the Middle Ages. The illumination of manuscripts was done in gall-nut ink, which is very intense and brilliant, though rather unstable, until an ink called "India" (so called because it was used in the Far East) was introduced from the Arab culture into Europe. This ink was unalterable and was made from black pigment obtained from burnt twigs and then mixed with gelatin and camphor.

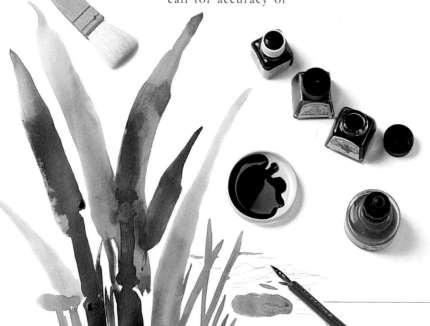

COLORED INKS

Talens, among others, makes bottles of colored inks in a wide range of tones. Most of these inks are based on colorings called anilines, which are very intense and opaque. Colored inks are designed for use with airbrushes, though they also produce good results when used in nib or brush drawings. They cannot, however, be combined with other media, as anilines stain all types of paint, even when completely dry.

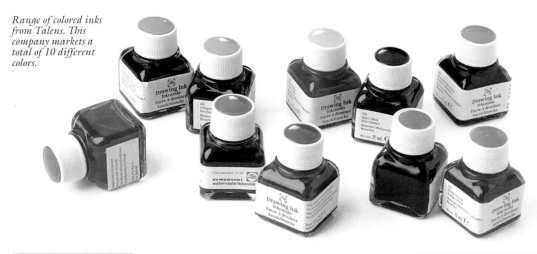

Range of colored inks from Talens. This company markets a total of 10 different colors.

INKS FOR WASHES

Inks for fountain pens from Parker, in blue and black, offer interesting possibilities for wash drawings, with a brush. The tones of these inks vary according to how diluted in water they are, giving rise to a range that is rich in hues. These inks can be used both with a nib and brush, or even combining both media in the same work.

PENS AND NIBS

The metal nib did not appear until the end of the eighteenth century. Up until that time, artists had used goose feathers as drawing instruments. The classic metal nib is sold loose and is inserted onto plastic or wooden handles. There are a wide variety of nibs on the market: flat or curved, flat tipped or round tipped, special tips for calligraphy, and so on. Graphos sells a total of 70 different types of nib. Drawing with a nib obviously requires the artist to constantly load it from the inkwell, controlling the amount and the time

each load lasts. Many modern artists avoid this drawback by using drawing pens with ink reservoirs or simply fountain pens.

Modern fountain pens, with their special tips that provide constant, uniformly

The traditional nib-pen can be replaced by a fountain pen or special drawing pens such as those manufactured by Rotring.

WRITING TOOLS

Pens (ballpoint, fine point, felt-tip, and so on) and other writing instruments can be used as interesting drawing instruments, provided the artist does not expect results that can only really be obtained with specialized drawing instruments. They are useful for notes, quick sketches, and small, mostly linear work.

thick lines, are also used by some artists.

CHARACTERISTICS

The characteristics of India ink vary depending on the manufacturer. All India inks are an opaque black, their brilliance depending on the type of product, and all are water soluble. Only distilled water should be used for mixing with this type of ink; the usual impurities in water could easily break up their black tone. They are usually dense, very opaque, and require a considerable amount of water for diluting to lighten the tone. Sepia-colored ink, or the old form known as "bistre," is a traditional variety of this type. Writing inks have similar characteristics, though they are generally lighter and less opaque. Some have great potential for the artist's work.

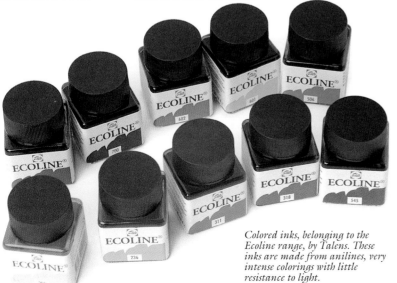

Colored inks, belonging to the Ecoline range, by Talens. These inks are made from anilines, very intense colorings with little resistance to light.

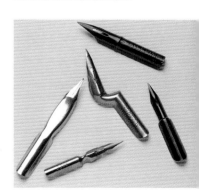

There are different types of drawing nibs for obtaining different types of lines.

Other Media

A book on drawing techniques should naturally exclude other pictorial media. But many of the pictorial media are also used as drawing media. Mixed techniques deserve to be mentioned because they put many creative possibilities at the artist's disposal. All these techniques have been brought together into two large groups: water-based media and oil-based media. The description of these techniques is accompanied by explanations about recent drawing tools, such as felt-tip pens.

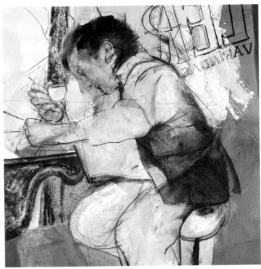

David Sanmiguel (1962), Nou Celler, *1996 (detail). Private collection. A work using mixed techniques, combining both wet and dry media.*

MIXED TECHNIQUES

Mixed techniques are considered to be those that combine several different media and cannot be classed with the usual techniques. Using mixed technique combines the advantages of each material, which ultimately enriches the work. Contrasts in texture and different finishes are the most characteristic feature of this form. The limits of combined techniques lie in the incompatibility between certain media. Thus, for example, water-based media cannot be mixed with oil-based media, nor can satiny papers be used for drawing media such as charcoal or pastel. Occasionally, a mixed technique can appear temporarily stable, only to deteriorate over time. The best way of avoiding this is to be fully familiar with how each medium behaves when combined with others. Experimenting is a highly stimulating activity for the artist, who should, however, base it on his prior knowledge of mixtures that he knows to be compatible.

DRAWING AND PAINTING

All pictorial media can be used for drawing. Lines can be drawn using all types of media, while mixed techniques take drawing beyond its usual bounds into the realm of painting to such an extent that certain monochrome works take on an unquestionable painterly quality. In such circumstances, the division and the strict distinctions between drawing and painting become unnecessary, as even pure color can become a drawing medium when used as such.

The combination of different media, provided they are compatible, can give rise to original and highly creative results.

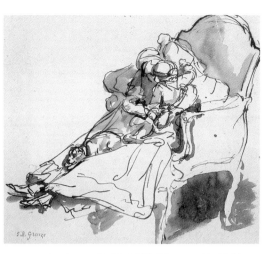

Jean Baptiste Greuze (1725–1806), Woman with Child and Dog on a Divan, *1762. Private collection. This nib drawing is enhanced with a dark, watercolor wash.*

WATER-BASED MEDIA

Water-based media are media that are diluted in water. The most popular of all is watercolor, but the term also includes gouache and, to a certain degree, acrylic paint. They are essential pictorial media that are fast-drying and that can be applied in many different ways. As drawing media, they can be very useful for preparing backgrounds, drawing in color, creating textures, and direct drawing using a brush.

WATERCOLOR AND GOUACHE

Watercolors are transparent and luminous. Thus, they can be overlaid in the form of glazes, which are successive transparent layers that lend the work a special quality and depth of tone.

Gouache colors are matte, slightly earthy, and opaque; when they are overlaid, the base color is completely concealed by the new tone.

Watercolors, made by grinding pure dry pigments into gum arabic and glycerin, are sold in tubes and pans. Both forms of presentation, in professional ranges, are of the same quality. Among the brands that make high-quality watercolors are Winsor & Newton, the German brand Schmincke, the Dutch Talens, and the Spanish brand Titan. Whether in tube form or in pans, they can be bought loose, though all brands sell metal boxes with an assortment of colors. These boxes are very useful because they act as a palette and are easily carried about. Gouache colors are sold in tubes or bottles of creamy color in very wide ranges of tones to cover all the requirements of illustrators, who most use this medium.

LATEX AND ACRYLIC PAINT

These two media are relatively recent (manufactured for the first time during the 1940s) and both use the same binder in the form of a polymerized substance, that is, a chain of molecules in suspension, which on drying forms an elastic film that is insoluble in water. In the case of latex paint, the polymer is polyvinyl acetate, and in acrylic paint, acrylic polymer is used. Another characteristic they share is that they are both quick-drying paints and both have a plastic, satiny appearance. Acrylic colors show great similarities to oil paints, with the added advantages that they do not require organic solvents and they dry quickly. These characteristics make them very popular among contemporary artists.

Acrylic colors come in tubes and tins in a range of tones as wide as that of oils. Talens, Schmincke, the American brands Liquitex and Golden, and the Spanish brands Vallejo and Titan make professional quality acrylic colors.

Boxes of moist watercolors in pans.

WATER-BASED OILS

Recently, Talens has launched a range of water-soluble oil paints. Although this may appear to be a contradiction in terms, these paints contain certain resins that allow them to be dissolved in both organic solvents and water. Because they are a new medium, they cannot yet be judged accurately. This will require the practice and experimentation of different artists.

Water-based media are those that have water as a solvent. All of them, except watercolor and gouache, are insoluble when dry.

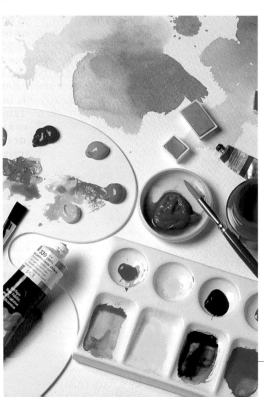

Gouache is excellent for quick notes and sketches, working with the tip of the brush.

OIL-BASED MEDIA

Oil-based media are based on oil or wax and can be used with an organic solvent (turpentine, petroleum, and so on). The most common oil-based medium is oil paint, but this category also includes wax crayons and solid variations of oil colors. In a book on drawing, we cannot undertake an exhaustive study of media that are essentially for painting, but these media in particular have great potential for drawing techniques.

Wax and oil are the basic binders of oil-based media. Colors are applied directly onto the paper or other surfaces by rubbing or by using a brush or palette knife; to make them more liquid, a solvent such as turpentine is used. They are slow drying, taking anywhere from a few hours, in the case of a very liquid color, to several days or weeks if thick impasto has been used. Almost all these colors are opaque, although they can be made transparent by diluting them with different solvents.

OIL STICKS

Oil sticks, also known as oil pastels, are a relatively recent development that has an interesting application in drawing. These sticks can be used directly on the support without the need for brushes or palette knives. They can be mixed and spread out with the aid of a brush dipped in solvent. They produce thick, highly opaque strokes and can be combined with traditional oil colors.

Tintoretto (1514–1594), Battle on the Taro, 1579. Museum di Capodimonte, Naples. A sketch drawn in charcoal with touches of oil paint in order to achieve the various values of bluish gray.

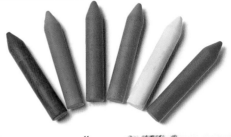

Wax crayons are usually considered a drawing medium for school use, yet quality wax crayons can produce excellent results.

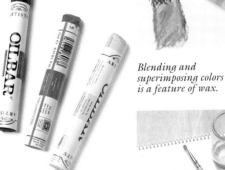

Blending and superimposing colors is a feature of wax.

Oil sticks are used by rubbing them on the surface, in the same way as pastels.

Oil-based media are those that include wax or oil and that require an organic solvent (turpentine) to make them usable.

Because it is an oily medium, wax can be dissolved in turpentine.

WAX CRAYONS

Wax crayons are usually considered a drawing medium for school use, but the quality of many of them together with their wide range of colors make them suitable for producing professional quality works. They are used in a very similar way to oil sticks: They are rubbed on the support and can be mixed or overlaid quite easily. Because they are an oil-based medium, they can be liquefied with the help of a solvent.

SOLVENTS AND MEDIUMS

The most suitable solvent for oil painting is turpentine. This solvent is equally well suited for working with wax crayons and can be used to liquefy the color for it to run more easily on the support. Mediums are different substances designed to accelerate the drying time, to obtain more brilliant finishes, or for obtaining base textures that can then be painted over.

CHARACTERISTICS

Oil-based media in general and oil paint in particular have a creamy, opaque consistency and can be applied in many different ways: from plain, uniform colors to texture finishes with wrinkles and lumps created by the colored paste. Oil is the most prestigious of traditional painting media and many modern artists consider it the finest of all media. Oil paints can certainly be used in ways that are beyond any other media: The colors can be mixed together without any problems, to produce a rich and subtle variation of hues. The painting can be reworked, retouched, or recast an infinite number of times, and the slow drying allows the tones to be perfectly graded. Oil paints are sold in three different sized tubes, loose, or in assortment boxes. Professionals generally buy their tubes loose, selecting them from each manufacturer's color chart. The English brand Winsor & Newton, the Dutch Talens, the German Schmincke, the French Lefranc Bourgois or Blockx, and the Spanish brand Titan manufacture quality oil paints.

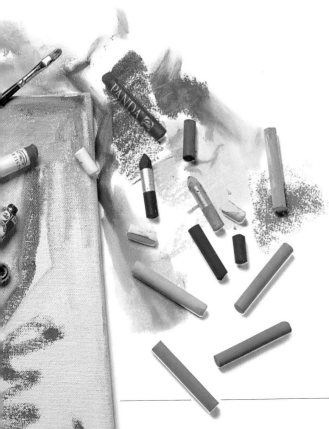

FELT-TIP PENS

Working with felt-tip pens is the most modern of drawing techniques and is specially suited for illustrations and publicity that require clean tones, sharp outlines, and a quality that can easily be adapted to photographic or photomechanical reproduction. This does not mean that felt-tip pens cannot be used for more creative, artistic works. The enormous potential of felt-tip pens on the market takes in all styles and methods of drawing. Felt-tip pens consist of a tip that originally was felt but now is usually polyester, containing very small openings that allow the ink to flow from the interior to the tip. The reservoir of the pen is a piece of felt saturated with ink in contact with the tip; the ink rises to the tip when writing or drawing.

A work by Montserrat Mangot, drawn with watercolor felt-tip pens.

VARIETY AND PRESENTATIONS

Almost all brands manufacture both fine-tip pens (suitable for writing and drawing lines) and broad-tip pens (the most suitable for drawing). The colors available depend on the manufacturer: AD Marker, an American brand, offers a range of 200 colors; the Danish brand Edding has 80; the English brand Magic Marker, 123 colors; the French brand Mecanorama, 116 colors; the American brand Pantone, 500 colors; and the Danish Stabilo, 50. In addition to the school types, firms do not usually sell assortments of these colors as it is usually the artist himself who buys the felt-tip pens singly. Almost all the above brands make two versions of each color: fine- and broad-tip; Pantone combines both versions in the same pen, with the fine point on one side and the broad tip on the other.

A professional generally works with a very wide range of colors to avoid having to mix them as combining colors is difficult with felt-tip pens. Usually, the drawing project itself will suggest which colors to use. It should be remembered that color charts give only an approximate idea of the real tone, so it is advisable to try the tone out on a piece of white paper before buying each pen.

produces completely opaque colors and which can be used to obtain good results when working with blocks of solid, opaque, and uniform color.

ALCOHOL BASED

Alcohol-based pens are used by most artists. The ink usually evaporates quickly, allowing it to dry quickly. When it is dry, the colors are fast and other tones can be superimposed without the colors mixing or running. If the artist wishes to obtain color merges and a smooth finish, however, he must work very quickly without waiting for the colors to dry. The

tones are usually fairly transparent, so these felt-tip pens produce their best results when used on white surfaces that do not subtract from the luminosity of the colors.

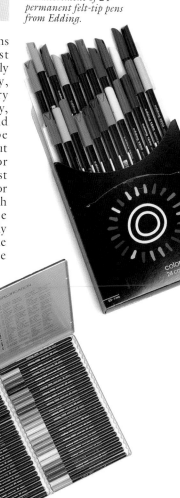

An assortment of 24 permanent felt-tip pens from Edding.

A box of 48 water-based and watercolor colors from Edding.

WATER BASED

Water-based pens are usually designed for school use. The lines take longer to dry and some colors may alter others when overlaid. Some manufacturers sell water-based felt-tip pens with a pigment similar to that of gouache, which

CHARACTERISTICS

Felt-tip pens can be used for making color sketches faster than any other drawing medium. The ink dries quickly, allowing the artist to control the lines easily and obtain a clean, uniform tone when it is necessary to cover large areas. Because the pen contains an ink reservoir, no other materials are necessary. Colors can be superimposed and juxtaposed almost instantly, as they do not run or change tone over time. The finish varies depending on the type of ink, but it is usually opaque or semiopaque, with an almost perfectly even tone and extremely luminous colors.

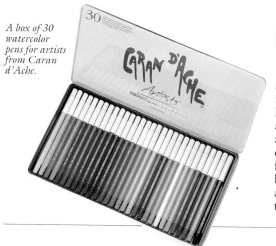

A box of 30 watercolor pens for artists from Caran d'Ache.

Brushes

Except for the dry techniques (pencil, charcoal, pastel, and so on), brushes are essential instruments in most drawing techniques. But not all brushes are equally well suited; some have a specific use and all of them come in different qualities, with differing degrees of artistic potential.

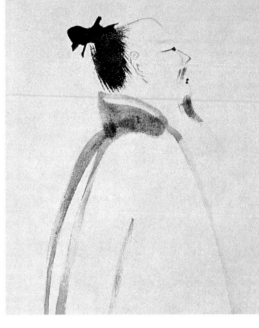

AN INTRODUCTION TO BRUSHES

Quality brushes consist of natural or synthetic hair (which is what determines the quality of the brush), tied together and glued to an enameled handle. Around this area there is a metal ferrule that protects and secures the hairs.

Brushes are numbered by size, usually from 1 to 18. The shape of the bristles determines the characteristic lines of the brush. Generally speaking, there are three shapes of bristle for each type: round-tipped, flat-tipped, and filbert. The first two are the ones most commonly used by artists.

SABLE BRUSHES

Sable-hair brushes are the highest quality and the most expensive. Sable hair has a fineness and a strength that are far superior to any other type of hair. Strength refers to elasticity combined with the capacity to recover its original shape after each brush-stroke, an essential factor in all types of brushes. In addition to this, sable-hair brushes maintain a perfect tip, allowing the artist to control the thickness of the lines, and they can absorb a large amount of paint, for painting in masses of color.

The high price of this type of brush means they are only made in small and medium sizes; sable hair is also mixed occasionally with other, inferior types of hair to lower the cost. They are excellent brushes for all types of wet techniques, for ink drawings, and even for certain oil techniques.

Leang K'ai (middle of 8th century), Li Po Reciting a Poem. Committee for the Protection of Cultural Property, Tokyo.

The brush is the classic painting instrument, though it can also be used to great effect in drawing.

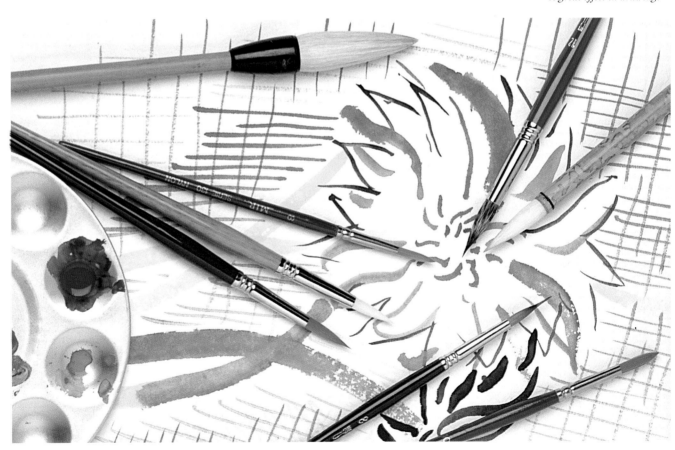

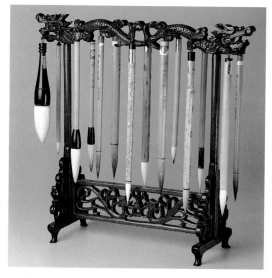

A collection of Chinese brushes hanging from a traditional support specially designed for the purpose.

strong, and the tip is fairly good quality. Ox-hair brushes are usually round and come in medium or large sizes.

Other more economical hairs, such as mongoose, are suitable for round brushes for painting large formats, using flowing brush-strokes that call for many patches of color.

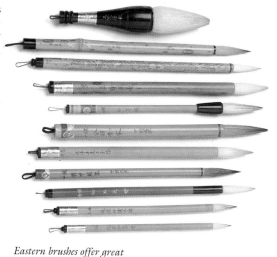

Eastern brushes offer great potential for drawing and especially for what is known as "Japanese wash," in which the shape of the hairs is adapted to the subject being painting.

OTHER NATURAL HAIRS

Sable-hair brushes are the best instruments for wet techniques, but most artists use slightly lower quality brushes for a large part of their work, especially when they need to absorb a lot of paint or apply large patches of color. Ox hair is excellent for washes, watercolor, gouache, and ink. It absorbs a good amount of paint, is reasonably

HOG'S HAIR

The best quality hog's hair is obtained from Chinese pigs. It is marble colored, and its hardness and elasticity make it ideal for working with dense, pasty colors, meaning it is perfect for oil painting. After a certain amount of use, the bristles split and the brush improves considerably. Because it produces rough strokes, it is not well suited to water-based media (although in certain cases the effects obtained may be very attractive). It is perfect for dynamic work on supports such as canvas or wood.

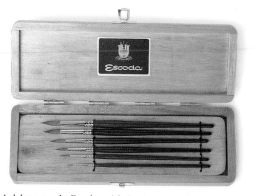

A deluxe case by Escoda, with 6 superior-quality sable-hair brushes.

The Escoda company manufactures special brushes for drawing with a tip that allows very fine lines to be drawn with abundant color.

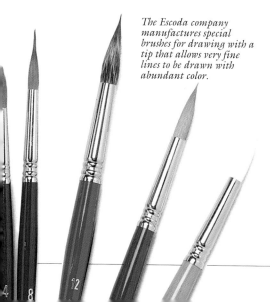

A selection of brushes for working with wet techniques: flat, synthetic brushes; large round ox-hair brushes; and fine sable-hair brushes.

SYNTHETIC HAIR

A recent arrival on the market, synthetic hair produces good results with standard brushes and larger, flat brushes and all types of techniques.

Synthetic hair cannot absorb as much water as soft, natural hair nor can it apply paint with as much density and texture as natural bristles, but the flat version is excellent for drawing lines and is

perfect for covering large areas with an even color. It is the ideal instrument for painting with acrylic colors. Synthetic-hair brushes with a round or filbert tip produce mediocre results; they split too easily and cannot absorb a large amount.

JAPANESE BRUSHES

Fude, their name in Japanese, are magnificent

brushes designed for a particular purpose: washes in India ink. The handle is made from bamboo and the hair is of the softer type, usually deer, goat, or boar.

Japanese brushes come in many sizes and shapes, some containing very few hairs up to those that are almost 10 inches (25 cm) wide.

They can also be used for other techniques, provided the color is highly diluted in water.

Drawing Papers

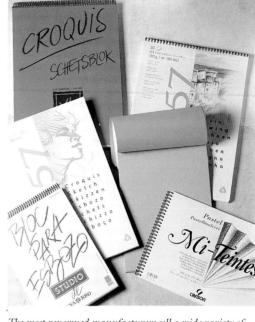

Paper is the universal surface for drawing on and, as a rule, you can paint on virtually any type of paper. But each drawing technique works best on a certain type of paper, so it is important to be aware of the various drawing papers available. Regardless of whether the paper used is smooth or rough, heavy or light, the end result will vary considerably, as much in the intensity of the stroke as in the quality of the finish. Only by knowing these factors is it possible to choose the correct type of paper.

The most renowned manufacturers sell a wide variety of drawing papers in pads of various sizes.

DRAWING WITH PENCIL & CHARCOAL

We should distinguish between medium-quality papers made of wood pulp along with those manufactured by machine or molds and high-quality papers, which contain a high percentage of rag and are made with great care. High-quality paper is very expensive and all manufacturers make medium-quality papers. High-quality papers can be distinguished by the mark bearing the name of the manufacturer that appears on the paper either stamped in relief or in the traditional trademark, which can be seen by holding the paper up to the light. Among the professional quality drawing papers available, you can choose from smooth paper, fine-grain paper, medium-grain paper and coarse-grain paper. The three latter types of paper can likewise be used for drawing with charcoal.

Smooth paper, with its almost imperceptible grain, is compressed smooth while hot in order to heighten its smoothness. It produces a wide range of gray tones and very good results when lines drawn by graphite pencils or colored pencils are blended with fingers or a stump. Medium-grain paper is particularly suitable for drawing with charcoal, as it holds onto particles. Coarse-grain paper is the most commonly used type for drawing in charcoal. Its special texture has just the right degree of "grip" to allow the artist to draw fluid and obtain good gray tones.

DRAWING WITH FELT-TIP PENS

The choice of paper for felt-tip pens will vary according to the felt-tip pens used, be they water- or alcohol-based. The alcohol-based variety must be allowed to glide over the paper, which is why the paper must be perfectly smooth, without any trace of roughness. The ink must penetrate the paper without running and, at the same time, remain fresh enough to be able to blend with another color applied on top; so the paper should be absorbent. The ink must dry quickly, although not too quickly. Furthermore, in many works, the preliminary sketch must remain visible underneath, so it cannot be totally opaque. This type of paper (sold especially for markers or layout) comes in separate sheets or in pads. These papers are often used by professionals who work in the field of advertising. But for normal use, the water- and alcohol-based pens work fine on white paper (the color that always lends them the most luminosity) with a glossy surface, but never with the *cuché* type, because the impermeable layer that covers the surface makes it very difficult to draw on, and, in the case of water-based felt-tip pens, absolutely impossible.

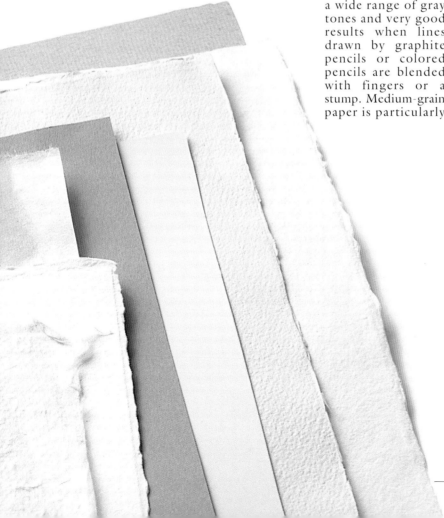

There are many types of paper for each drawing technique. The artist should choose quality that is guaranteed by a well-known brand.

DRAWING IN INK

The papers for drawing with pen and ink must not be too rough for drawing sketch lines; neither should they be too soft or spongy that they do not absorb extra ink or they hinder the movement of the pen. The best papers for this technique are the glossy variety. Grainy paper can be used for drawing with a reed pen, since this pen is used by rubbing lightly against the paper rather than allowing it to glide over the paper.

RICE PAPER

Rice paper is Japanese. It is generally used for wash drawings with India ink. It is not sized very much when it is made and is highly absorbent. To remove any excess dampness from this paper, the artist should place a piece of felt underneath. Rice paper is sold in both sheets and pads.

Ink wash is best drawn on rice paper, its most traditional surface. It offers a highly absorbent surface that highlights the qualities of ink.

DRAWING PADS

Drawing pads of different sizes and qualities are an indispensable tool for any artist who wishes to have something on which to capture ideas and that will help him to keep his drawings together. Most of these pads are suitable for working with both dry and wet media.

There is no substitute for pocket-sized drawing pads for sketching.

DRAWING WITH PASTEL

Any surface on which pastel finds a texture that the pigment can adhere to is suitable. The most appropriate papers for pastel are those of the medium- and coarse-grain variety. Fine-texture paper is easy to cover rapidly, because soft pastel runs easily, but it is difficult to apply several layers as the grain is almost immediately filled in. Rough paper is harder to cover completely, so it is easier to apply successive layers.

One of the most commonly used papers for drawing with pastel is the Canson Mi-Teintes type, a quality paper containing 65 percent cotton and with a different texture on each side. It is manufactured in a wide variety of colors that range from the most subtle and grayish tones to solid reds, yellows, and blues. This paper is sold in two sizes and also comes in pads of harmonic ranges (siennas, ochres, grays, etc.).

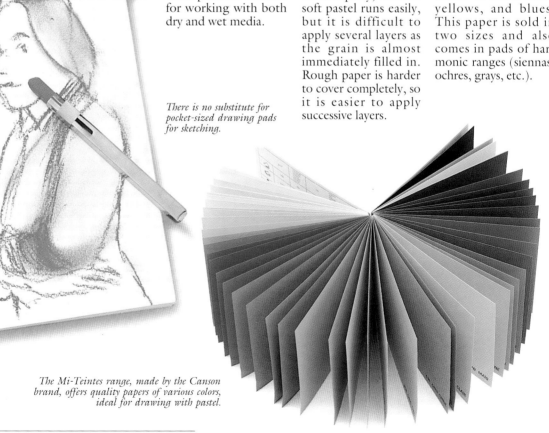

The Mi-Teintes range, made by the Canson brand, offers quality papers of various colors, ideal for drawing with pastel.

MATERIALS AND TOOLS

PAPER FOR WET TECHNIQUES

The most commonly used paper that uses water as a solvent is watercolor paper. This type of paper comes in cold-pressed or medium texture, rough, and hot-pressed or smooth texture and is manufactured with a high percentage of rag, that is, high-quality materials. Professional watercolor paper is sold in separate sheets, with the characteristic deckle edge on all four sides—proof that the paper has been manufactured sheet by sheet—as well as in pads.

The roughness of watercolor paper indicates the amount of water it can absorb. Good watercolor paper has moderate powers of absorption. The smoother the surface of the paper, the less water it can absorb. The smooth surface of hot-pressed paper allows very luminous finishes and plenty of detail, while a rough paper will absorb much more water in the form of patches or blotches of saturated color.

Among the brands that manufacture quality watercolor paper are the French companies Arches and Canson, the English brands Winsor & Newton and Whatman, the American brand Grumbacher, the German brand Scholler, the Italian brand Fabriano, and the Spanish brand Guarro. Each one of these brands sells paper of different thicknesses and textures, although the grain pattern varies with each brand.

The grain of the texture of the paper determines the result of a pastel painting, thus allowing a more energetic or subtle finish.

HANDMADE PAPER

This type of paper is produced by certain manufacturers in limited amounts. It has an irregular distribution of fibers and tends to be rougher and more absorbent than conventional papers. Each manufacturer has its own particular type, some of them having vegetable decorations imprinted in the fibers. Handmade paper can be used as much for drawing as for wet media, but it is advisable to test its special characteristics before beginning a work.

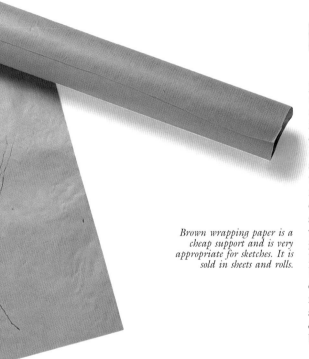

Brown wrapping paper is a cheap support and is very appropriate for sketches. It is sold in sheets and rolls.

Drawings with a reed pen can be executed on rougher paper than those used for drawing with a nib.

Texture produced by 130 g Basik paper, by the Guarro brand. This is a universal support for all manner of dry media.

Texture of a sheet 160 g Canson Mi-Teintes, ideal for drawing in pastel.

Grain of 20 g Canson sketch paper. This paper is quite fine and is suitable for pencil drawings and sketches.

Watercolor paper (240 g) For dry media like charcoal or pastel, this is a robust support that allows energetic finishes.

Texture of Ingres paper, ideal for charcoal drawings.

Texture of a 180 g sheet of Canson "C á grain." A quality paper for all manner of works in charcoal and in pastel.

Watercolor paper (200 g) produced by Talens. Its medium texture offers many possibilities for all manner of techniques.

OTHER PAPERS

Sketches, thumbnail drawings, and preliminary drawings can be drawn on all types of papers. These need not be high-quality. Brown wrapping paper, sold in various tones of gray, is good. Its light texture makes it suitable for drawing in pencil, charcoal, and pastel, although it cannot be gone over too many times. The German brand Schmincke manufactures one type of paper called Sansfix. This kind of paper is especially suitable for pastel, as its sandpaperlike texture allows the pastel to adhere to the paper, thus producing very saturated color tonalities. Conventional sandpaper can also be used for pastel, as long as it is a fine grain, but you should bear in mind that the surface of this paper is very dark. Recycled paper offers a cheap and acceptable surface for drawing in pencil.

Dry mark (in relief) of a sheet of Schoeller paper for drawing in ink.

Watermark of a handmade sheet of paper made by the artisan Aquari manufacturer.

Canson Mi-Teintes watermark. Watermarks guarantee the quality of the paper.

Ingres-type paper, with its characteristic rough texture, is sold by different brands. In this case, the watermark on this paper is Fabriano.

The watermark, visible by holding the paper up to the light, of a sheet of drawing paper by the Fontenay company.

Arches manufactures paper of excellent quality both for drawing and for watercolors.

Watermark of the Guarro company, manufacturer of high-quality papers for all types of dry and wet techniques.

Other Supports

Although paper is the most highly versatile support at the artist's disposal, some media require a different support to simplify their use. The main support of this kind is canvas, the surface most used for oil and acrylic painting. These other supports not only adapt to specific techniques but also open other possibilities for using different media.

CANVAS

The best quality canvas is made from linen. This is a highly resistant material, very stable under variations in humidity and temperature. It offers different degrees of textures, from extremely fine-textured fabric to rough quality. The best linen is virtually knot-free and has a very tight weave. This type of canvas is very expensive. A more economical variety is cotton canvas, which is a little rougher and more sensitive to changes in humidity. All these canvases are sold unprimed or primed with a special primer for oil or acrylic paints. This primer is usually white although some primers may be gray or sienna. It is essential for the canvas to be primed before it can be painted on. The best idea is to buy it already prepared, as priming requires a lot of patience and practice. The most useful primers are universal, suitable for oil and acrylic painting. Canvases of a certain quality can be continually worked over using a large amount of paint; they are also durable

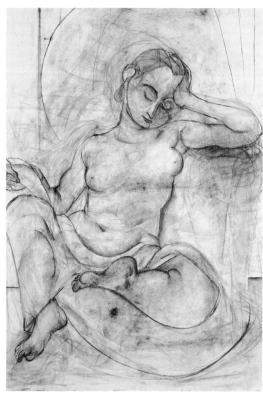

David Sanmiguel (1962), Reading Sanskrit, *1997. Private collection. A painting on canvas prepared with an acrylic primer.*

Acrylic primers can be used for preparing all types of porous surfaces or those that, on the contrary, are too smooth.

and ensure the work will remain unchanged.

Canvas can be bought in rolls or mounted on stretchers (wooden frames that tighten the canvas). These stretchers are sold in standard formats which range from 8 inches to 60 inches (21 cm–152.4 cm).

Although traditionally canvas is used for painting in oil or acrylic, canvas also produces good results when drawing in pastel or charcoal.

Canvas, cardboard, and wood are workable supports for artistic drawing. Most of them are sold ready prepared and primed.

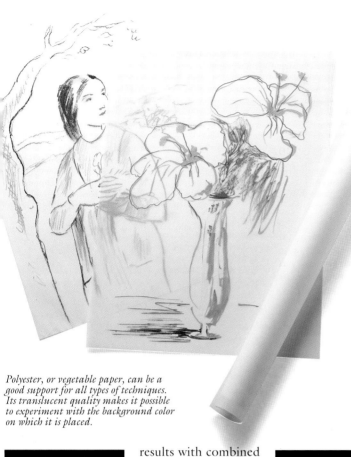

Polyester, or vegetable paper, can be a good support for all types of techniques. Its translucent quality makes it possible to experiment with the background color on which it is placed.

A colorless acrylic primer for dry techniques such as charcoal and pastel.

CARDBOARD

Cardboard of reasonable quality is a good support for gouache as well as for charcoal and pastel. One of its advantages is that it is more rigid than paper and produces good results with combined techniques. Some major brands of paper manufacturers sell special cardboard for drawing with different overlaying and grains that are characteristic of traditional drawing paper.

PREPARATION

The wide variety of primers for supports currently available on the market allow the artist to choose the type of surface that best suits the work. The different conventional preparations seal the pores of supports such as wood or cardboard and provide a good base for oily, dry, and wet techniques. In addition, there are also textured primers that lend the support a special roughness. Most of them are designed for oil and acrylic painting, but there are certain variations that, when applied in several layers, create a texture that is specifically aimed for charcoal and pastel drawing. These primers are transparent but can be stained with acrylic colors.

POLYESTER PAPER

Polyester paper is also known as vegetable paper. It is translucent, very satiny, and highly resistant. It is generally used in technical projects, but it can also be a magnificent surface for drawing with felt-tip pens, with India ink, and even with compressed charcoal. Its translucent quality makes it especially attractive for artists who experiment with combining different media.

WOOD

Oils, acrylics, and pastels can also be applied to wood. The wood should be of good quality and requires a primer to seal the pores. There are many types of primer for wood, some of which are very complicated, but an acceptable universal primer is gesso, a white acrylic paste with just the right degree of porosity and grip to meet the needs of different techniques.

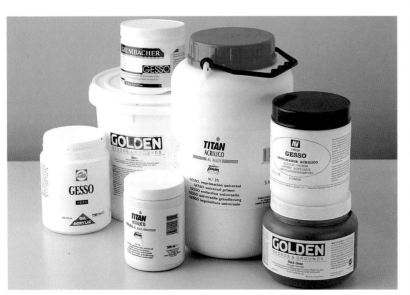

Different priming media. Some incorporate additives that give the surface texture with varying degrees of roughness.

MATERIALS AND TOOLS

Complementary Material

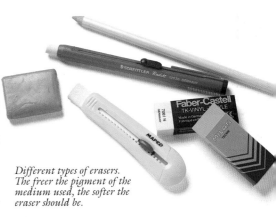

Every technique requires a series of special accessories that can be enlarged if the artist uses sophisticated methods. These pages detail a series of tools, most of which are essential, that complement the artist's work. All of them form part of the equipment a professional artist will have in his studio.

Different types of erasers. The freer the pigment of the medium used, the softer the eraser should be.

ERASERS

Erasers are not only a means of correcting errors; in the hands of an expert artist, they are transformed into a true drawing medium to obtain grays and clean tones and to create lights and shadows.

The most suitable erasers for graphite are made of plastic and soft rubber. These erasers are also suitable for works using charcoal and pastel, although malleable erasers are generally used. In all these techniques, the only erasers that are unsuitable are those that are too hard, since they spoil the surface of the paper. In India ink drawing, it is inadvisable to use an eraser, though abrasive erasers can be used to remove the surface layer of the paper.

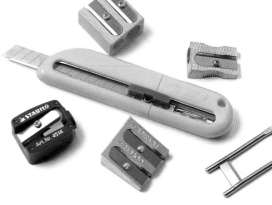

Pencil sharpeners are essential in graphite and color pencil drawings.

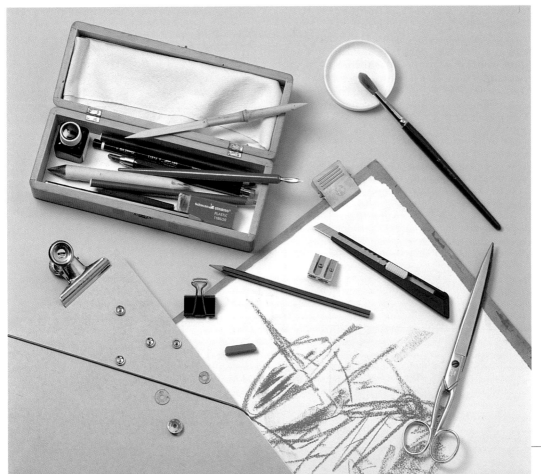

PENCIL SHARPENERS

The most common pencil sharpeners are made from metal or plastic. When working with colored pencils, it is a good idea to have a table-mounted pencil sharpener, with a handle and a compartment for the shavings. In addition to these small machines, small pieces of fine sandpaper can be used, and certain types are sold especially for this purpose, attached to small boards so they can be held in the hand.

In addition to the drawing media themselves, the artist requires a large number of complementary materials to carry out his work.

FIXATIVES

In order to conserve charcoal drawings, it is essential to apply a substance to attach the charcoal particles to the surface. These substances are usually solutions of gum arabic in aerosol form or in containers in which a spray device is fitted. These fixatives are also useful for fixing pastel during the intermediate stages of the work because, if the work is fixed at the end, some colors may be altered. When using an aerosol, several fine layers should be applied, holding the spray at a distance of some 8 to 12 inches (20 to 30 cm) from the paper, which should be held in a vertical position.

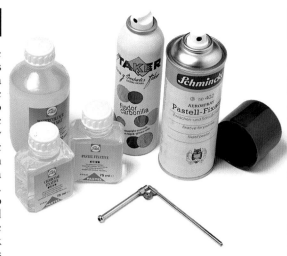

pastel sticks clean. In wet techniques, a cloth can be used to soak up excess water from brushes, so it is advisable to have a number of them at hand when working with paint and for general cleaning.

Charcoal and pastel drawings should be fixed to prevent the pigment from coming away from the surface over time.

The choice, therefore, depends on the artist.

STUMPS

Stumps are made of tightly rolled spongy paper, leather, or felt, with a pointed tip at each end. They are used to blend or smudge pencil, charcoal, or pastel. It is customary to use two or three stumps of different

Different size stumps suitable for pastel and charcoal.

BOARDS

Boards are essential for drawing on medium- and large-sized sheets of paper. They should be rigid, completely flat, and always slightly larger than the sheet you are using, so it is a good idea to have several sizes available.

CLOTHS

A soft cloth is virtually indispensable for all drawing techniques. It is very useful for erasing charcoal; although it does not erase as well as proper erasers, it can remove excess charcoal without damaging the paper. It can also be used for keeping hands and

CLIPS AND THUMBTACKS

Clips and thumbtacks are used to secure the paper to a wooden board in order to obtain a rigid surface on which to work. Thumbtacks take up very little space, but they do leave holes. Clips, on the other hand, do not spoil the paper but they can interfere with the artist's work.

SCISSORS AND UTILITY KNIVES

Scissors and utility knives are very necessary whenever paper is the chosen support. Scissors should be long and comfortable to use, in order to obtain straight lines. Utility knives should be used on a soft, yet cut-proof surface; these types of surfaces are sold in the form of plastic-coated rubber table coverings.

thicknesses for different colors. These tools get dirty very easily and can stain, so it is important to clean them by rubbing them on very fine-grain sandpaper.

COTTON

Cotton and cotton swabs are used to blend charcoal and pastel to create effects that are gentler and more subtle than those obtained with stumps. They are also useful for cleaning pastel sticks to remove powder of different colors.

Paper can be secured to the board with thumbtacks, adhesive paper, or clips. The choice depends on the artist's preference.

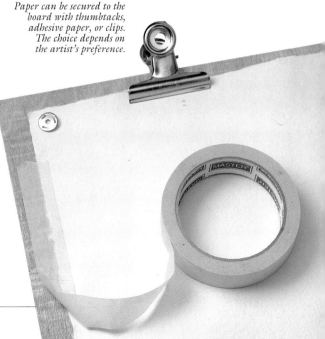

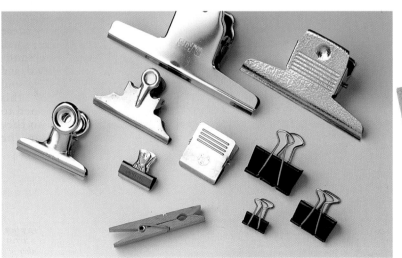

Clips for securing the drawing paper to the board or a folder used as a support.

MATERIALS AND TOOLS

PAPER TOWELS

Paper towels, sold in rolls, are useful for removing excess water from the brush when painting in watercolors or any other water-based medium. In addition, they are useful for cleaning both tools and hands.

GLUES

It is often necessary to glue paper or pieces of paper. The most suitable glues are the quick-drying types, which are easy to handle. Solid glue sticks (usually almond glue) are easy to use but not very strong. Stronger and equally fast are rubber-based glues, which allow the paper to be removed easily even after a long time, though rubber-based glues are cumbersome in large formats. A modern version of this glue is aerosols, which are very easy to use although they do tend to end up on the working surface if continuously used over time. Liquid glues (provided they are not water based, as this would wrinkle the paper) are reliable and clean, but they are more difficult to use and slower drying.

METAL RULERS

When using a utility knife, a metal ruler is necessary to prevent nicking the paper. It should not be too short; a yard or meter is the ideal length. A 90-degree triangle is essential for obtaining right angles, though it doesn't need to be metallic.

CONTAINERS

Containers are necessary for holding the water in water-based techniques. They should have a large capacity and a wide neck so that even large brushes can reach the water. Organic solvents should be placed in glass or tough plastic containers. Generally speaking, it is a good idea to have many different containers on hand to make it easier when painting.

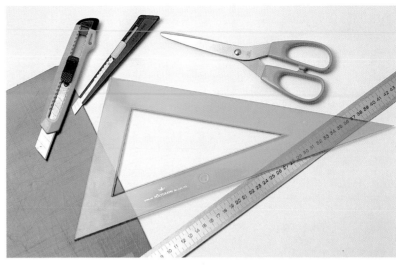

A large pair of scissors, a utility knife, a metal ruler, a good right triangle, and a cutting surface to keep the work table in good condition are all necessary for cutting pieces of paper to the right size.

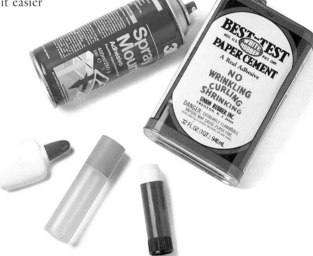

Each glue is designed for a particular type of surface. For gluing paper, it is best not to use glues that are too strong.

ALCOHOL AND SOLVENTS

The rulers, work table, and different tools used by the artist easily get soiled when working. In order to remove these stains easily, alcohol can be used, as it is a strong solvent and cleans almost all types of stain. Some stains, however, may be resistant to alcohol (oil, acrylic, dry rubber, and so on); in these cases, organic solvents such as turpentine or acetone can be used.

SPONGES

Sponges are very useful when working with a wet technique. In watercolor painting, sponges (which should be natural sponges) are used both for applying color and for removing it from the surface of the paper, as well as for dampening the paper before starting to paint. In the other wet techniques, sponges are used to clean any surface that has been accidentally stained during the painting process.

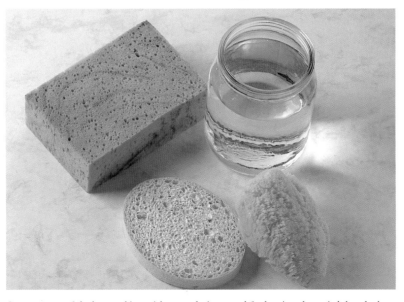

Sponges are useful when working with wet techniques and for keeping the artist's hands clean when drawing in pastel.

PANS

Small porcelain pans designed for mixing watercolors, gouache, or India ink are sold individually in different sizes. Pans are also grouped together in metal or plastic palettes. They are very easy to clean.

PALETTES

Palettes for gouache or watercolor painting should be made from metal or porcelain (a dinner plate can also be used), with or without small compartments. For oil painting, the palette should be varnished wood, although plastic and disposable paper palettes can also be used. Palettes for acrylic painting should be completely impermeable and hard, as dry acrylic colors can only be removed by scraping them off with a knife; a glass surface is an excellent solution for this.

PALETTE KNIVES

Palette knives are used in both gouache and oil or acrylic painting. They are used to spread the color out into even patches, textured or otherwise, as well as to remove paint from the surface, to collect impasto, or to clean the palette. Palette knives come in different degrees of hardness and are made in a trowel or knife shape. The knife shape is the most flexible and suitable for spreading a large amount of paint, while the trowel is more rigid and can be used to create textures or remove accumulated paint.

PORTFOLIOS

Paper should always be kept in portfolios, never rolled up. It is useful to have a sufficient number of different-sized portfolios so that too many sheets of paper are not accumulated in a single one. In addition, portfolios can also be used to replace a board as a supporting surface for drawing on loose sheets.

ADDITIONAL MATERIAL

Lecterns are very useful for tabletop work. Used as easels, they allow the artist to work comfortably on small-format works. All artists should have a case for carrying their most commonly used tools, such as pencils, charcoal, chalk, nibs, pencil sharpeners, erasers, and so on, in addition to a cloth for general cleaning during work.

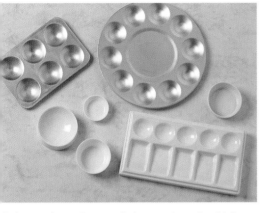

Palettes and pans for wet techniques, such as colored ink, watercolor, or gouache.

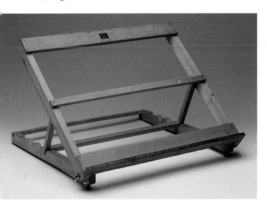

A tabletop lectern for resting or displaying drawings on.

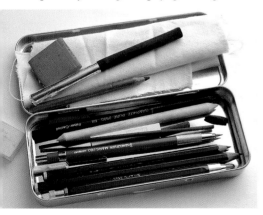

A portable case for drawing instruments. All artists have one of these boxes for keeping the most commonly used tools.

Palette knives are very useful whenever you are working with wet or oily techniques, both for cleaning the palettes and for spreading out the colors.

Portfolios are essential, both for storing finished work and for conserving all types of drawing paper. They can also be used as a support surface for drawing on loose sheets of paper.

Graphite Techniques

Since graphite is the most immediate drawing medium, it is relatively straightforward. But you should bear in mind that good results are achieved only by using a specific procedure. The way in which you hold the pencil, shade, or erase depends on the type of work you are drawing. This section explains these and other factors that come into play when you are drawing with pencils.

DRAWING WITH A GRAPHITE PENCIL

HOW TO HOLD THE PENCIL

The best way to draw details and lines is by holding the pencil like any writing instrument, close to the tip; however, don't attempt to draw the entire picture in this way, as you will lose track of the work as a whole. By supporting the pencil within the palm of your hand you can draw broad strokes with greater confidence; this is the best way to begin a drawing. To obtain shaded areas and intense grays with soft leads, the pencil should be held very close to the tip while pressing the lead flat against the paper.

The artist must hold the pencil in the middle and hold it almost parallel to the paper to shade in an area with long, medium-tone strokes.

The pencil should be held like a writing instrument to outline contours and add details.

Denser or intense tones are achieved by pressing the tip flat against the paper.

For drawing long lines while maintaining control over the pencil, it must be held in the middle, with the end firmly supported in the palm of your hand.

DRAWING WITH A GRAPHITE PENCIL

BLENDING

Soft graphite, the type that renders an intense tone, can be blended with a stump pencil in order to achieve gray areas and gradations without any traces of lines. Nonetheless, most artists prefer to use a finger for this purpose, a technique that allows greater control over the results. Another possibility is to file some graphite and blend it by rubbing your finger over the tiny shavings. This technique produces very dark gradations without fingerprints.

Graphite can be blended with a stumping pencil, although it is advisable not to overuse this implement because it tends to make the result look less dynamic.

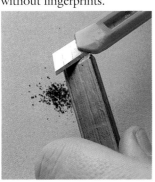

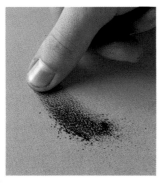

The artist may file down a graphite stick with a knife in order to obtain tiny shavings that can be used to stump with. This provides an excellent solution for darkening certain details.

By blending with your fingers, and persisting, you can darken shaded areas and lines.

**DRAWING WITH A
GRAPHITE PENCIL** **ERASING**

Graphite is easy to erase with a rubber or plastic eraser, which must be as soft as the leads being used. A dirty eraser will smudge the paper. This can be avoided by rubbing the eraser over a separate sheet of paper before you use it. If you need to erase details, the best procedure is to slice off a piece of the eraser in order to take advantage of its corner. To erase part of a drawing at a very advanced stage, you should place a piece of paper just below the detail so as not to affect the adjacent area.

The tiny pieces of rubber that are shed when erasing must be removed with a soft brush or a fan brush. It is important to make sure there are no remaining pieces of eraser on a finished work because they will continue to absorb and erase the drawing, to such a degree that lines disappear.

Before you erase, clean the eraser by rubbing it over a piece of paper.

To erase tiny details without altering adjacent areas, lay a sheet of paper next to the area to be erased.

Remove the tiny particles of rubber left after erasing on the paper with a soft brush or similar item.

**DRAWING WITH A
GRAPHITE PENCIL** **GENERAL CLEANLINESS**

If you plan on doing a lot of blending with your fingers, you should wash your hands several times during the session, because the combination of graphite and sweat will smear on the paper. The most commonly used technique is to place a sheet of paper under your hand while you draw to prevent your hand from coming into contact with the paper and producing smudges.

To keep your drawing clean, a sheet of paper should be placed between your hand and the surface of the drawing in order to prevent it from touching the paper and smudging it.

GRAPHITE TECHNIQUES

In addition to its function as a drawing medium based on lines and shaded patches, graphite allows a number of graphic effects that enhance the work with special textures and qualities. These techniques can be applied to any drawing that requires a particular type of atmosphere or one in which the realistic representation of the motif is less important than the purely formal elements, and—dare we say—"creative" construction.

Textures and blended gradations are the primary effects on which all graphic techniques are based.

GRAPHITE TECHNIQUES **GRAY BACKGROUND**

You can use a stick of pure graphite to obtain a uniform gray base, over which the pencil lines will stand out and be harmoniously integrated into the background, without having to rely on the usual procedure of using the white of the paper as a contrast. The texture of this type of background depends on the grain of the paper and its intensity will be greater or lesser according to the tone of the paper. Generally, the best paper to use is the medium-grain type since it provides the necessary texture and does not have too much of an effect on the subject.

The shading of the paper provides a good base on which you can effect a linear drawing.

GRAPHITE TECHNIQUES **TEXTURED BACKGROUND**

A textured base or background can be achieved by rubbing the stick of graphite against paper that is placed on a rough surface. The grain and texture of the surface determines the type of texture the paper will display, and all manner of effects can be obtained: linear textures (against corrugated cardboard), undulations (against a piece of very dry wood), granulated (against a wall), and others. In the example included here, the artist has used a mat to obtain a texture akin to the ripples on a river or a lake.

We can obtain a background by placing the paper against a textured surface and rubbing a stick of graphite over the surface.

The pattern obtained here could be used for a number of different subjects.

GRAPHITE TECHNIQUES **DIRECT BLENDING**

You can create all manner of shapes, lights, and shadows on a treated base by blending with your finger, without shading beforehand. The result is very subtle thanks to the homogeneous gray tone that merges all the light and dark hues. A work of this nature requires the artist to plan the effects he wants to achieve beforehand; in other words, he draws sketches in order to design the work.

Having spread the graphite over the paper, we begin to draw the outlines and blend the shaded areas. This procedure requires the artist to calculate the result of the technique beforehand, otherwise any insistence or accumulation will ruin the texture of the background.

GRAPHITE TECHNIQUES | SHADOWS ON WATERCOLOR PAPER

Rough-grain watercolor paper provides a surface on which the artist can draw large patches of graphite (using a stick of pure graphite) to obtain an atmosphere that integrates the work. In this example, rather than drawing the fishes with contours, the artist has simply added greater pressure to the stick so as to obtain the various tones of gray. The texture of the paper integrates the lights and shadows.

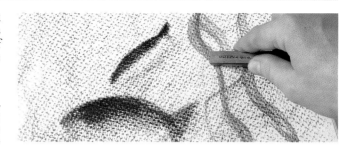

A graphite base on rough paper (watercolor paper, for instance) provides an interesting texture on which to draw.

GRAPHITE TECHNIQUES | BLENDING

To attain subtle effects, in which the blended areas perfectly merge with the white of the paper without leaving any traces of lines, the artist should stain several pieces of paper with graphite and then rub them against the paper. This method does not allow the blending of the more intricate parts of a drawing but it can be used in broader areas, such as the sky or the water, which require an especially soft and delicate treatment.

A piece of cotton covered in graphite can be used on a gray patch to obtain a soft blended effect, be it to model a shape or to create a tone for it. This example shows you how the shapes of prickly pears have been made entirely by blending with cotton.

Blending on paper that contains shaded patches should be carried out very softly to obtain a delicate finish.

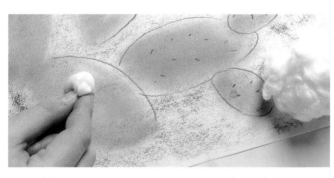

Cotton is better than a stump for bringing out the softest and most continuous shadows.

GRAPHITE TECHNIQUES | TURPENTINE

Since graphite is greasy it can be diluted with turpentine. Only a tiny amount of turpentine should be applied because graphite lacks sufficient consistency to be used in the same way as other pictorial media, and the result can turn out dirty. By adding a few drops of solvent on a cloth and applying it lightly over the drawing, you can obtain darker patches that lend an impressionist effect to the work.

Turpentine can be applied to certain areas of the drawing. This is done by applying a few drops of turpentine to a piece of cloth. The end result is a series of dark patches that can heighten a shaded area.

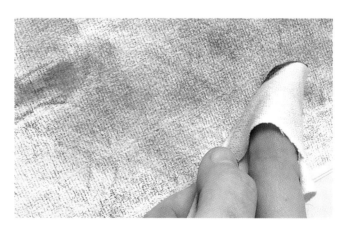

GRAPHITE TECHNIQUES | DISSOLVED IN WATER

Watercolor graphite is soluble in water and can be used to obtain effects akin to wash. The most recommendable procedure is to first draw with abundant shading. Then a wet brush is applied to the areas where specific effects of light and shadow are to be included. If you plan on using the brush in many areas, it is advisable to work with thicker paper than you would normally do for drawing in pencil.

Watercolor graphite can be touched up with a brush wetted with water in order to blend the lines together.

VALUE AND MODELING **A JUG**

The shape of this object is further complicated by the sphere. It is, however, more theoretical a complication than real; because its shape is more irregular than the latter, it provides more reference points for defining its contour. The shininess of the jug's surface is an additional factor in modeling and obtaining the value of the work: Light values among the dark ones are the result of a reflection or highlight, rather than a mistake or accident. These tiny highlights can be resolved by obtaining a correct distribution of highlights and shadows using the same procedure as in previous drawings.

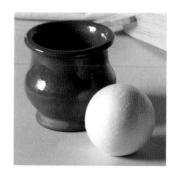

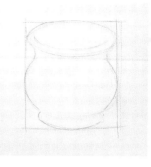

1. The shape of the jug can be enclosed within a square. Then, by marking in the points where the object comes into contact with the square, you will see how easy it is to draw the object's outline. Forget the sphere for the moment until you have successfully drawn the jug. Then you can erase the area that is hidden.

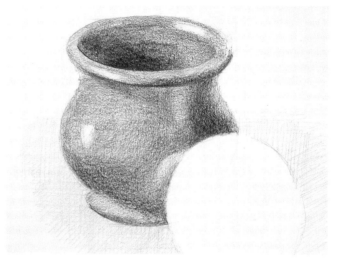

2. Regardless of how dark certain shadows are, don't try to represent them in their true intensity from the outset. The work of darkening the shadows must affect all of them, from the lightest to the darkest ones. Only by following this procedure is it possible to achieve a correct modeling and credible highlights.

3. Thanks to the gradual darkening of all the shadows, the barely touched parts stand out as highlights. Furthermore, the reflection of the curve of the adjacent sphere can be clearly made out due to its color.

VALUE AND MODELING **DRAPERY**

Drapery refers to the drawing of folds and creases of a fabric. To capture these aspects of fabric is a traditional exercise in all art schools. Folds and creases are much more complicated to draw than any of the shapes we have practiced up to now, but they can be rendered by applying the same criteria. The curved shapes of drapery may be shaded in the same way as simple forms, except that they have less uniformity.

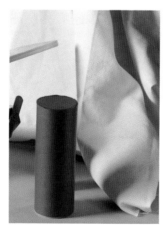

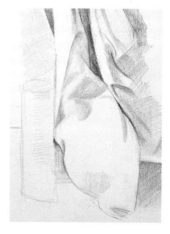

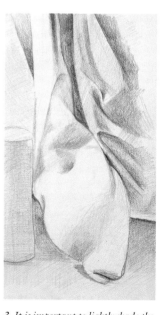

1. The preliminary drawing is no more difficult than the previous ones. Without including unnecessary details, the artist should begin by sketching the general outlines of the folds, comparing the shape and the position of the narrower form above with the wider fold below. From the outset, the artist should begin softly shading the darkest shadows.

2. New shaded areas are added that darken the values and thus highlight the brightest areas. The folds are now given more details.

3. It is important to lightly shade the surface of the table so that the fabric is correctly represented in its context and also so that the highlights acquire their correct value in relation to the highlights and shadows of all the forms in the picture.

VALUE AND MODELING | THE WHOLE

To conclude this series of exercises, we will create a picture using all the subjects drawn in the exercises within this section. By incorporating them into a larger drawing, they become groups of values within a whole, and as such the artist must consider all of the values in relation to one another. The procedure to follow is the same: a preliminary drawing, the gradual shading of the relevant areas, and then the darkening of all the shadows until the correct modeling has been achieved.

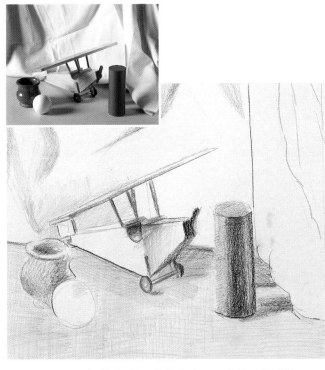

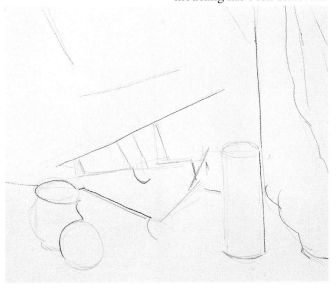

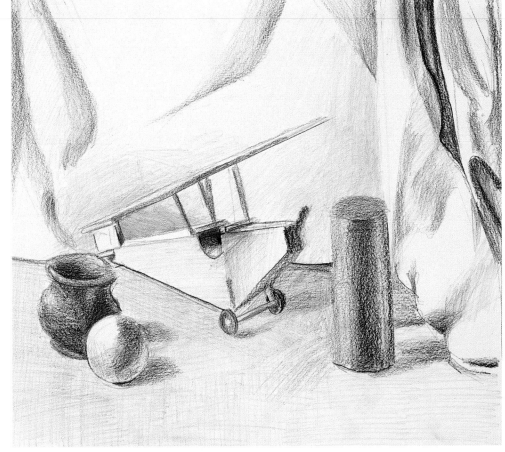

2. The work of gradually shading all the shadows and objects should be simplified to the utmost. At this point the drawing combines the most intense highlights and shadows.

1. The preliminary drawing requires only the lines that define the position of each one of the objects. No attempt need be made to outline the elements exactly.

NOTE

Hard lead pencils can be combined with soft leads throughout the entire drawing process. The former can be used to add tiny variations and nuances in tone.

3. The unitary effect is achieved by working the theme as a whole. Each element has its own highlights and shadows while, at the same time, forming part of a composition that harmoniously integrates everything together.

Perspective

This book will not deal with the subject of perspective in all its aspects; however, it is important to know the basics of perspective in order to represent depth, a feature that is present in all types of drawings. This section is concerned with the fundamentals that will arise in subsequent works in this book, regardless of the subject matter. Two essential concepts to have in mind are parallel perspective and intuitive perspective.

PERSPECTIVE LINEAR PERSPECTIVE

We could include the theory of perspective in all its aspects, but it would be a highly summarized version of all the points that need to be taken into account. In order to draw a picture in perspective, the objects must be reduced in size in accordance with the distance they are from the observer. The correct size of each object in perspective is obtained by means of receding "vanishing" lines. For instance, we can obtain a "vanishing" line by joining the highest points of two posts of equal height seen in perspective. If, in front of this row, there is another parallel to it (something that tends to happen with the tracks of a railroad), the "vanishing" lines obtained from this second row of posts meets the previous line at a point on the horizon, called the vanishing point, as well as all the other lines of parallel elements that can be identified in the scene (rooftops, the train on the track, etc.). There are a number of exceptions to this basic rule, but it can be applied to most pictures. The accompanying exercise demonstrates this theory.

This path lined with palm trees provides an excellent example. The path, the tips of the leaves, and the building on the right determine lines that will converge at the same place on the horizon: the vanishing point. In fact, the position of the horizon line, which cannot be seen in this scene, is indicated by the vanishing point. These elements allow the artist to reconstruct an image whose "real" perspective can be altered without affecting the apparent naturalness of the drawing: one of the boundaries of the path has been deliberately altered and no longer converges at the vanishing point. Nonetheless, the effect does not ruin the believability of the representation. This is a good example of the freedom the artist can allow himself to break the rules with only a minimum knowledge of the theory of perspective.

1. This is a diagram of the perspective of this drawing: a horizon line and a series of diagonal lines representing the path, the palm trees, and the building.
Theoretically, all these lines converge at the vanishing point, but one of the lines has deliberately been altered in order to demonstrate that it is not essential to apply the theory of perspective to the letter to obtain a convincing representation of the subject.

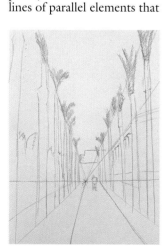

2. To achieve the desired effect, it all boils down to raising the row of palm trees to the height of the vanishing lines, while considering the distance between each tree.

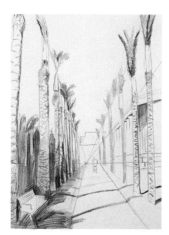

3. Now that the main elements have been situated, the artist adds the details and shadows.

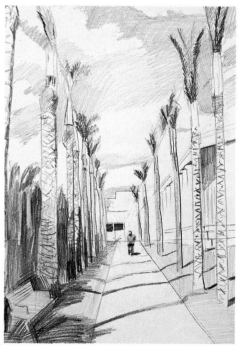

4. The shadows and the various details help to conceal the perspective lines and lend a natural appearance to the scene.

Rather than theoretical principle, this form of perspective is based entirely on sight and experience. The artist requires no knowledge of perspective to represent the spatial distance that separates the components in most subjects. The artist can understand and draw perspective using his intuition: the large being close by and the small being far away. To demonstrate this with several useful techniques, we are going to offer an exercise in which perspective does not depend on vanishing points but on modeling, shading, and proportions—in other words, issues that are directly related to the artist's techniques.

These two public statues form part of a large monument with steps leading to the top. By going up and down the steps the artist can discover a variety of interesting points of view that give rise to more unusual perspectives. Vanishing points would not be able to resolve the space between the two figures. In this case, each statue must be drawn in a different way and the relationship between the values of the highlights and shadows must be treated with caution.

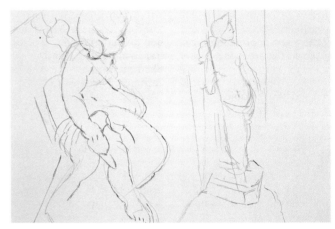

1. From the outset, more importance must be given to the figure in the foreground, by means of the intensity of the line and the inclusion of more details.

2. The values of the shadows must be darker in the closest statue so that it appears to "approach" the spectator, leaving the other statue free of stark contrasts.

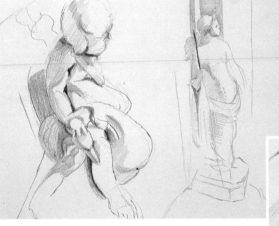

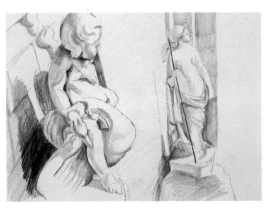

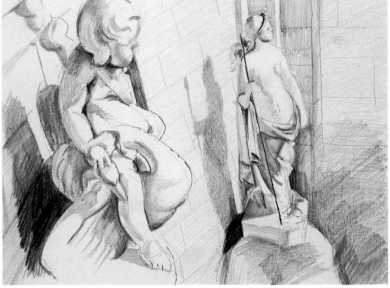

3. The shape of the statue in the background is defined by means of more general shading; the figure in the foreground requires a wide variety of highlights and shadows in order to intensify the details.

4. The shadows and modeling of the figure in the foreground have a greater intensity than the one in the background. This effect makes the former appear much closer to the spectator.

The Value of the Line

In pencil drawing, the quality of the line plays a vital role in making graphite an expressive medium. The function of the line varies according to the artist's aims: It may be used to represent shadow, to model the motif, to obtain a value, or merely to add a descriptive or ornamental element. This section shows you the possibilities the pencil line has to offer, depending on what the artist wishes to achieve.

THE VALUE OF THE LINE	SHADING BY STROKES

In a pencil drawing, the brightest highlights are represented by the white of the paper (if the paper is not colored). Therefore, in order to a___ ___ ___ the ___ction of sh___ ___ ___ ___face of

certain areas and darken those in shadow. To shade correctly by means of lines, it is essential to draw all the lines in the same di___ ___ allows you ___ ___ the ___ction of the light over ___ ___face of ___ ___ ___.

The complexity of the interplay of highlights and shadows in the leaves of the plant can be resolved by shading areas with lines in various directions, according to their undulations.

1. T___ ___ ___ ___ ___ the be a___ ___ ___ ___ment of the its s___ ___ ___ment of the plant's leaves. The contours should not be closed up, as this would ruin the transitions between the areas in light and those in shadow.

___ ___ ___ ___ ___ r to control the direction of the strokes. The direction of the lines must conform to the shape and inclination of the leaves defined in the preliminary drawing.

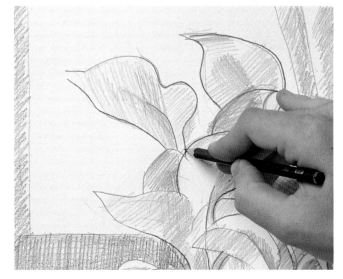

3. Once all the values of the highlights and shadows have been obtained, you should go around the outlines of the most prominent leaves with continuous strokes, holding the pencil as if you were writing.

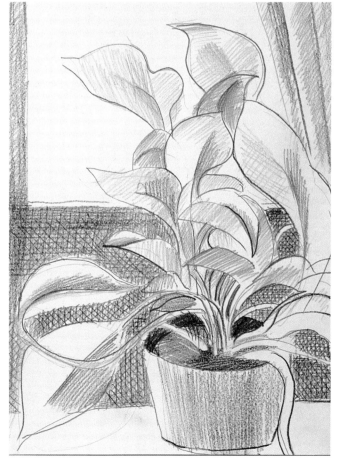

4. Even though we have not included all the details of the subject, the result provides a good example of how the combination of strokes gives rise to a rich interplay of transitions between light and shadow.

THE VALUE OF THE LINE MODELING

Lines in subjects that do not require such great contrasts between light and shadow, but rather a description of the volume through the chiaroscuro technique, demand more precision and subtlety. It is a question of knowing how to make undrawn areas of the paper appear to form part of the same surface as the shaded parts. To model the subject in this exercise we have to ensure that there is a correct distribution of curved lines of various intensities.

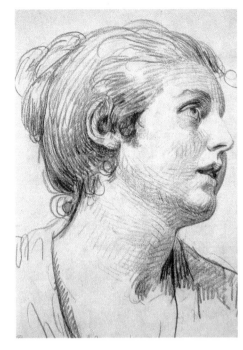

The subject is a version of Head of a Young Girl, *by Jean Baptiste Greuze (1725–1806), a drawing based on subtle pencil work modeling that expresses with utmost precision the volume of the face.*

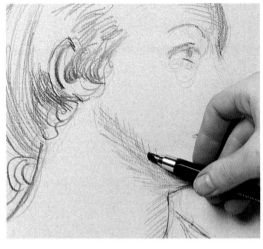

1. The outline has been drawn in pencil, in order to obtain a line of uniform thickness. The work of the face itself can be drawn with a thick lead inserted in an automatic pencil, since the tone is more important than the line in order to attain the effect through subtle cross-hatching. The lines are most relevant under the chin in order to indicate the change of the head's plane with respect to the neck.

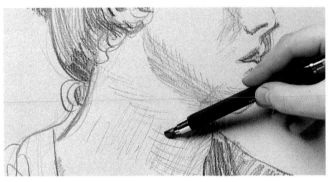

2. The artist needs to be especially careful with the direction of the lines drawn to express the roundness of the neck. In this case, the diagonal and curved crosshatched lines that are drawn faintly in the part mostly in shadow follow the direction of the neck's natural curvature.

NOTE

Drawings that require abundant tonal contrast should be drawn with an automatic pencil loaded with a thick lead, which can produce a wide range of intensities. It will allow the most subtle of shadows as well as the darkest ones.

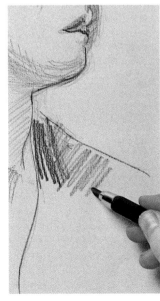

3. The most intense contrasts are located in the nape and the uppermost part of the shoulder. These two areas require a dark tone, which in the hair has been obtained by drawing curved strokes while the area of the shoulder has been drawn by superimposing a series of rapid lines in all directions.

4. All the areas we have shaded in have obtained the same result: The volumes of the head, neck, and face have all been brought out while avoiding the stark contrasts of chiaroscuro and respecting the unity of the form.

The Sketch

Technically speaking, a sketch is an abbreviation of the techniques of shading, modeling, and obtaining values, all characteristics of a pencil drawing. The aim of a sketch is to capture a fleeting moment, an unrepeatable and spontaneous movement that compels the artist to use the minimum of implements. To capture a characteristic gesture or a shape that expresses much with very little is what makes sketching a difficult and extremely satisfying art form. The exercises presented in this section provide an analysis of the technical factors entailed in this artistic practice.

THE SKETCH	THE LINEAR TECHNIQUE

The quickest and best way to capture a fleeting view of a subject in movement is with a linear sketch. The tremulous and abrupt lines, typical of this type of sketch, possess a characteristic dynamism that is the product of a speedy execution. There is barely any time for shading when the artist must concentrate on capturing the movement at the same moment it is happening.

This exercise reconstructs the process of a sketch by the artist Charles Nicolas Cohin (1715–1790) called Study of a Man. *This work, with all probability, was drawn from nature and probably conceived for a painting. Of course, the process shown in this photographic sequence does not reflect the speed of the real work.*

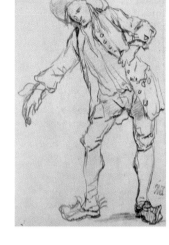

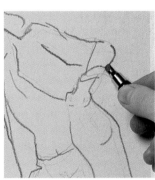

1. The first part involves getting down the most significant outlines, those that best enclose the general movement of the figure. Normally there is not time for much else, but this basic outline is more than enough for adding the rest of the representative elements.

2. By way of direct observation and the use of details seen during the instant of the action, we can include important elements, such as the characteristics of the clothing or the folds they produce.

NOTE

The sketch requires no preliminary outline, since the object of a sketch is to obtain an outline. It is advisable, nonetheless, to begin by mentally calculating the sizes and proportions of the subject.

3. A few faint lines are enough to indicate the facial details, the hair, and the creases of the shirt. There is hardly any need to look at the motif to draw these kind of details because they can be worked out from the figure's general outline.

4. The experienced artist's hand will have gone from one to the next phase nimbly and without time for reflection. Thanks to this type of analysis we can perceive the technique and process involved in the linear sketch.

The aims of a sketch may be very varied. We have seen how the linear sketch captures above all else movement, gesture, and the moment itself. But the artist may be more interested in capturing the corporeity of the subject than the story of the moment. In such case, he can opt for a type of sketch based on strokes that model, lines that create volume, patches of light and shadow.

A sketch by the Austrian painter Oskar Kokoschka (1886–1980), titled Model with Her Back Turned, *is an ideal sketch for learning how to draw this type of sketch in which the volume of the figure is summarized before the precise characteristics of his pose.*

1. The general outline and the first shaded areas to model the subject are carried out simultaneously. The shadows and volumes that require definition during this first stage are suggested by the general outline itself; they are deduced without the need to look at the model.

2. The general shading by lines are as much a form of expressing volume as a general shading of the drawing over which the most important areas can be darkened. The volume is obtained by sketching almost intuitively, applying greater or lesser pressure to the pencil over the paper.

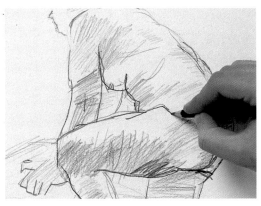

3. The general outlines are lost under the abundance of strokes, making it necessary to go over those where there is a fold or a very shaded area.

4. The result is a figure with open areas in which the lines do not enclose it completely. This technique allows the power of the masses to be highlighted without actually having to draw them in their entirety.

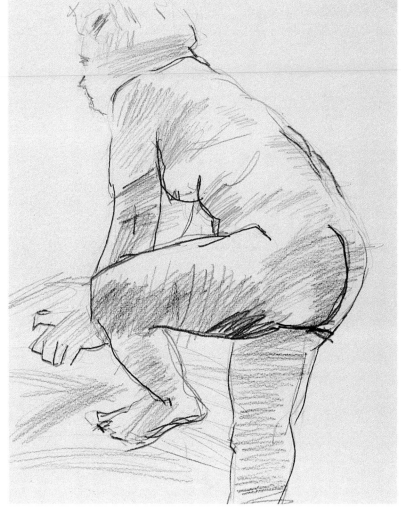

Drawing with a Range of Grays

The wealth of gray tones that can be produced by using various hardnesses of pencils can be heightened further still by using graphite sticks. These drawing implements are used to create large patches of gray with speed and without leaving traces of lines. By combining these tools we can obtain works in which the value of a patch of gray is as significant as a purely linear drawing or one effected by shaded areas of lines, with the resulting enrichment of the drawing's final result.

PICTORIAL EFFECT

Although we are dealing with drawing in graphite, in this exercise we are going to demonstrate how to achieve a pictorial effect through an atmosphere created with gray tones. The forms are not enclosed, but rather they relate to and blend with one another in specific areas, creating a sensation of a whole and a unitary intonation. A monochromatic drawing can also suggest color by means of different values of the same tone and the relationship among them. A work correctly executed with a range of grays can produce a pictorial composition if these values are interpreted as colors.

The present exercise will be drawn with the following graphite pencils: an HB and a 6B as well as a fine 2B lead and another thick lead of 5B hardness, inserted in automatic pencils, and an all-lead pencil and a stick of graphite (which can be substituted for a hexagonal stick). You will need a utility knife—to sharpen the thick lead—and a soft rubber eraser.

The sculptural group of Miguel Blay (1866–1936), titled El Frío, is a perfect motif for the present exercise. The lighting is directed in a way so as to bring out the wealth of gray tones and half-tones that can be resolved by means of linear shading and gray patches applied with the graphite sticks. The chiaroscuro and the modeling are factors that determine the technique employed in order to draw this work.

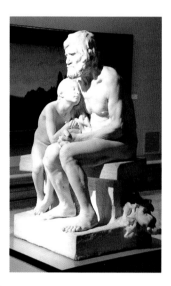

1. The purpose of the preliminary drawing, effected with an HB pencil, is to provide the artist with a guide. The forms have been situated in their correct proportions and the provisional outlines of the subject are in place.

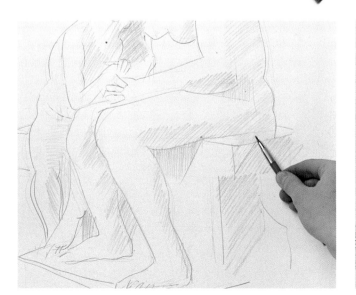

2. Using the automatic pencil loaded with a hard lead, we carry out a preliminary general shading, all with the same intensity of gray, filling in the most important dark areas and ensuring that the relief of the forms looks suitable.

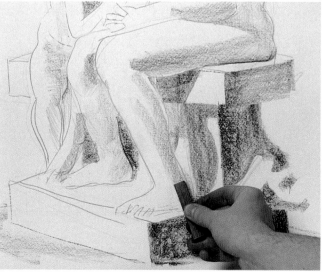

3. By applying the graphite stick on its edge, the shaded areas are darkened, which have straight outlines (those of the bench and the pedestal) and also a couple of the shadows on the elder man's feet.

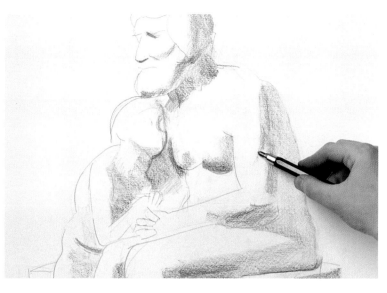

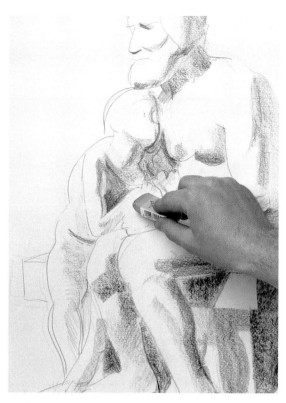

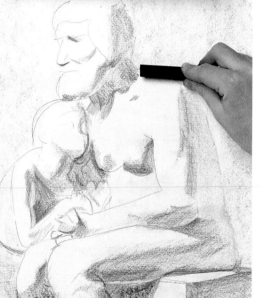

4. The soft lead loaded in the thicker automatic pencil allows us to darken the interior shadows that model the most prominent muscles.

5. The excess details of the preliminary drawing can be erased in order to work the highlights and shadows better. A preliminary drawing that is too elaborate always hinders the shading.

6. With the new graphite stick, the background is darkened slightly. The tone is an essential reference point for lending greater or lesser intensity to the shaded areas of the figures. As they are gradually darkened, the background, against which they stand out, must also be shaded in.

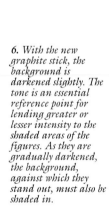

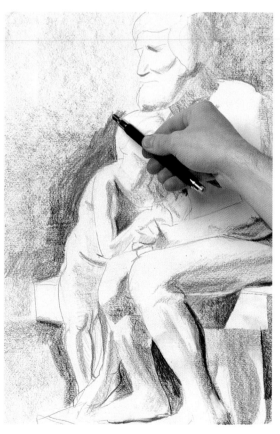

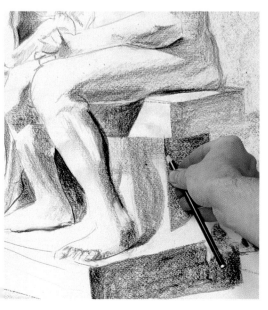

7. Using the soft pencil, we go over the edges of the white and the pedestal, to provide the angular shape of these elements with relief.

8. The whiteness of the marble that is directly in light can only be highlighted by contrasting it with a very dark tone. The background requires much more darkening in the illuminated area.

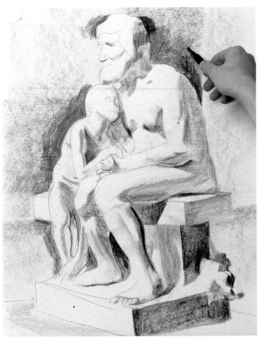

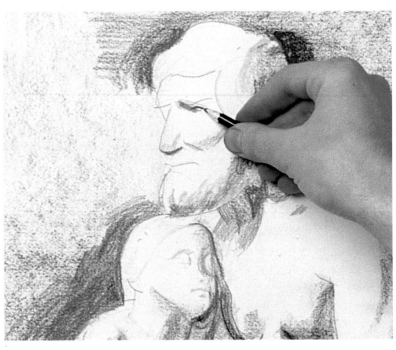

9. By shading the background, the figures are defined more precisely. It is important to remember that the contours are defined by the interplay of highlights and shadows rather than by lines.

10. The facial features must also be constructed by means of tiny contrasts of shadows. The eyes and the nose are tiny volumes and therefore must appear as such, and not as drawn planes.

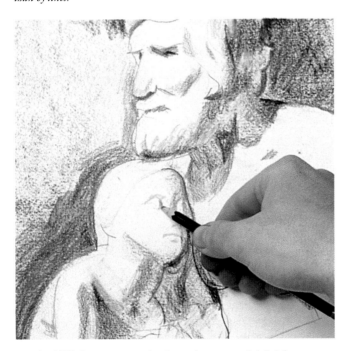

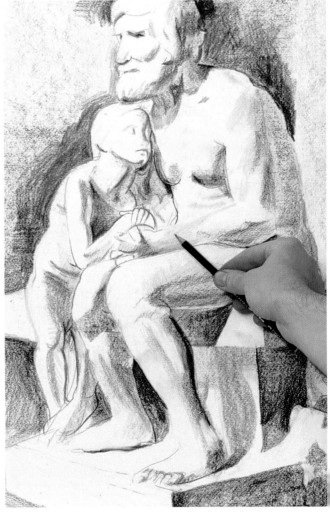

11. The child's features are much softer and more rounded. It is best not to overwork them and leave them for the final phase of the of the work, when they can be finished with some retouching in accordance with the general feeling of the drawing.

NOTE

The details should be left for the lightest parts. Shadows distort details so adding details in such areas will only lead to an overloading of the drawing.

12. This is one of the most difficult areas, because the shadows are faint and the forms are somewhat complicated (hands clasped together and fingers crossed, etc.). Here it is a question of simplifying and seeing details in accordance with the whole, lightly modeling the drawing only where an important detail has to be distinguished.

14. *The final phases of the work are taken up with drawing in details like the feet and finishing off shading very lightly certain areas that help to highlight relatively undefined areas, such as the top of the pedestal on which the feet of the figures are resting.*

13. *Different types of shadows, some lighter than others, are combined and superimposed in the white area. The work should be drawn with care so that the interplay of shadows does not appear as bulges or cracks in the marble, but as though the shadows are cast over a flat surface.*

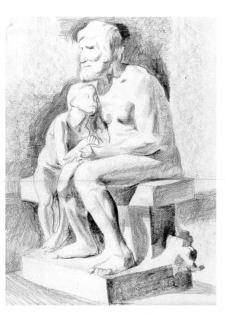

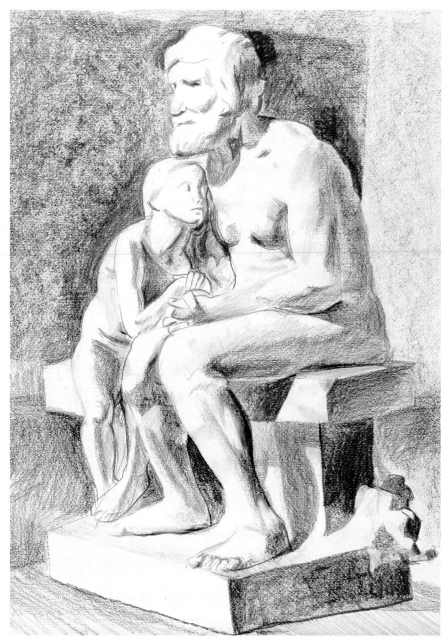

15. *The figures are virtually finished; the only remaining task is to finish off the background tone.*

16. *We apply the new graphite stick over the background lengthwise in order to spread the gray and go around the figures and thus create the appropriate semidark atmosphere for this subject.*

17. *The final result clearly demonstrates that graphite can be used to render a wealth of tones. This is a drawing in which the artist has obtained the right values and painstakingly modeled and adjusted all the forms.*

Colored Pencil Techniques

Compared with all other drawing media, colored pencils should be used on a small scale. They offer the best results when used to draw small pictures, rather than large-format ones, and cannot be used to obtain the great creative effects produced by charcoal, pastel, or ink. It is this limitation that makes the colored pencil medium interesting, as it forces the artist to work with care, delicacy, and sensitivity. The following technical guidelines explain the characteristics of this medium.

DRAWING WITH COLORED PENCILS

LINES AND COLORS

Drawing with colored pencils is also coloring. The appearance of the color depends, therefore, on the type of lines used. Subtle colors are produced by means of hatching or cross-hatching, but whatever technique you use, it is important not to cover the entire surface of the paper. The accumulation of lines may be fluent and rapid or premeditated in the form of superimposed diagonal cross-hatching (appropriate for a uniform type of texture). Even though with this medium the colors never become very saturated, it is possible to fill in an area by applying the lead flat against the paper.

Soft tones are produced with light strokes that are not applied too closely together.

In the case of graphite, the pressure applied to the lead determines the intensity of the stroke.

The color mixtures can be of the optical type, that is, they may be based on the superimposing of lines that from a distance appear to blend together into one.

DRAWING WITH COLORED PENCILS

COLOR MIXTURES

Rather than mixing, we should speak of superimposing tones, as the physical mixture is never absolute with this medium. The colors that result from superimposing tones follow color theory: When combined, the primary colors yellow, blue, and red produce the secondary colors orange (a mixture of yellow and red), green (a mixture of yellow and blue), and purple (a mixture of red and blue). Artists always use broad color ranges (to avoid too many color mixtures), among which both the primary and secondary colors should be included. There are few drawings that do not require some superimposing of colors in order to produce a third one. This type of work must be carried out in a specific order: The light color must be superimposed over a dark one, since light colors cover less and allow the underlying layer of color to remain visible, a necessary condition for obtaining the desired color mix. If, for instance, we paint red over yellow, the resulting color will be the same red with a slight orange tone. If yellow is superimposed over red, the orange tone will be more prominent.

The lightest colors do not possess sufficient intensity to affect darker colors in a mixture.

The color mixture must be carried out in a specific order: The lightest color should be applied over the darkest one, and not the contrary.

DRAWING WITH COLORED PENCILS

BLENDING GRAY OR WHITE

Colored pencils have a unique characteristic due to their composition. We are referring to the possibility of blending strokes with a light gray or white over other colors. The slight waxy consistency of lead, together with the weak coloring power of white or gray tones, makes strokes blend together, so that the gray or white are barely noticeable. Certain tones not only blend but become darker when covered with gray. This technique comes in very handy for all types of works with colored pencils.

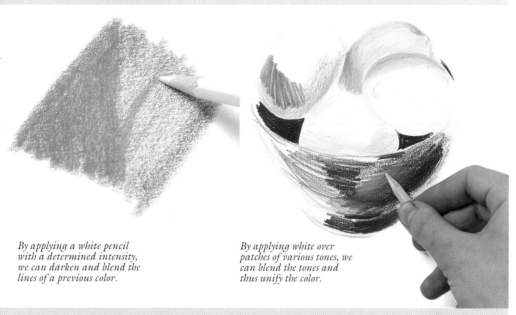

By applying a white pencil with a determined intensity, we can darken and blend the lines of a previous color.

By applying white over patches of various tones, we can blend the tones and thus unify the color.

DRAWING WITH COLORED PENCILS

COLOR RESERVES

The artist can outline shapes by using a darker tone, reserving the color in the same way he would in a watercolor painting. This procedure requires the artist to foresee the final result, knowing that the base color has to be quite light in order to maintain the tonal richness. Regardless of the many light tones we may use, by outlining shapes on a dark background, there will barely be any alteration in the tone of the original color. Color reserves ensure a lustrous finish, provided you do not go over or superimpose lines with new applications of color.

If we apply a dark color over a light one, we can create forms by reserving the background color and superimposing another tone on top.

DRAWING WITH COLORED PENCILS

MIXING WITH WATERCOLOR PENCILS

Although drawing with watercolor pencils almost verges on the category of a painting medium, it is worth mentioning in this section. Watercolor colored pencils add a new dimension to typical drawing techniques in which tones are superimposed on one another. This method consists of combining pigments by dissolving the color in water. With watercolor pencils the mixtures are not carried out on the palette, but are done directly on the paper. After painting the colors, the artist adds water in order to blend the strokes and obtain the desired chromatic result. Whenever you work with watercolor pencils, especially when you want to obtain a result similar to that of watercolor, you will have to choose a thicker sheet of paper than the one usually used for drawing, because when the paper absorbs water it has a tendency to warp. Fine-grain watercolor paper is the ideal support for this purpose.

Watercolor pencils can be worked with a brush and water, thus achieving results akin to watercolor painting.

TONES

One of the most interesting aspects of colored pencils is the wealth of intensities of each tone, more than the brightness and variety of colors. The artist models the shape by softening or intensifying the strokes, rather than superimposing colors. At this stage, colored pencil is a drawing rather than a painting medium. In drawing, the maximum highlight is obtained through the white of the paper itself, while the shadows are obtained through shading. In this case, the shadows are achieved with the same color.

TONES	ORANGE TONES

The variations within a single color can be obtained by applying the pencil softly or hard or even by working with two or more pencils of different colors that produce a single predominant color. This orange-colored tomato cannot be drawn with just an orange pencil. It requires red and yellow pencils. These two colors can be used to obtain all the necessary hues, which can be used to model the volume of the tomato.

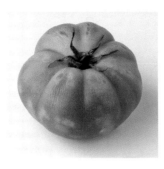

Both the color and the modeling of this tomato can be carried out at the same time by combining a yellow pencil with a red one.

1. The preliminary drawing begins with a red outline. The contour is virtually definitive, but it can be altered as we paint within it.

2. We begin by painting the areas in which yellow appears unmixed, or almost unmixed. The work must always be carried out from light to dark, given that the orange tones will be produced by superimposing red over yellow, and not the other way around.

3. The orange tones, which represent the predominant color of the tomato's surface, emerge out of the red patches shaded over certain yellow areas. By intensifying the stroke of the red pencil, we obtain the volume and relief of the tomato's bulges.

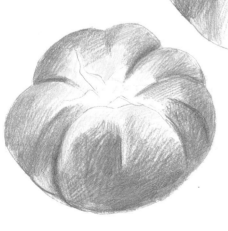

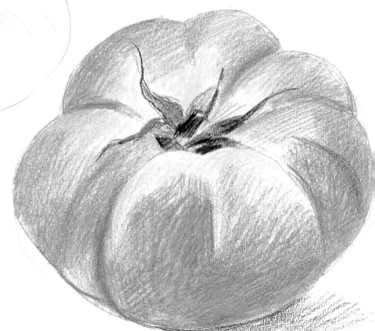

4. The entire surface has been filled in except for the stalk and the tiny leaves. More yellow has been applied over red in certain places in order to lessen its intensity and to unify the modeling of the subject's round shape.

5. The inclusion of green is purely anecdotal and is limited to the stalk. With this last detail now added, the drawing is complete.

TONES RED TONES

In this drawing we will use only red pencils—carmine, magenta, and vermilion. These will be combined and superimposed to heighten the complex shape of this vegetable, using the white color of the paper itself for highlights. The procedure is identical to the one we have demonstrated in the last drawing, the only difference being that there is no need to use the pencils in any particular order.

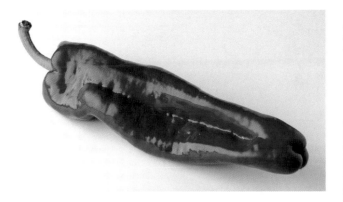

The red colors of this pepper contain different hues and intensities that can be resolved by using various colors of the same range.

NOTE

The color must be applied from light to dark. It is impossible to create new tones or hues over a solid color, therefore the first stages of work should be done with faint strokes.

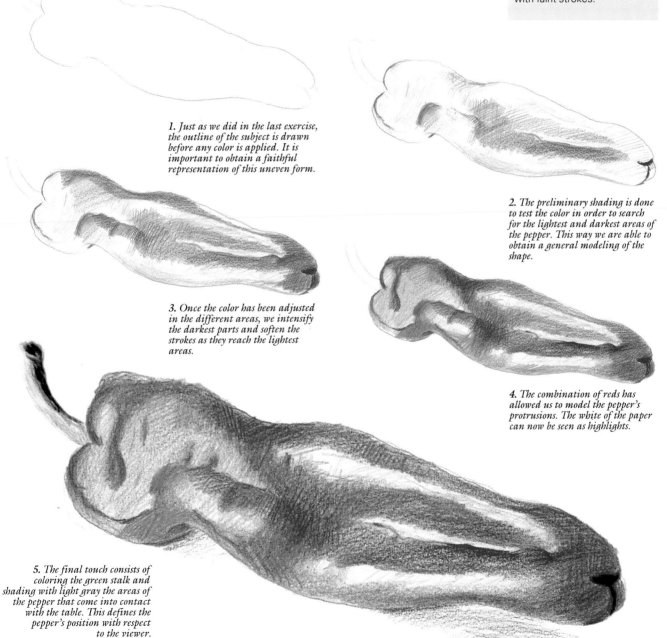

1. Just as we did in the last exercise, the outline of the subject is drawn before any color is applied. It is important to obtain a faithful representation of this uneven form.

2. The preliminary shading is done to test the color in order to search for the lightest and darkest areas of the pepper. This way we are able to obtain a general modeling of the shape.

3. Once the color has been adjusted in the different areas, we intensify the darkest parts and soften the strokes as they reach the lightest areas.

4. The combination of reds has allowed us to model the pepper's protrusions. The white of the paper can now be seen as highlights.

5. The final touch consists of coloring the green stalk and shading with light gray the areas of the pepper that come into contact with the table. This defines the pepper's position with respect to the viewer.

SOLID COLORS

There are motifs whose interest lies more in the colors than in the contours. Colored pencils do not allow us to draw significant color effects in the same way that we can with oils, acrylics, or even watercolors, but it is possible to achieve reduced areas of "solid" color to cover the paper by applying linear shadings and intensifying tones through contrasts. The exercise included in this section illustrates the procedure for producing relatively solid colors by means of tonal contrast.

SOLID COLORS FRUIT

We have chosen this bowl of fruit as our motif because of the vibrant color contrasts, the yellow lemons, the orange mandarins, and the deep blue—almost violet— bowl. Violet blue is the complementary color of yellow, making it one of the strongest contrasts within the entire harmonic range. Thanks to such strident contrasts, the limited covering power of colored pencils is compensated for and the visual impression of the colors becomes more striking and solid.

Three lemons and a mandarin in a blue bowl is the subject we are going to use in order to demonstrate how colored pencils can produce intense and solid colors.

1. The contour of the subject is drawn in gray without including any shading. The artist must concentrate to ensure that the curvature of the bowl and the shapes of the fruit are correct.

2. The first shading serves to adjust the tonality of the colors and to test out the contrast between the elements.

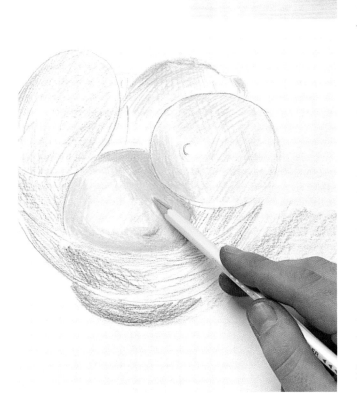

3. We begin to model the lemon using two yellows: The lighter one is applied in the center, where the lemon receives most light, and the darker is used to shade in the rest. This combination already begins to produce the effect of volume.

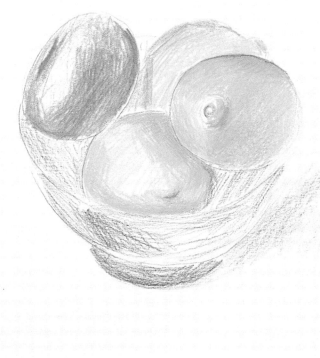

4. The yellows produce a more compact color, which will be heightened by the contrast with the rest of the elements.

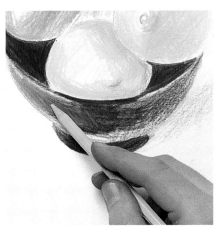

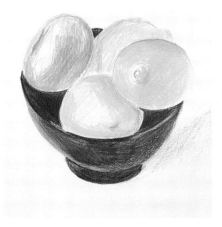

5. *The color of the bowl is obtained by superimposing two blue colors and violet. The highlights are left virtually untouched.*

6. *Using a gray pencil, we blend some of the blue strokes, thus obtaining a continuous color surface that perfectly expresses the bowl's volume.*

7. *Thanks to the intensity of the blue, the color of the lemons has acquired more "solidity" and their shape now looks rounded.*

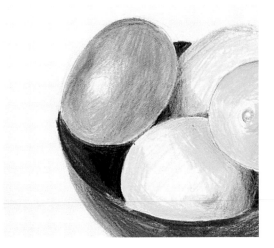

8. *The orange tones of the mandarin have been drawn by shading with orange and ochre. The latter color has been applied to the darkest areas of the fruit.*

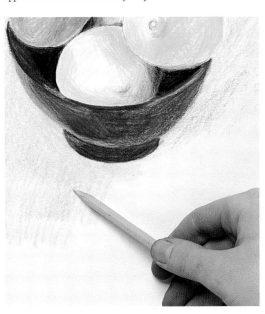

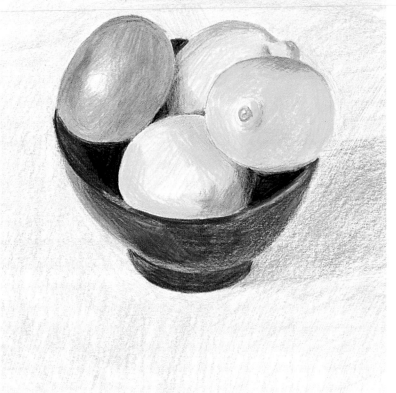

9. *The tablecloth is shaded in with crisscross strokes until a uniform area of color is obtained.*

10. *The final touches are for the surface of the table, which is given a gray value, shading in the shadow with a bluish gray and contrasting the background with a combination of blue and black. The end result shows you how the stark contrasts of the fruit and the bowl create the effect of the solid color we were searching for.*

Color by Strokes

Colored pencils offer the possibility of coloring a shape in a very precise way by applying an accumulation of short strokes, alternating diverse colors and the intensity of the lines in relation to the white of the paper. This allows the artist to obtain very rich chromatic effects that can be adapted to the characteristics of the subject. This technique is one of the most suitable for this medium, but certain subjects are less suitable than others for this type of treatment. This lake scene with ducks provides an excellent example to demonstrate this technique.

PLUMAGE AND WATER

An animal theme is especially appropriate for this exercise. The plumage of birds can only be rendered with tiny touches of color in different directions and with abrupt changes in tone, characteristic colors of these animals. Colored pencils allow highly realistic results, with the added advantage that they can be used to tone delicate highlights by using the color

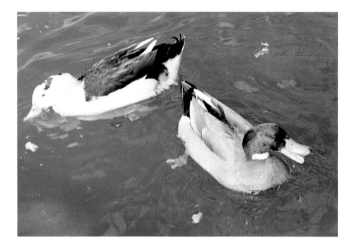

of the paper and the intensity of the stroke. The white of the paper itself must be taken into account throughout the process, shading it in some parts and leaving other parts visible between the strokes.

Both the plumage of the ducks and the ripples on the surface of the water form an ideal subject for practicing one of the most effective colored pencil techniques: drawing and shading with groups of lines.

2. The darkest areas of the plumage can be drawn in, since these areas will not be superimposed with color nor will they be touched up.

1. The first lines should define the contours and situate the most outstanding features of the plumage without going into detail.

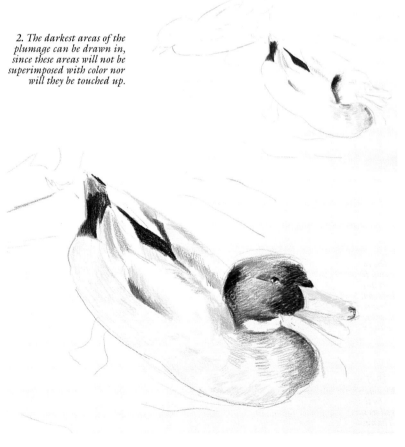

3. The green tones of the head emerge between the black shadows. By combining these two colors we obtain the characteristic iridescent effect of the plumage of this part of the duck's body.

4. The body is softly modeled with a series of very short gray and sienna parallel strokes. This work method requires well-sharpened pencils in order to draw precise strokes.

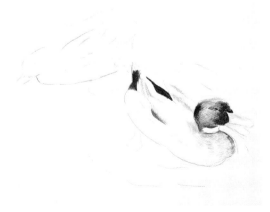

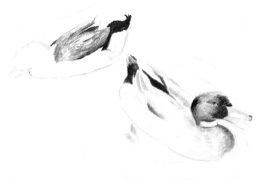
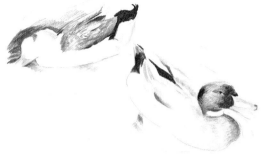

5. With brown, gray, sienna, and black, we can draw the detail of the plumage of the uppermost duck. The crisscross lines used to model the plumage make it look very realistic and convincing.

6. The white parts of the duck must be left untouched, adding the barest touches of color. By drawing the water around this reserved area, the duck acquires form and volume.

7. The work on the water must be carried out very gradually and methodically, beginning with faint strokes and then gradually adding evermore intense color. The direction of these strokes is very important because it represents the plane of water on which the ducks are floating.

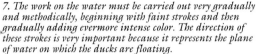

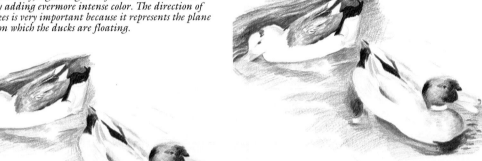

8. The color of the water along the flanks achieves the necessary effect of flotation. Another aspect that must be taken into account is the distortion of the shapes of the legs, due to the ripples of the surface of the lake.

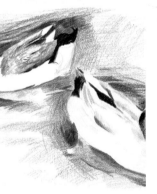

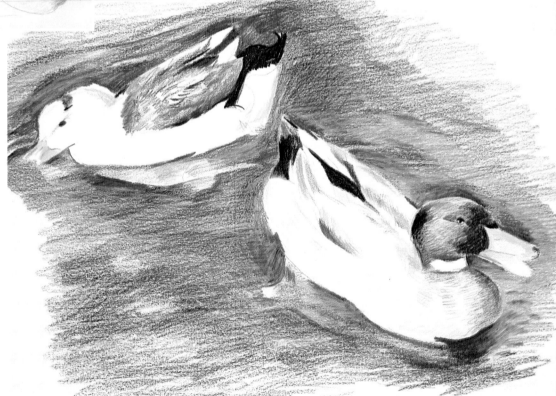

9. The color of the water should be drawn from the legs outward, superimposing dark gray tones and blues to tone the green and to adjust the tone of the water, taking special care to create natural-looking ripples on the water.

10. The impact of the intensity of the color of the water is highlighted by the pure white of plumage, as well as several very clear reflections. Thanks to the methodical drawing process we have followed, consisting of lines and dark patches, you can see the possibilities that colored pencils offer when they are used to color with strokes.

Color Drawings

I t is important to bear in mind that colored pencils provide the best results when they are used as a drawing medium rather than as a painting medium. If the maximum form of expression in a drawing is the line, the richness of a work effected with colored pencils lies in the interplay of colored lines. It is not easy to list subjects that are most appropriate for this technique, as most objects, in reality, are three-dimensional and have mass rather than being groups of lines. But it is possible to find subjects that can be drawn exclusively with lines. By drawing an example of one, you will see the special attraction of colored pencils when used on a subject that is tailor-made for them.

BOTANICAL GARDEN

The subject selected for the present exercise contains some palm trees in a botanical garden, which boast branches of long leaves that almost begin at the trunk. The leaves can be seen individually. This is a perfect motif for a color drawing executed by means of colored pencil lines.

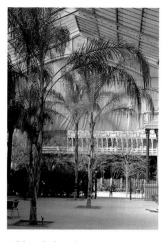

Although the subject may look complicated, it will not pose many difficulties. The artist will have to pay much attention to the directions the leaves droop and make sure his pencils are sharpened before commencing.

1. In the preliminary drawing we concentrate only on indicating the linear directions of the subject: the diagonal lines of the roof, the vertical lines of the trunks, and the arch formed by the palm leaves.

2. The branches are drawn over the faint-colored background of the enormous marquee. This color must be applied from the outset using a pale pink and a gray for the folds that form in the uppermost part.

3. The details of the roof are simplified. The pencil should be held lightly over the paper so that the details are only insinuated. The artist must take care not to confuse the lines and colors of the background with the branches.

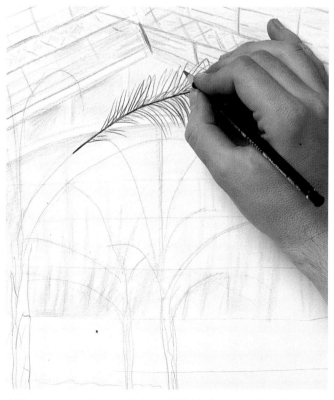

4. The most separate leaves can be drawn individually, having checked beforehand their direction and on which part of the branch they are located. This does not imply copying each leaf, but rather drawing them in synthesis with lines running in a similar direction. It is advisable to study them before starting this task.

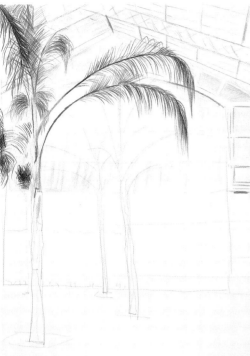

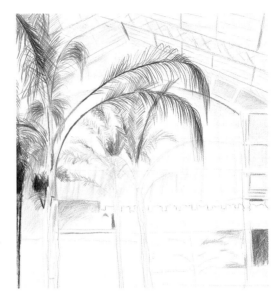

5. The nearest palm tree looks like this now that all its branches have been drawn in. The direction of the leaves is determined by the curve of the branches and their position. The branches facing us do not allow the leaves to be seen individually, so they are drawn with more patches of colors than lines.

6. The rest of the palm trees must be drawn more roughly in order to produce a sensation of distance.

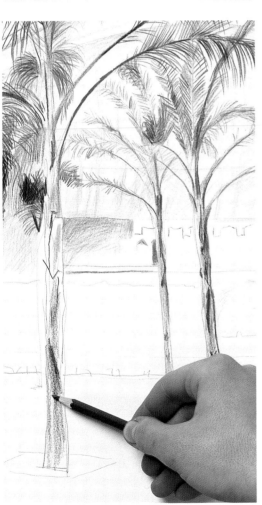

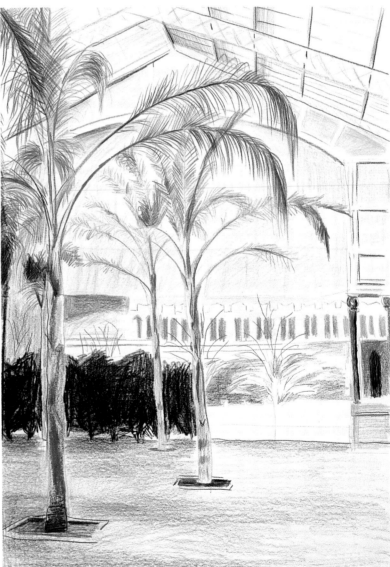

7. The trunks are shaded in with brown, bringing out the spaces between the bark with a darker color. Just as we did with the palm leaves in the distance, the furthermost trunks must be drawn roughly, without detail.

8. The buildings and vegetation in the background of the botanical garden should be colored more softly so that they really look distant from the place where the palm trees are situated. The blackish bushes create a separation between the background and the foreground. The final task to complete the drawing is to darken the ground.

Drawing and Color Ranges

The last drawing we are going to do with colored pencils will demonstrate the possibilities of modeling the subject within a limited harmonic range of grays, bluish grays, browns, and greens. It is far easier to model with a range containing few tones than it is when drawing many contrastive colors. Modeling is based on obtaining the form of the subject through tonal values, highlights, and dark areas, instead of through pure colors. This subject suggests such a treatment.

AN OLIVE TREE

Colored pencils have their limitations when it comes to modeling large volumes: The artist would have to fill in a large area of the paper with fine strokes and the result would be crude and childish. The narrow long body of this olive tree is an excellent example with which to practice the present technique. The crown cannot be drawn leaf by leaf, neither can it be modeled as if it were a solid volume. It must be treated with tiny contrasts of light and dark areas of color, always working within the same tonal range.

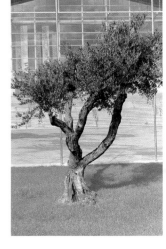

The shape of the tree is clearly outlined against a clean background and the only shadows present are those cast by the tree itself. The study of the form takes priority over any other pictorial elements.

1. The contour of the trunk is drawn in gray. It is important not to close up the outline, as the definitive shape will be produced by the patches of color.

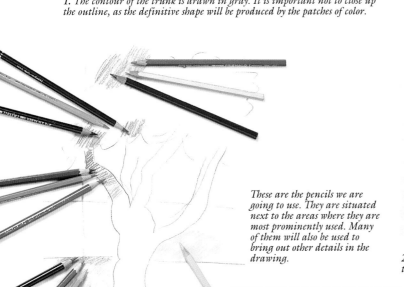

These are the pencils we are going to use. They are situated next to the areas where they are most prominently used. Many of them will also be used to bring out other details in the drawing.

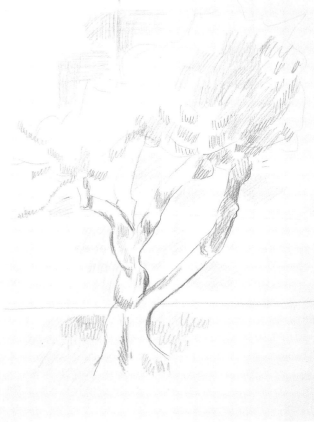

2. The first shaded areas lend more definition to the volume of both the trunk and the leaves.

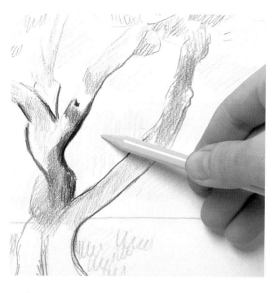

3. *The esplanade situated behind the olive tree is painted pale pink which, in later phases, will be intensified with applications of other colors.*

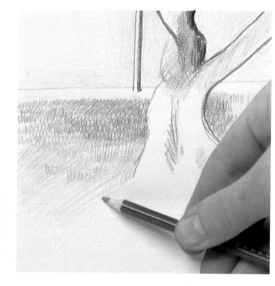

4. *The grass must be worked in stages. First, we shade the area with yellow and pale green, over which tiny strokes of a darker green are applied.*

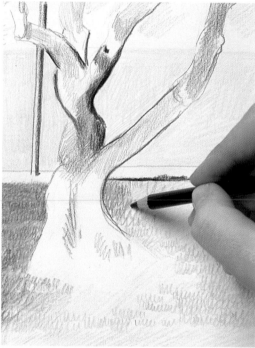

NOTE

When drawing a picture with colored pencils, it is advisable to begin shading in the shadows with a pale color before adding the definitive color, once the different tones of the subject have been added.

5. *The next stage in coloring the grass consists of darkening the tone by means of further tiny strokes that lend more density and color to this area.*

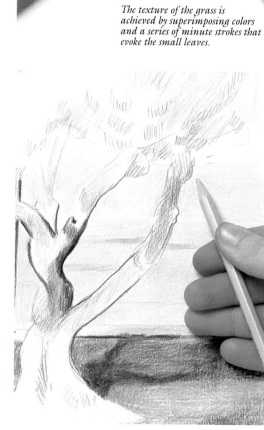

The texture of the grass is achieved by superimposing colors and a series of minute strokes that evoke the small leaves.

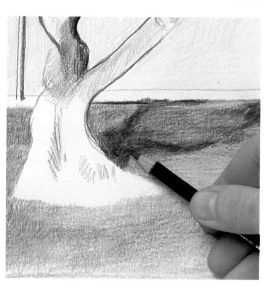

6. *In the last stage of the work on the grass, we darken the shadow cast by the tree, taking care not to outline it too much. The edges of the shadow must remain soft so that it appears to be cast over grass rather than a smooth surface.*

7. *The background is prepared by drawing soft strokes of bluish gray. These strokes outline the shape of the tree, leaving the areas that we will now color in untouched.*

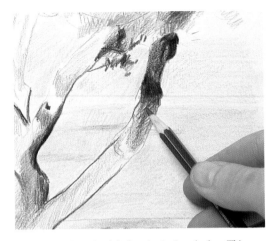

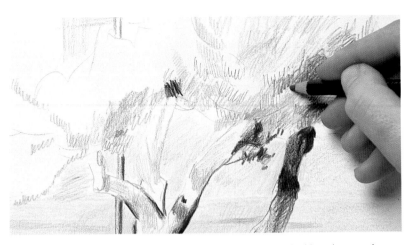

8. The branch on the right has the darkest shadow. This cannot be modeled because it covers the diameter of the trunk and barely has any tones to bring out the volume.

9. The leaves are drawn with dense patches of color that gradually build up the crown by means of successive contrasts of lighter or darker grayish or intense greens.

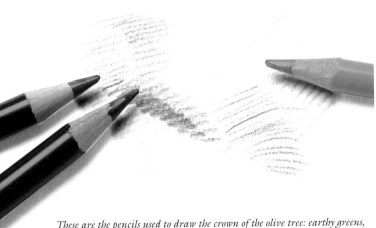

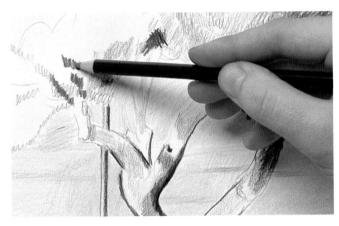

These are the pencils used to draw the crown of the olive tree: earthy greens, combined with brown and gray.

10. The fine branches of the olive tree can be drawn with patches similar to the ones employed in the central mass, although thinner and longer, bending outward.

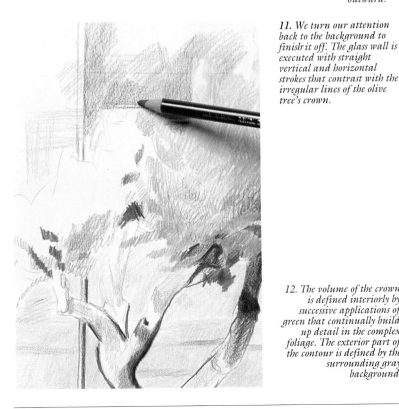

11. We turn our attention back to the background to finish it off. The glass wall is executed with straight vertical and horizontal strokes that contrast with the irregular lines of the olive tree's crown.

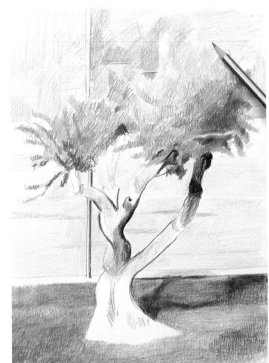

12. The volume of the crown is defined interiorly by successive applications of green that continually build up detail in the complex foliage. The exterior part of the contour is defined by the surrounding gray background.

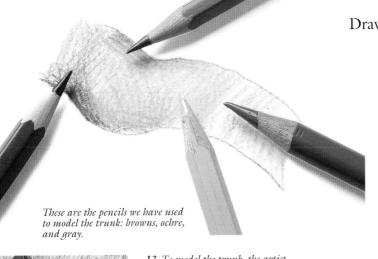

NOTE

It is advisable not to press the pencil tip down too hard against the paper, otherwise you will end up creating grooves that hinder shading and will remain visible in the final result. Only during the final stage of the work can you apply a little more pressure.

These are the pencils we have used to model the trunk: browns, ochre, and gray.

13. To model the trunk, the artist must darken the edges in order to bring out the volume, especially in the parts where the branches undulate.

The vertical and horizontal lines of the background provide a convincing rendition of the glass, in addition to producing a contrast with the treatment of the tree, made up of lines leading off in all directions.

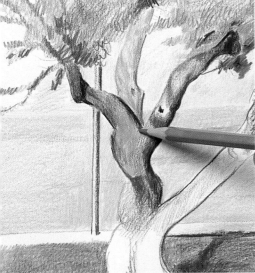

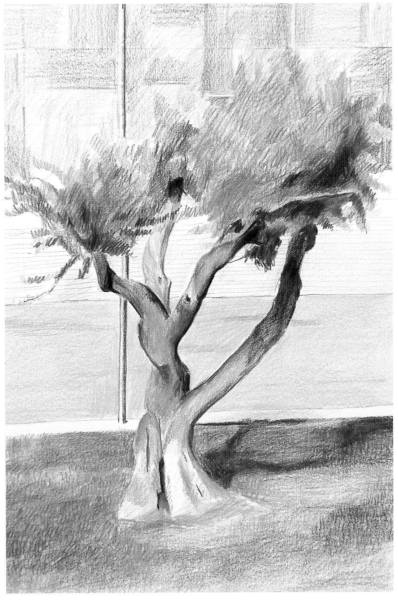

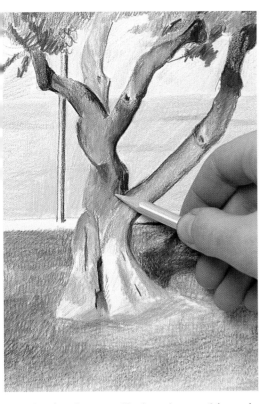

14. *Using the pale gray, we blend certain tones of the trunk, so that the color is continuous without abrupt changes.*

15. *In the final result, we can appreciate the realistic effect produced by the modeling process as well as the free pencil work applied to the thick foliage.*

Drawing with Charcoal

Because the charcoal medium has more covering power than pencil, it can be used to create more effects than the latter, at the same time conserving its possibilities for drawing considerable detail. An important characteristic of charcoal is its wide range of tones (from the most subtle gray to black). Charcoal can be spread, blended, and manipulated with your fingers. Without doubt, this is a "dirty" medium and, therefore, should be used on larger formats than those used with pencils, and more care has to be taken when handling charcoal. This part of the book is concerned with some of the most interesting charcoal techniques that can be used with the charcoal medium.

DRAWING WITH CHARCOAL	BLENDING

The fact that charcoal can be blended with a stumping pencil or with a finger opens up a wide range of possibilities. When the artist rubs charcoal, its tone lightens. This is almost the only way to achieve gradations, as there is barely any perceivable change in the resulting intensity when charcoal is applied with lesser or greater pressure over the paper. It should be pointed out that the possibilities for stumping are much greater when you use natural sticks of charcoal or compressed charcoal.

A brush is also a good implement for blending, as it is much softer than the stumping pencil, and it lightens the tone much more as well.

Whether you use your fingers or a stumping pencil, gradations multiply the possibilities of charcoal as a drawing medium.

A gradation of tones that can be achieved by blending range from the virtual black color of natural charcoal to the color of the paper. If you use white paper, you can gradate to white by using a piece of white chalk.

DRAWING WITH CHARCOAL	ERASING

The limited adherence of charcoal makes it very easy to erase. The kneaded eraser is an indispensable tool, since not only is it used for erasing, but also for opening up white areas within a patch or a gradation, in other words, for restoring the color of the paper after having drawn over it. This type of eraser also allows you to draw with it: tones can be lightened, details can be drawn and the brightest parts of the model can be illuminated.

The eraser can also be used like a rubber stamp, by molding it into a form and repeatedly applying it to a dense application of charcoal, thus creating textures.

Used as a drawing accessory, the eraser can be used to define completely straight boundaries by rubbing it along a strip of paper.

The kneaded eraser is also a drawing implement: not only can it be used to rectify errors, but also for lightening and even drawing white lines, which makes it indispensable for modeling forms.

DRAWING WITH CHARCOAL — MASKING WITH PAPER

In works that demand neatness and very clear effects, the artist can cut out a piece of paper with the desired form and use it as a mask. By drawing and blending within the interior of the form, the artist can obtain a completely uniform tone and very precise contours that cannot be attained in any other way.

2. The charcoal patch is rubbed from both sides toward the center so that the particles of charcoal do not go over the limits of the mask.

1. First we cut out the shape of the paper we want to reserve, that is, that we have left undrawn. Then the paper is placed over the support and filled in with charcoal.

3. The final result is a shape colored in a completely uniform tone with a perfectly delimited contour, something that is impossible to achieve by any other method.

DRAWING WITH CHARCOAL — TEXTURES

In addition to the texture of the paper itself, we can obtain textured bases using papers placed underneath the drawing paper. By holding a stick flat against the drawing paper and rubbing, the underlying paper leaves its imprint on the drawing paper in the form of lines and angles that can create patterns. By the same token, we can substitute the underlying paper with any rough surface.

If you work on fine paper, you can place a sheet of paper underneath and then draw with the stick held flat against the paper to obtain lines and angles that can produce an interesting base texture.

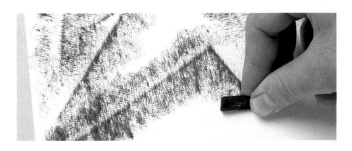

DRAWING WITH CHARCOAL — FIXING CHARCOAL

Charcoal must always be fixed when the drawing is finished. The tiny charcoal particles are not adhesive and slowly release from the paper. An old technique was to spread linseed oil over the stick before using it to draw. The oil, on drying, fixes the charcoal permanently in place. This method only works on drawings in which the charcoal has not been blended.

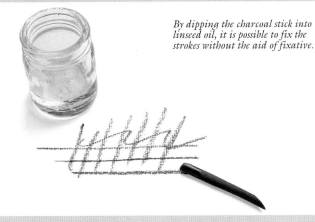

By dipping the charcoal stick into linseed oil, it is possible to fix the strokes without the aid of fixative.

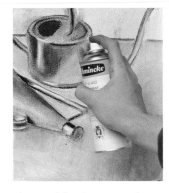

An aerosol fixative prevents the charcoal from falling off the paper and protects the work.

DRAWING WITH CHARCOAL — NATURAL AND COMPRESSED CHARCOAL

By using natural charcoal with compressed charcoal you can combine patches and strokes of various intensities. Natural charcoal is much easier to use for creating large patches and for stumping, while the little sticks of compressed charcoal allow the artist greater control over the line.

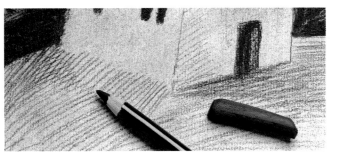

Blended areas and broad patches are best obtained with natural charcoal, while more precise and intensive lines are more easily drawn with compressed charcoal.

Blending and Strokes

Every subject requires a particular treatment. In these pages we are going to demonstrate two diametrically opposed techniques on two very different subjects. The atmospheric landscape demands blended strokes and blurred open lines, and suggestions of form rather than precise contours. The human figure, on the other hand, is a subject that requires greater precision of the artist: resolute lines and shading by lines. These two very different subjects and techniques are, at the same time, very characteristic of charcoal drawing.

BLENDING AND STROKES **LANDSCAPE**

The blending technique is excellent for creating atmospheres by merging values together. In a sketch or a landscape painting, the view is more important than exact renderings of each trunk and rock. In such cases shaded areas tend to link the different values into a coherent unity.

2. In order to attain an atmospheric effect, the stick of charcoal is applied flat against the paper over the areas that require some general shading.

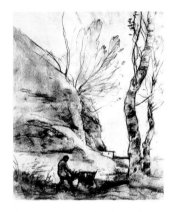

By reconstructing this picture by Corot (1796–1875), we can examine the way in which we can draw and blur successively through shading.

1. The most important elements of the landscape are drawn with simple charcoal strokes, determining sizes and proportions as well as several shadows that lend body to the trunks and brushes.

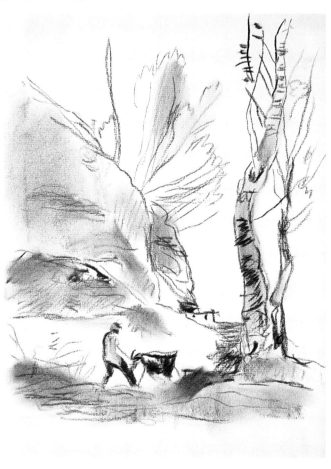

3. The previously applied areas of shading are rubbed with the fingers. Those areas that need further shading are gone over with the stick.

4. The result is a landscape in which only the most relevant parts are brought out, leaving the rest enshrouded in an ethereal atmosphere.

BLENDING AND STROKES FIGURE

This classical figure gives us an opportunity to practice shading by lines. This technique is normally carried out with a charcoal pencil, as the little sticks of charcoal produce a stroke that is too thick and imprecise. The execution of the figure on colored paper is complemented with highlights of white chalk.

This foreshortened figure (drawn from an unusual point of view) is a work by François Boucher (1703–1770), Study of Male Figure, *drawn with white chalk highlights. By reconstructing it, we can understand the process of shading without blending charcoal.*

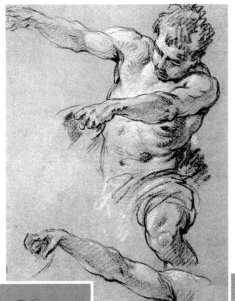

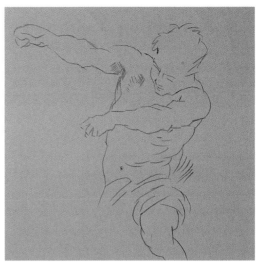

1. The contour must be left open, without joining up the lines completely to allow the shadows to finish off the modeling of the form.

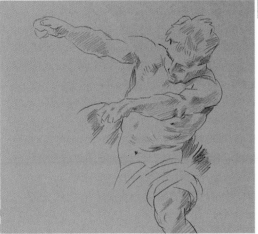

2. The shadows are created with short lines of different intensities. The darkest parts are an accumulation of series of lines.

3. The left arm is drawn with soft shading, which is mainly situated in the forearm and elbow. The shading must be applied in this area with very short strokes.

4. The drawing is finished off by adding highlights in the chest, shoulders, and knee with a little piece of white chalk.

Modeling

Charcoal is extremely versatile for modeling forms, especially for lending volume to the human figure, used not with stiff surfaces but variable, mobile, and changing shapes. These two drawings illustrate other techniques of representing relief and volume in human figures using the eraser in the first and gradations in the second.

MODELING	TORSO

We will refer to a classic subject drawn by Titian (1511–1576) in order to study how to model form with a kneaded eraser. The eraser allows the artist to open up whites, lighten a tone, and establish the volume of forms. By combining this technique with shading, the various forms that comprise the torso can be represented.

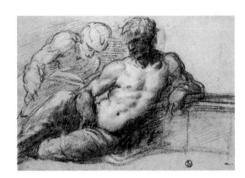

Although the artist did not use an eraser in the original, the result can be reconstructed by erasing parts of the gradations.

1. As always, the preliminary drawing is used to situate the forms in their correct proportions and establish contours to contain the main volumes.

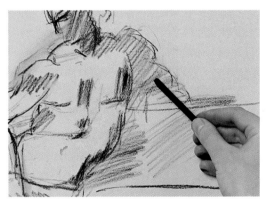

2. The artist draws lines, which will later be smoothed and blended, in order to bring out the loins of the torso. These lines will also serve to establish, after a rough calculation, the figure's proportions.

3. The previous lines are blended with the fingers without worrying much about the real volume of the torso. The volume will be defined by erasing with the kneaded eraser.

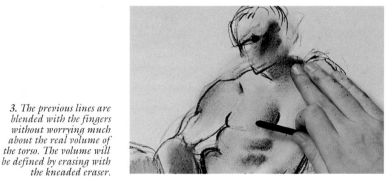

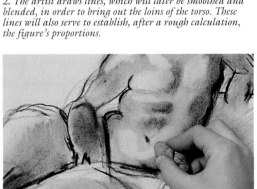

*4. Opening up spaces with the eraser.
The kneaded eraser is used as a drawing instrument. By erasing parts of shaded areas, we can remove part of the charcoal to create highlights that, in contrast to the darkest areas, model the volume of the figure.*

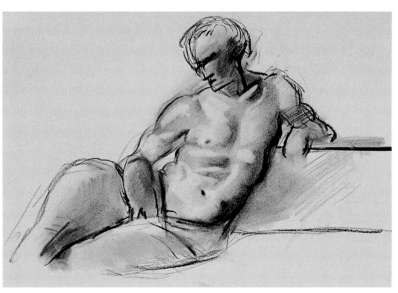

5. The result is a soft and clearly modeled body, achieved with a technique especially suited to smaller formats when little sticks of charcoal cannot produce very precise strokes.

MODELING HEAD

One of the most predominant features of the head of this young man is its mass of hair. Its dark form is an important part of the contour of the profile, which determines the natural relief of the facial features. The face is achieved by modeling with intense strokes crisscrossed by subtle blending.

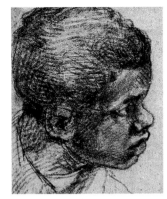

This foreshortened head by Paolo Veronese (1528–1588) is the model for practicing the next modeling technique based on darkening lines and blending.

1. The outline is the most important aspect of this drawing, as it describes the facial features and situates them in correct proportion with respect to the large volume of the skull.

The two pictures were drawn with these two implements: vine charcoal and a charcoal pencil.

2. The lines applied with the charcoal pencil must run in a determined direction, following the gesture of the head.
The work of darkening is produced by intertwining lines that render the facial features and situate them in correct proportion to the large volume of the skull.

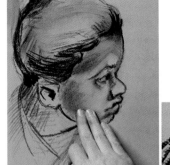

3. Blended strokes are added to the shadows where the modeling must be more delicate, in the cheeks and other areas of the face.

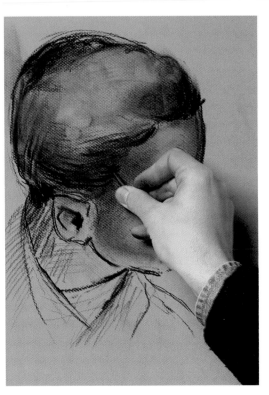

4. New intertwined strokes are drawn to emphasize the part of the shadows where the blending has softened the volume.

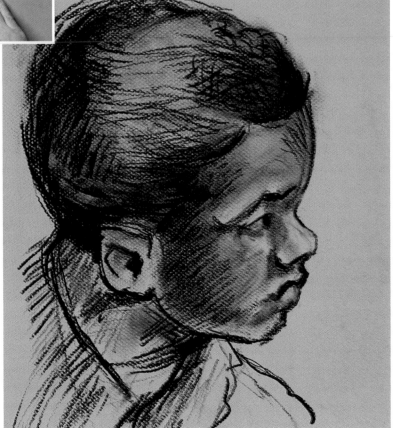

5. This result has been achieved by carrying out several rectifications in the profile, adjusting the volumes obtained by shading. To summarize, our drawing has been given an energetic treatment highlighted with dark tones.

Surfaces

In certain subjects, the shape is merely one more aspect of the object. One aspect is not enough to determine character; other factors need to be included. The most important of these is very often the materials that lend volume to a form.

The surface of an object can be smooth or coarse, matte or shiny, fine or rough, and so on. The representation of these properties is as important as the drawing of the contours and the volume. The versatility of charcoal allows us to convey some of these subjects in a convincing manner. We have chosen a selection of subjects to practice drawing over the next few pages.

SURFACES A SHINY SURFACE

A black metallic lamp is a particularly easy subject to practice drawing with charcoal. Its surface has a dullish shine that can be rendered by blending and touching up in white chalk, working on a sheet of colored paper. The most important aspects are its tonal gradations and the triangular-shaped highlight, in accordance with the conical shape of the lamp.

This is a very common type of lamp. Its simple geometric shape and attractive shiny black color make it a perfect subject for this exercise in representing surfaces in charcoal.

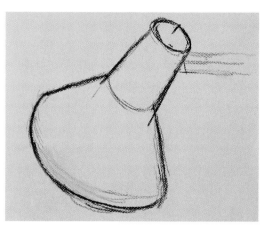

1. The beginning is important in this type of drawing. A seemingly simple shape like this one should be drawn by studying it with utmost attention, as any irregularity would be immediately visible. The contour must be perfect, so any imperfection should be erased and drawn again until it is completely correct.

2. The first charcoal patches are applied in the darkest areas, although no attempt is made to delimit their size. For the moment the only task is to accumulate the charcoal where it will later be rubbed and blended.

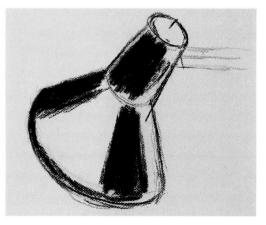

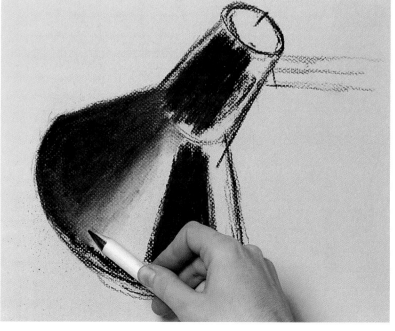

3. The darkest shadows are approximately in place. There is still no need to begin to model the motif, as we are concerned only with covering the darkest shadows.

4. Using a stumping pencil we begin to blend, extending the patches and working in the same direction as the highlight, that is, rubbing the stumping pencil toward the edge.

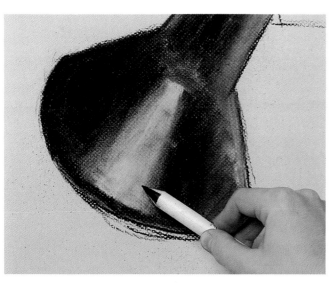

5. *The first stage of the blending and shading is at an end. We have managed to situate the values of light and shadow in their respective areas over the lamp's surface, thus correctly rendering its conical volume.*

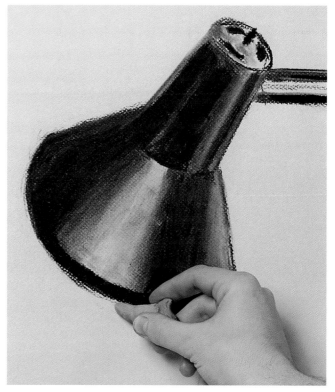

6. *It is logical that the charcoal will have extended over the edges of the object. Therefore you will have to erase any exterior patches and go around the outline of the lamp once again.*

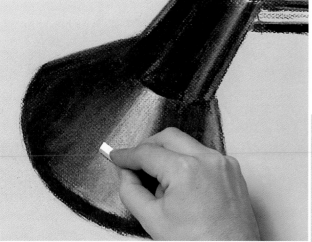

7. *Once the interplay of highlights and shadows is considered definitive, we apply white chalk in the broadest part of the highlight.*

NOTE

Make sure the eraser has a clean tip each time you use it. The best way to clean dirt accumulated when erasing and stumping is to mold the dirty part inward until you obtain a clean tip.

8. *Finally, the patch is rubbed and blended into the gray tones of the charcoal. If you study the triangular highlight carefully, you won't have much problem in obtaining a convincing finish.*

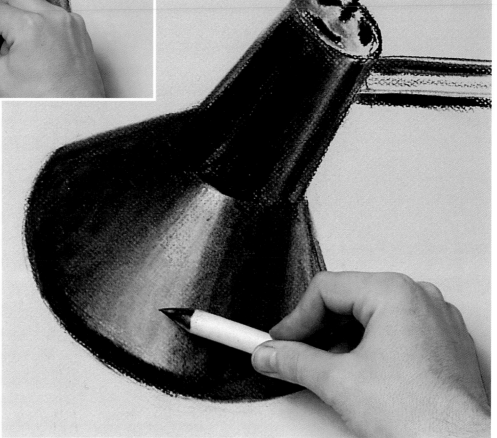

SURFACES
OLD METAL

Burnished metal has a special kind of shine comprising highlights and reflections. This helmet by Titian is a magnificent example of what can be achieved with charcoal when drawing this kind of metal. It is important to study the changes in the highlights and shadows, as they are the factors that convey the shape and curvature of the helmet's surface.

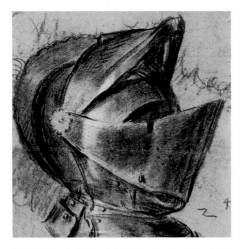

This Study of a Helmet by Titian is a perfect subject for studying the technique of rendering burnished metal, using charcoal and light touches of white chalk. In order to make the highlights visible and effective we are going to draw on a light gray sheet of paper, a tone that combines harmoniously with the tones of the charcoal drawing.

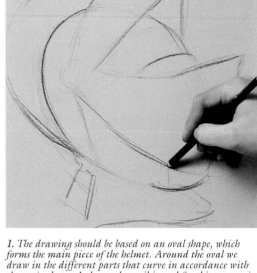

1. The drawing should be based on an oval shape, which forms the main piece of the helmet. Around the oval we draw in the different parts that curve in accordance with the main shape. A charcoal pencil is used for this purpose in order to better control the lines.

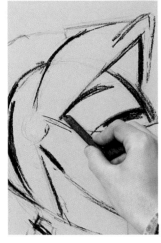

2. Now that the contours have been drawn, the lines indicating the shadows cast on the helmet should be gone over and shaded in, particularly the shadows cast by the visor and on the inner corner of the visor.

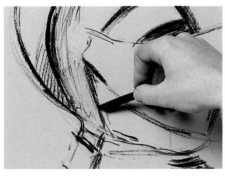

3. We continue shading in, without blending, the areas that most make the volume of the whole stand out.

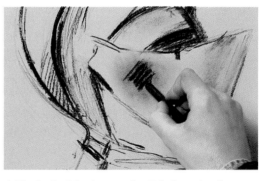

4. The flanks of the visor reveal a slight depression that can be drawn by means of shadows blended in the middle.

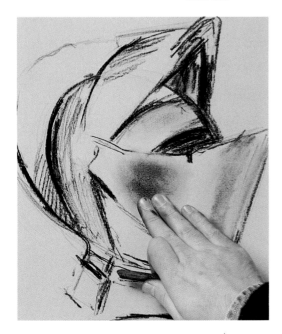

5. It is important to pay close attention to the shading. Since we are dealing with a burnished surface, the gradations will begin and end independently of the surface's logical volume.

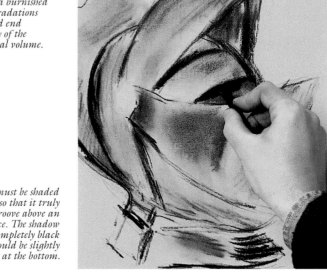

6. The visor must be shaded in a way so that it truly looks like a groove above an empty space. The shadow cannot be completely black but should be slightly lighter at the bottom.

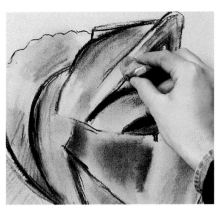

7. Now that the surfaces have been blended, it is time to bring out the highlights of the edges and the solderings with the kneaded eraser.

8. The hinge of the visor must be drawn with care, defining its shape with the charcoal pencil (marking in the contours that form a rosette) and opening up highlights with the kneaded eraser.

9. The hinge should appear to jut out from the body of the helmet. This effect is attained with pencil highlights and "eraser strokes."

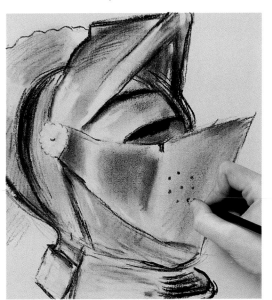

10. Once the highlights of the visor have been drawn correctly, we can add the small details, such as the group of holes in the front, which can be drawn with charcoal.

These are the tools used to draw this picture: a small stick of charcoal, a kneaded eraser, and a stick of white chalk.

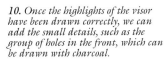

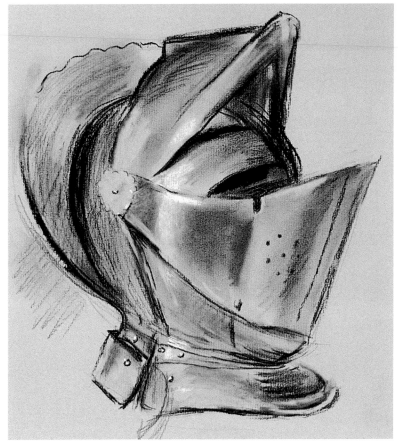

11. The white chalk must be used sparingly, without exaggerating the highlights, drawing only in the places that are hit directly by the light.

12. The final result is achieved by alternating soft blending with stark dark accents, all of which is toned with light touches of chalk.

SURFACES | CHROMIUM-PLATED SURFACE

Chromium-plated metals are considered very difficult to draw, but with charcoal, it is possible to obtain a very convincing result, using white chalk to draw the brightest highlights. The contrasts of chrome are very harsh. There are no gradual transitions from light to dark; a dark zone may be adjacent to a dazzling highlight. By studying the limits of these zones, we can achieve a good reproduction of this chrome-plated teapot.

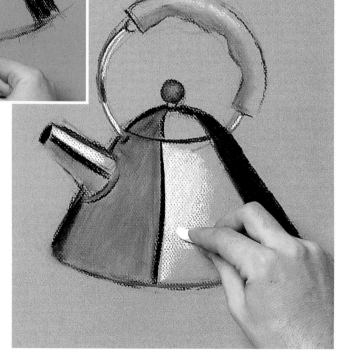

This chrome-plated teapot is an ideal subject for practicing the technique demonstrated in this exercise. Thanks to its simple and regular shape, the highlights and reflections are arranged in a simple order that can be studied and drawn with relative ease. As always, when drawing simple shapes, the preliminary drawing must be drawn with great care.

1. The truncated cone-shaped teapot has a handle that forms a perfect circumference. The combination of these two basic shapes must be drawn in their best possible dimensions.

2. The darkest shadow is located on the right end of the teapot. Now we can begin to darken the zone with direct lines of charcoal. On the opposite side, a rough shadow is drawn that is later to be blended.

3. The tone of this shadow is intermediate. To adjust it correctly, we blend the charcoal applied in the last step.

4. The center of the teapot is lighter and brilliant, so we are compelled to use white chalk to achieve maximum light.

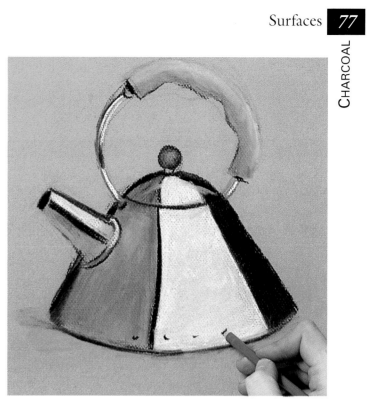

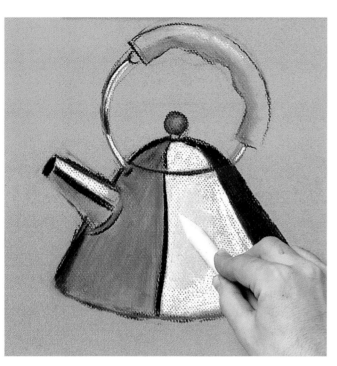

5. *Now that the white area has been filled in, we blend the entire patch to obtain a uniform texture.*

6. *The tiny screws along the base of the teapot cast a slight shadow. They are rendered with the charcoal pencil.*

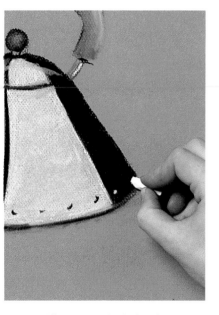

7. *Some of the screws are in shadow, but in a fairly light one. To make them stand out, you can draw in some dots of white chalk.*

8. *The result is convincing thanks to the bold contrast between the large patches of shadow and light that alternate over the surface of this chrome-plated teapot.*

Seascape

Charcoal allows as many possibilities with land-scape scenes as it does with any other subject. Nonetheless, there are certain differences that must be taken into account. The vegetation and mountains cannot be treated with detail, but merely as generalizations, leaving certain elements suggested and abbreviating the immense number of details in a synthesis of lights and shadows.

The combination of natural forms (the sea and rocks) next to man-made forms (the lighthouse surrounded by buildings) is one of the main attractions of this view. This seascape will be drawn according to classical charcoal drawing techniques.

THE SEA AND THE ROCKS

The surface of the sea is a subject which, rendered in charcoal, is obtained through a number of shaded areas without too many brusque changes in tone. The rocks, on the other hand, require an abundance of contrasts, profiles, detailed edges, etc. The seascape we are going to paint requires both factors: blurred and detailed forms.

The difference in treatment of these aspects constitutes one of the fundamentals of drawing, not only seascapes but any landscape subject.

1. The preliminary drawing is made up of simple sketch lines with which the artist tries to adjust the sizes of the different forms of the seascape and lend proportion to the areas of the sea and sky.

This drawing will allow us to study the different realistic effects that can be obtained by blending with a stump, shading, highlighting in white chalk, and using the eraser to remove tiny parts of the charcoal.

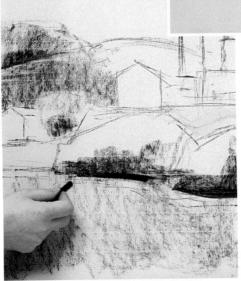

2. Next we extend large patches of charcoal to obtain the first values. These patches are especially very dark in the lower part of the rocks, where the shadows are most intense.

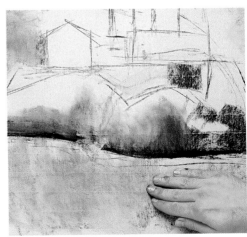

3. Now we must blend the previously applied patches so that each area adopts a tone that harmonizes with all the others.

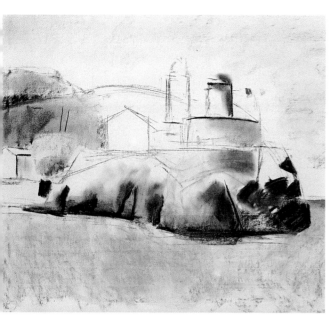

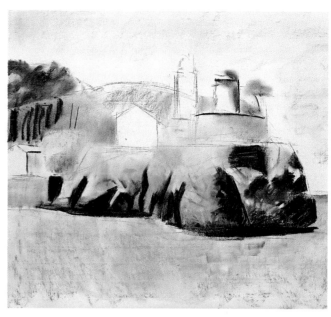

4. After the preliminary blending, the first most prominent masses of the landscape begin to take form. We continue to model the areas that until now were merely patches.

5. The successive applications of charcoal, with their corresponding gradations, begin to bring out the different volumes of the rocks, making some parts appear to jut out more than others.

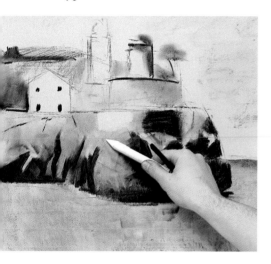

6. Once we have accumulated enough patches of charcoal, we use the stump to model with greater precision, bringing out the nooks and crannies of the different rocks. The process should always go from the most general to the most specific.

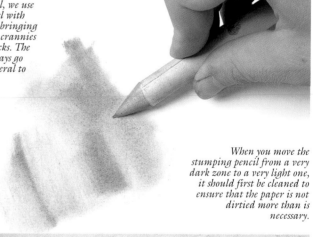

When you move the stumping pencil from a very dark zone to a very light one, it should first be cleaned to ensure that the paper is not dirtied more than is necessary.

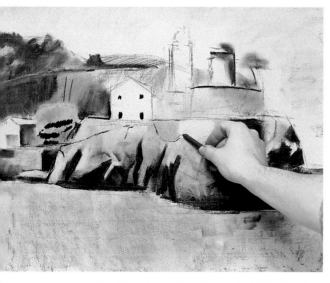

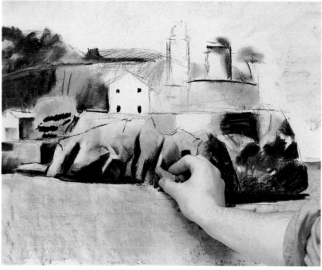

7. Once again, we use the stick of charcoal to outline and add detail to the edges that have been blurred by the stumping pencil.

8. The details of the rock also require the use of the eraser to remove certain edges in order to reveal the underlying color of the paper again.

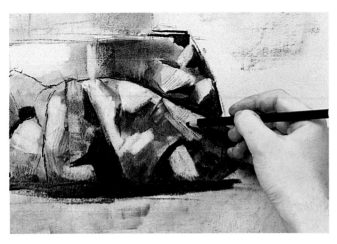

9. *Several subtle shaded areas that add detail to the complex structure of the rocks are drawn with the charcoal pencil.*

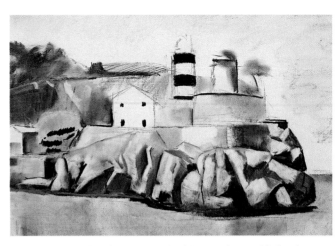

10. *The buildings have been given a finish in accordance with the other parts of the drawing and are suitably integrated with the rocky area.*

The shading with the charcoal pencil must be soft and fine, so it must be kept well sharpened.

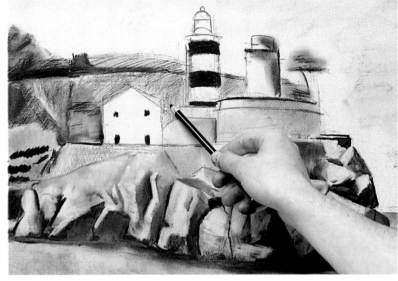

11. *The stripes on the lighthouse are an essential detail, since they lend interest and visual grace to the picture. The cliff tops that flank the complex from behind are defined by soft strokes with the charcoal pencil.*

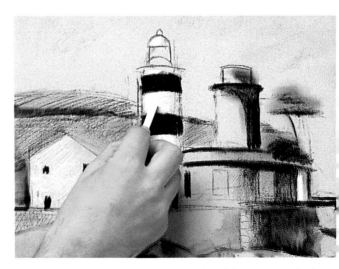

12. *Once again, the charcoal pencil is a very useful aid for modeling the curved facade at the very edge of the cliffs with intertwined lines.*

13. *Now it is time to highlight the stripes of the lighthouse tower with white chalk, which is applied in the intermediate stripes between the black ones.*

The chalk can be sharpened with a utility knife to obtain a point that will allow fine strokes.

14. Chalk is also very handy for highlighting the crags of the most illuminated rocks and to heighten the abruptness of the rocks.

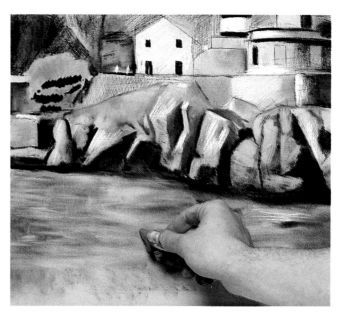

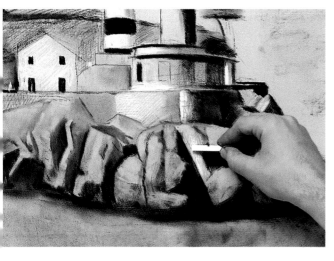

15. Having added considerable detail to the buildings and the rocks, the sea can only be conveyed with synthesis. After blending the shadows cast by the rocks, we use the eraser to suggest the effect of the waves.

16. The eraser has allowed us to obtain a distinct texture for the surface of the sea. This texture must be toned through the stumping pencil in order to achieve the desired effect.

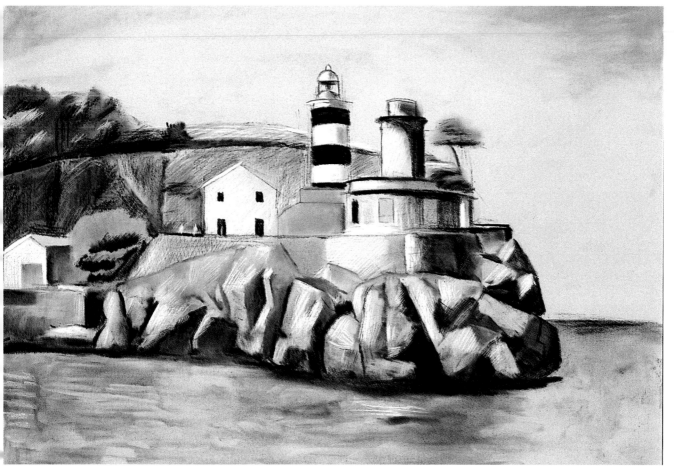

Still Life

Gray and black tones, gradations, and shading take on a different appearance when charcoal is applied to canvas. The grain of the canvas is very different from that of paper, and its coarser and less absorbent surface lends the tones a cooler aspect. This can favor certain subjects, such as the elements in this drawing: a collection of old metallic receptacles. The consistency of the canvas will aid the artist in achieving the textures of the different metals.

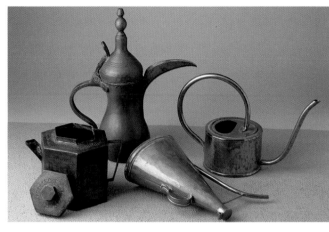

The preparation of the subject is as important as its execution. The artist has to study different arrangements, always searching for a harmony of the whole, before choosing the definitive one.

ARABESQUES

The harmony of the subject resides both in the qualities of the metal and in the rich curves of the contours. The contrast between flat surfaces and rounded ones and between angles and curves unifies and integrates each element within a unity characterized by the arabesque. An arabesque is like a rhythm, like a decorative stroke that links each part, establishing as much the shapes that enclose them as the spaces between the objects themselves.

We are going to draw the still life with sticks of charcoal and a charcoal pencil, together with a stumping pencil, on a standard canvas.

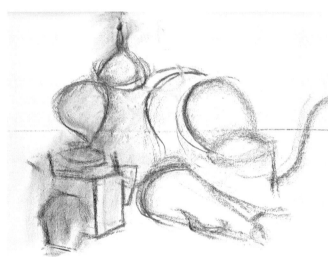

1. In the preliminary phase of the drawing, the most important task is to block in the objects and situate them in a way that they appear harmoniously proportioned.

2. Drawing on canvas means we can completely erase the drawing with a rag. In this case, we erase in order to give the form more detail, as the original strokes, although erased, have left their mark on the canvas, thus providing us with a guide to continue the work.

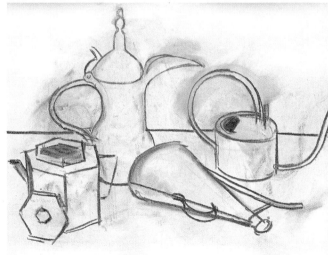

3. Thanks to the traces of the original lines, we have managed to draw in the outlines of each form and the linear harmony of the whole.

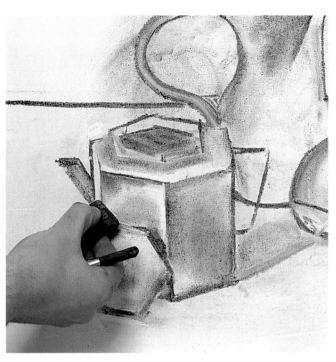

4. The first shading is carried out in charcoal, blending the lines and cleaning up certain areas with the eraser, as this work is more difficult to control when working on canvas.

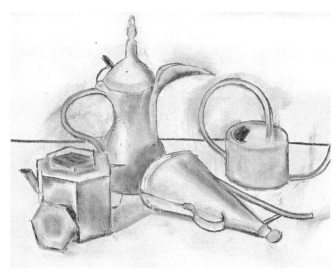

5. The first general shading is enough to convey the basic volumes of each one of the elements.

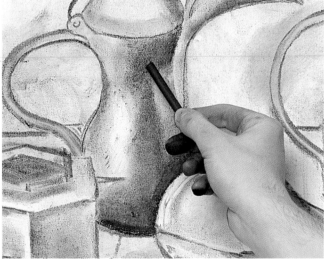

6. Going over the initial shading, we continue sketching and smoothing over the darkest areas and those that require more intense modeling.

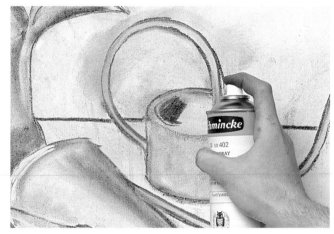

7. Once we have achieved the optimum modeling, the drawing is lightly fixed so that the successive blending does not alter the general values.

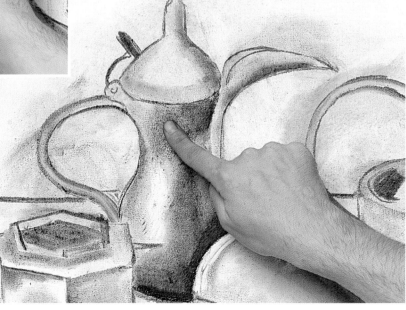

8. Working over fixed patches, we can darken the tone without altering their placement. This work is done with compressed charcoal, which has a darker tone than charcoal.

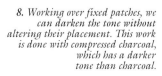

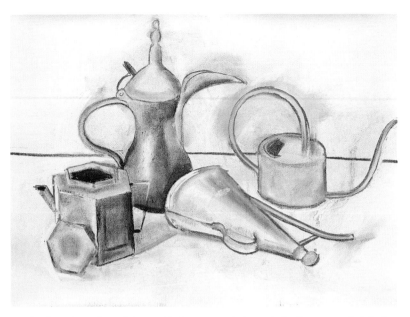

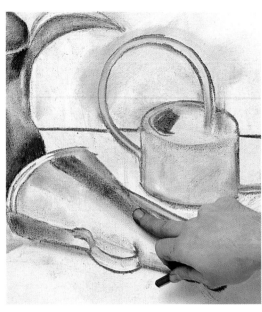

9. *Thanks to the work carried out with the compressed charcoal, the elements on the left of the composition appear more compact, with more detail in their relationship to light and shadows.*

10. *The shadow on the fallen receptacle is achieved with strokes of compressed charcoal that are then rubbed in the convergent direction of its planes.*

11. *It is essential that the degree of elaboration of each object be more or less the same, so that none of them is too sketchy or, on the contrary, too darkened because of excessive shading.*

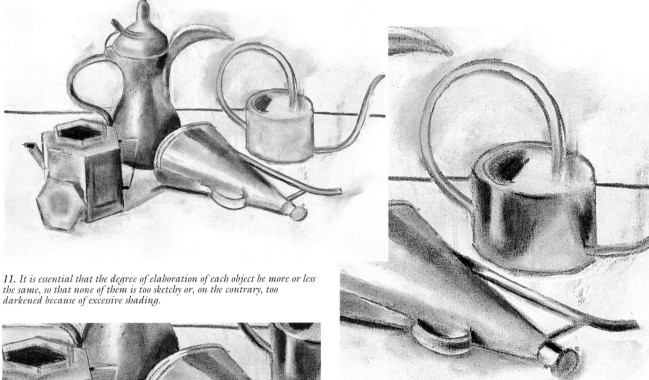

12. *The highlights on the object on the right convey a metallic surface that is different from the rest. It is important not to fall into the trap of drawing mechanically. The quality of each surface must be drawn accordingly.*

13. *To obtain the values of the plane of the table, we shade in the area with a stick of charcoal, and then blend the strokes, taking care to achieve a harmonious tone over the entire surface.*

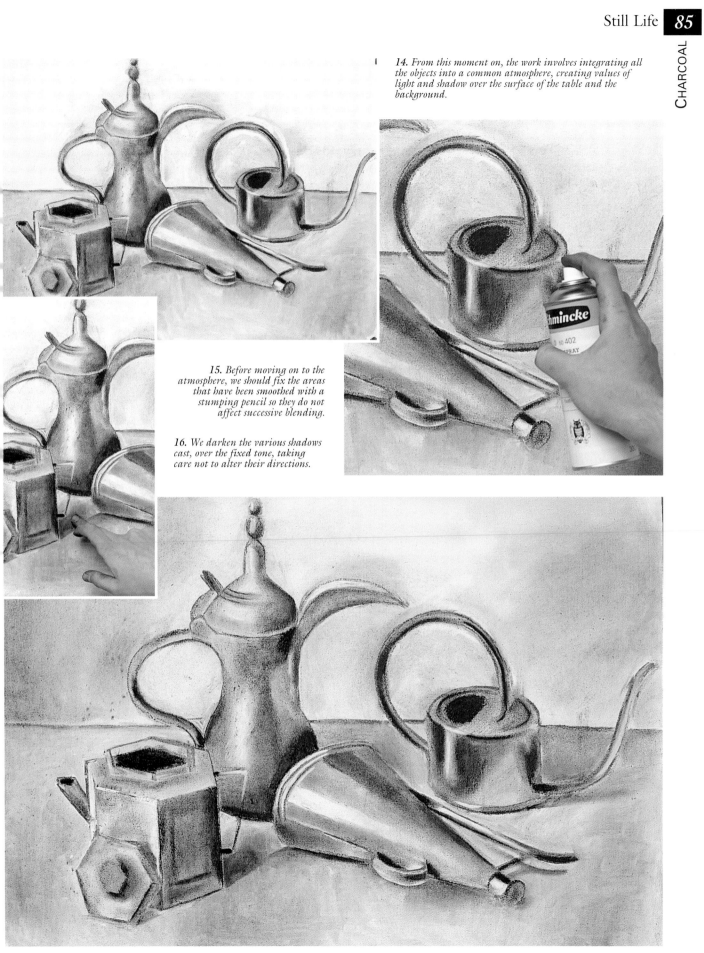

14. From this moment on, the work involves integrating all the objects into a common atmosphere, creating values of light and shadow over the surface of the table and the background.

15. Before moving on to the atmosphere, we should fix the areas that have been smoothed with a stumping pencil so they do not affect successive blending.

16. We darken the various shadows cast, over the fixed tone, taking care not to alter their directions.

17. Having darkened the plane of the table and also the base of some of the objects, the composition has acquired weight and credibility.

Drawing with Pastel

The pastel medium is very similar to working with charcoal. Both media can be applied as lines or patches, which can then be blended, and they produce a wide range of tones. The aspect that distinguishes pastel from charcoal is the color, although there are other particularities between the two that must be understood in order to work with it correctly. The following pages will introduce these factors and show you how to get the most out of them in practice.

DRAWING WITH PASTEL — **BLENDING**

When pastel is blended, the color is extended, pressing all the tiny particles into the pores of the paper, thus making the line disappear. With high-quality pastels, blended areas do not lose their original intensity, although they do lose some texture, as the layer of color takes on a smoother and more uniform appearance. Regarding tools, pastel stumps are no different from the type used with charcoal. In terms of the color, due to its greater oiliness and ability to adhere to paper, pastel can be applied in successive layers, even over pure unblended colors. This is what most differentiates pastel from other drawing media, as it is not a question of light and shadow, but of color contrasts.

The effects of the blending vary significantly according to whether you are using hard pastels or soft pastels. Hard pastels and chalk, above all, cannot be blended too much; the stroke remains in place (it doesn't disappear so easily when rubbed with a

finger, a stumping pencil, or a rag). But in contrast, hard pastels allow more precise lines than chalk. Their sharp contours can be used to outline forms and sketch lines, a fact that relates them closer to those media that we usually define as drawing media.

Soft pastels offer a more saturated color and have greater covering power, but they do not produce good lines since they have a tendency to crumble.

When blending, colors almost completely mix together. Nonetheless, the best results are obtained by mixing colors that belong to the same range.

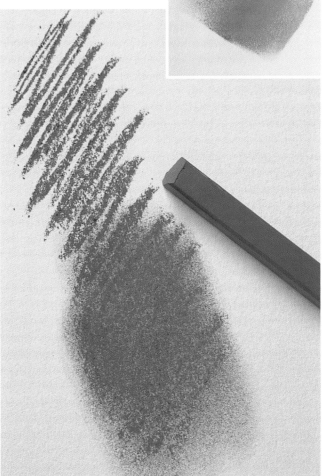

Drawing with pastel and chalk can combine both lines and patches of color.

Pastel can be rubbed with your fingers or a cloth. The second option is the most recommended when working on large formats. The cloth or rag should be made of cotton and must be replaced with another one once it is dirty.

Blending with the fingers allows the artist to create uniform patches from lines. Hard pastels and chalk must be blended much harder with the fingers because the line is more permanent.

DRAWING WITH PASTEL | WORKING WITH COLOR

Once the pastel pigment has been spread over the paper, it can be lightened and darkened by means of successive layers of white and black. The artist can then draw over this and, to a certain extent, erase it. Any erasing must be done with a kneaded eraser. Hard erasers are not recommended, since they can damage the paper and their reduced absorbency dirties the tones (especially if they are composed of various layers).

Pastel is much denser than charcoal and this is a decisive factor for mixing colors. A patch of saturated color is rather difficult to darken with charcoal. Color should be darkened while the layer of color is still thin.

Pastel color can be modeled easily with colors of the same range. The choice of colors is wide enough to carry out continuous gradations of varying intensities, ranging from a light tone to a dark one without the need to use black or white to darken or lighten, but rather using lighter and darker tones of the same range.

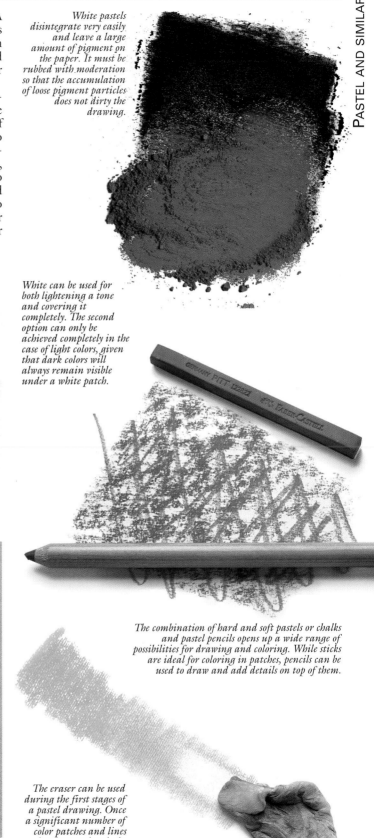

White pastels disintegrate very easily and leave a large amount of pigment on the paper. It must be rubbed with moderation so that the accumulation of loose pigment particles does not dirty the drawing.

White can be used for both lightening a tone and covering it completely. The second option can only be achieved completely in the case of light colors, given that dark colors will always remain visible under a white patch.

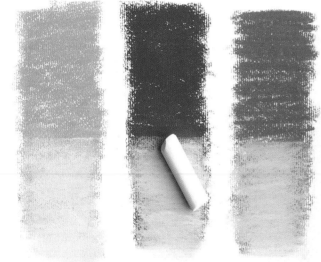

The combination of hard and soft pastels or chalks and pastel pencils opens up a wide range of possibilities for drawing and coloring. While sticks are ideal for coloring in patches, pencils can be used to draw and add details on top of them.

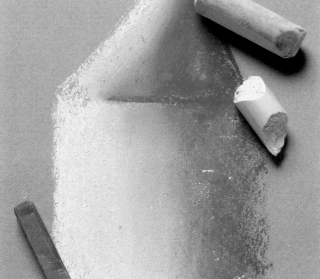

The eraser can be used during the first stages of a pastel drawing. Once a significant number of color patches and lines has accumulated, the eraser tends to dirty the tones already applied to the paper.

Modeling with pastels allows the artist to execute continuous shaded volumes, without lines or cutoffs. This factor permits a diversity of pictorial results with the pastel medium.

Drawing with Sanguine

Sanguine, often referred to as "red chalk," is a very interesting monochromatic color. Its range of tones is wide, but as a chalk it is much softer than charcoal and also more luminous. It is the principle color of Conté crayons. The best results are achieved when drawing human figures. Here we are going to reconstruct partially and completely two classic works in sanguine. Two very different styles are demonstrated with this drawing medium.

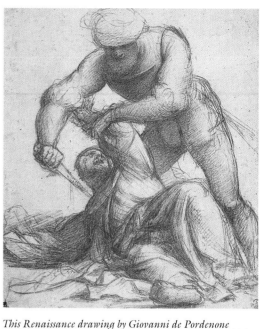

This Renaissance drawing by Giovanni de Pordenone (1484–1593) is constructed using oval-shaped forms which, due to their arrangement, situate the position and the proportions of the figure's limbs. This method of calculation is rough and is commonly used in this type of sketch, a conception for a future painting.

DRAWING WITH SANGUINE | **TWO FIGURES**

This exercise involves studying and reconstructing a drawing by Giovanni de Pordenone (1484–1593), *Study for the Death of Saint Peter the Martyr*. Even though this type of subject is not common among today's artists, the technique used is very interesting and reveals much about the possibilities of sanguine for drawing figures.

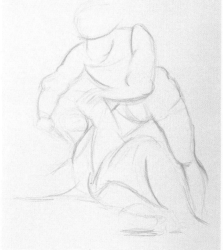

1. The artist begins by drawing a series of oval-shaped forms that suggest a movement and provide the figure with its basic proportions.

2. The sanguine pencil can be used for shading. The accumulation of lines darken the areas in shadow.

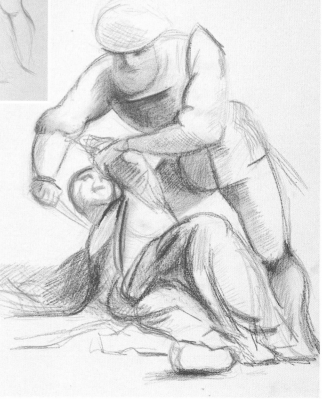

3. With a stick of sanguine chalk, we can also shade with strokes, although in this case they will be blended shortly.

4. The previous lines are blended to achieve greater clarity between the light and shadows, and to make the figure's limbs appear more solid.

5. The end result of the work is two figures that are considered more in terms of their volume and movement than their contours. The intense modeling does not look too overdone thanks to the attractive tonality of sanguine.

COMBINATIONS

Sanguine Conté crayon or chalk can be combined with other drawing mediums. Artists commonly use it in conjunction with charcoal or pastel. This drawing demonstrates how it can be combined with charcoal and white chalk, an excellent choice that allows us to shade and highlight in order to create an attractive chromatic harmony.

We have chosen a drawing by Edgar Degas (1834–1917), Woman Drying Herself, *to study this combined drawing technique whose main color is sanguine. This sketch is one of many of the same subject that the great master drew from nature.*

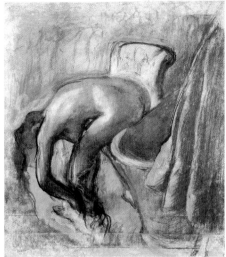

1. *The preliminary drawing, done in charcoal, is characterized by its speed and unfinished appearance. The drawing's sole purpose is to situate the figure on the paper and capture its general movement. Let us not forget that this sketch was drawn from nature and so it was executed with the utmost haste.*

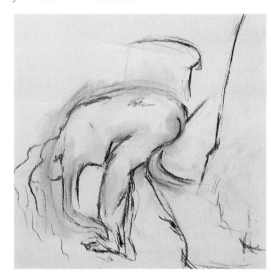

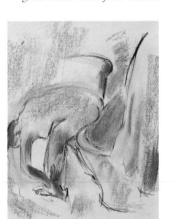

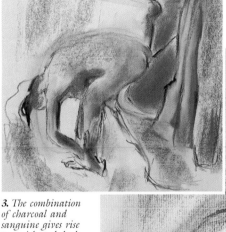

2. *The first sanguine patches are drawn with the stick held flat against the paper, looking for halftones, less intense shadows, and the volume of the curtain in the foreground.*

3. *The combination of charcoal and sanguine gives rise to a rich and dark color that is suitable for the areas most in shadow.*

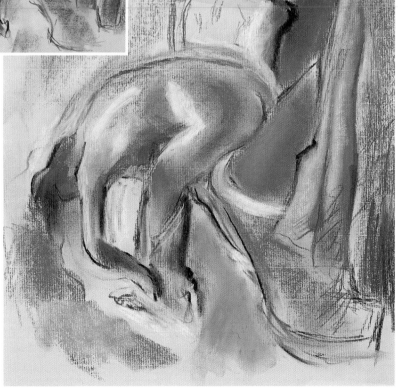

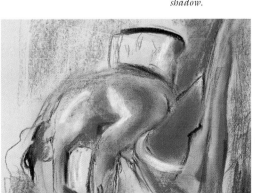

4. *The white chalk highlights the areas in direct light and also delineates certain contours that had been blurred during the hasty sketching session.*

5. *The nude has been modeled by bringing out the white chalk highlights with hardly any blending, superimposed over gradations of sanguine Conté crayon and charcoal.*

Drawing with Chalk

Classified as hard pastels, chalk is better suited in pictures in which the line has more importance than color. Even so, chalk should in no way be considered inferior to soft pastels. It can be shaded with a stumping pencil, blended, superimposed, and can cover the paper as much as any other type of pastel. In this section, we are going to use white, sanguine, and black chalk to draw these exercises. These three colors are more than enough to draw sketches and works that do not require so much color.

DRAWING WITH CHALK	A STATUE

White and black chalk are all we need to draw this stone statue. This drawing will illustrate how to shade and model with chalk, superimposing tones, blending lines, and building up the form by means of patches. Even though this is a fairly quick drawing, it does bring to light highly interesting technical solutions. The paper chosen to draw on is a sheet of pearl gray colored paper, a tone that harmonizes with the subject's white and cool colors.

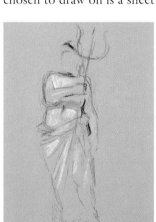

2. The first touches of white chalk are also applied with care. There is no need to fill the paper in so soon without having in mind the delicate interplay of lights and shadows of the statue. The chalk lines illuminate the figure's lightest parts.

Statues and sculptures are always a good subject to draw: They are static and—by and large—monochromatic. Such motifs generally display an interesting interplay of lights and shadows. The most outstanding aspect of this light-colored stone statue of Neptune is the outline of the trident that creates a contrast typical of a drawing.

1. The preliminary drawing consists of applying strokes of black chalk to establish the figure's pose, without adding details. The lines are drawn softly, as the white that is to be applied later must not be dirtied.

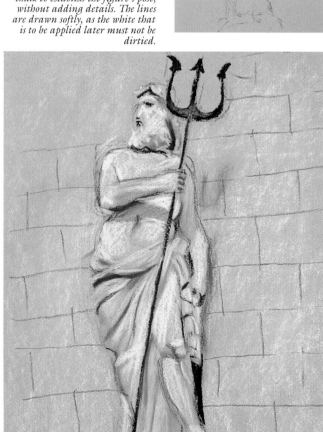

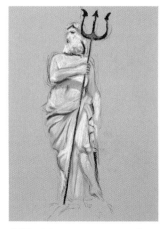

3. Some of the white strokes superimposed over the blacks become dirty. It is essential to bear this in mind in order to take advantage of it when shading and modeling the volumes.

4. The statue now appears precise and the details of the robe and the anatomy can be made out with greater clarity, thanks to the modeling carried out with the black and white chalk.

5. The final result is a drawing with an evident pictorial intensity: The black and white values, due to their density, evoke chromatic tonalities.

DRAWING WITH CHALK A MUSICIAN

The suitability of chalk for drawing fast sketches will be demonstrated in a drawing of a musician performing in an orchestra on a Sunday morning. This is a perfect subject: The model does not move much, the double bass has a beautiful volume and a very adequate color for drawing in chalk, and the scene has a graceful air about it. Subjects like these are most appealing to an artist who enjoys representing real life scenes. We are going to draw on dark cinnamon-colored paper, which will be highlighted with white and harmonized with tones of sanguine and sepia.

The harmonious form of the double bass, which constitutes an element of surprise and attraction, makes this a very promising subject.

2. The lights, shadows, and highlights of the back of the double bass are resolved by blending sanguine Conté crayon with sepia strokes.

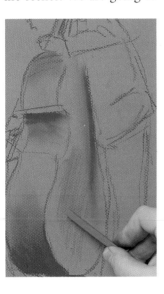

3. The gray of the jacket is obtained by first modeling its shape with black, so that it can then be covered with white. Once it has been covered, it is blended and the initial black modeling becomes a light gray.

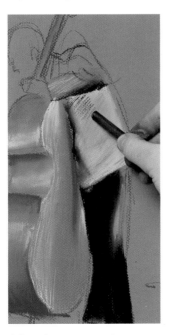

4. In order to tone certain gray areas that are too light, we can add several black strokes that can then be blended.

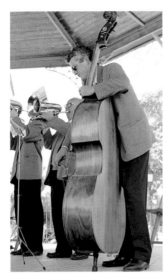

1. The drawing is begun with a piece of sepia-colored chalk. This color can be blended with the other chalks without creating any discordant results. The drawing is sketched with speed, getting down an approximate outline.

NOTE

The color of the paper, when drawing with a sanguine color, has an effect on the final result. It should be medium-tone, never too dark, which would hinder the correct application of the touches of color.

5. The figure is finished. The important details, like the hands and the face, have been obtained by means of a sanguine-colored base and white chalk with a few touches of black to gray the color.

Still Life

The elements of this still life have been chosen for the way in which their tones create a harmony within the whole. In general, the tone of the colors is subdued and muted, comprising a wide range of values from light to dark. The color base is located in the grays mixed with sepia and sanguine, along with blue and cream-colored tones. This drawing is an exercise in interpreting all these colors. It requires the artist to take them to the ranges that have been used up to the present but with some important enhancements.

This arrangement of objects is dominated by the large volumes of the two vessels on the right. The other elements in the arrangement are much smaller. However, they are similar in shape, and the same subtle shadows play over them.

1. Charcoal is an exemplary medium for obtaining form without the need to add details, by applying shaded patches to the paper, sketching some guidelines, and appraising the sizes and positions of the objects.

THE RANGE

The color range to be used in this drawing includes sanguine, sepia, black, white, and ultramarine blue. The combinations of these colors produce muted tones that are highly suitable for modeling and shading by means of the same procedure used for drawing in charcoal.

2. The first patches are drawn in order to achieve a preliminary color application without concerning ourselves with the exact positions of the objects.

3. The color of this vessel is a mixture of sepia, black, and white. It has a warm gray tone that can be modeled in a wide range of values, from off-white to black.

4. The blue isn't going to be used as a pure blue. It is going to be mixed with other tones. In this case, the blue is being combined with black over the vessel's large surface on the left.

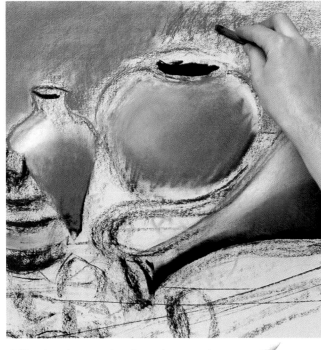

5. The excessive darkness of the large pot means it must be lightened with white. The result will be a cool bluish gray tone, modeled with little contrast between the highlights and shadows.

6. To reduce the saturation of sanguine, we apply strokes of charcoal which, once blended, will tone the color.

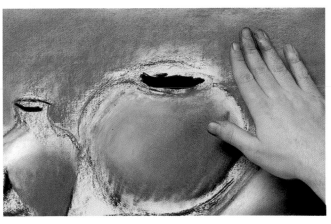

These are the drawing implements used in the drawing: sepia, sanguine, and black sticks of chalk, a stick of charcoal, a kneaded eraser, and stumping pencils.

7. Blending allows us to check the chromatic effect once the color has acquired a certain amount of unity and the tonal contrasts have been brought out.

8. The drawing acquires more detail as the color is adjusted. This is one way of creating a pictorial result obtained by a multitude of contrasts.

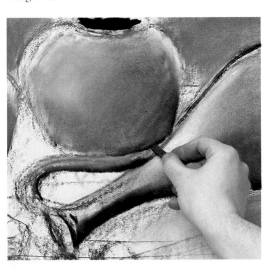

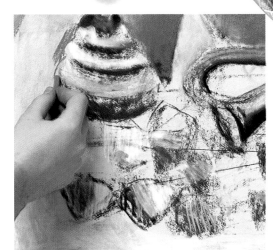

9. The contours are drawn with color, searching for a contrast to define them rather than a line to enclose the object.

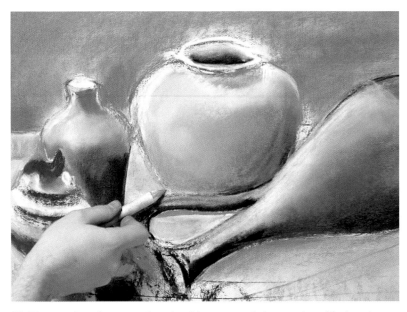

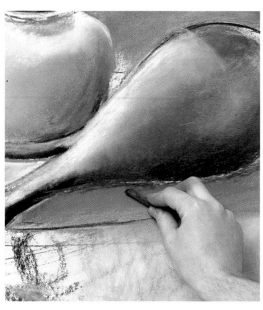

10. The stump is used to ensure the unity of the tone over the large surfaces, like that of the tablecloth. The stumping pencil extends and models the color by blending the highlights and shadows.

11. The part of the tablecloth within the shadow cast by the big vessel is darkened by drawing a line with charcoal that is then blended.

NOTE

In order to darken chalk or pastel with charcoal, the color must be applied first and then the charcoal. The greater covering power of chalk and pastel makes them sensitive to darkening or graying when they are superimposed by a medium with less dense covering power, such as charcoal.

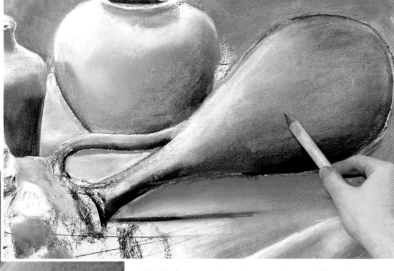

12. By the same token, the stumping pencil is used to achieve a uniform tone over the vessel, which, until this moment, appeared too modeled, with abrupt contrasts of light and dark.

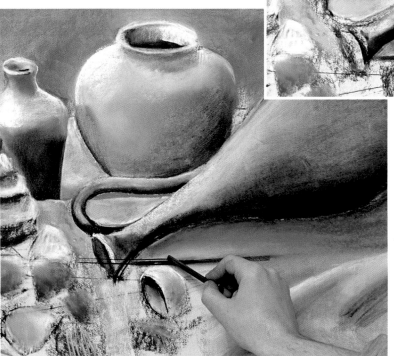

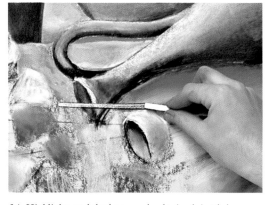

13. The stems of the dried flowers are outlined with the edge of one of the sticks of chalk. Since we are working with hard pastels, it is easy to draw precise lines.

14. Highlights and shadows can be obtained simply by drawing with the little stick applied on its beveled edge.

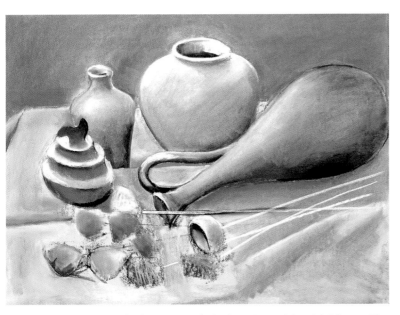

15. The finishing stages involve bringing out the intricate forms of these dried flowers. The color used is gray toned with sepia, lightened with abundant white.

16. Some of the irregular contours of the flowers must be highlighted to make them stand out against the tablecloth.

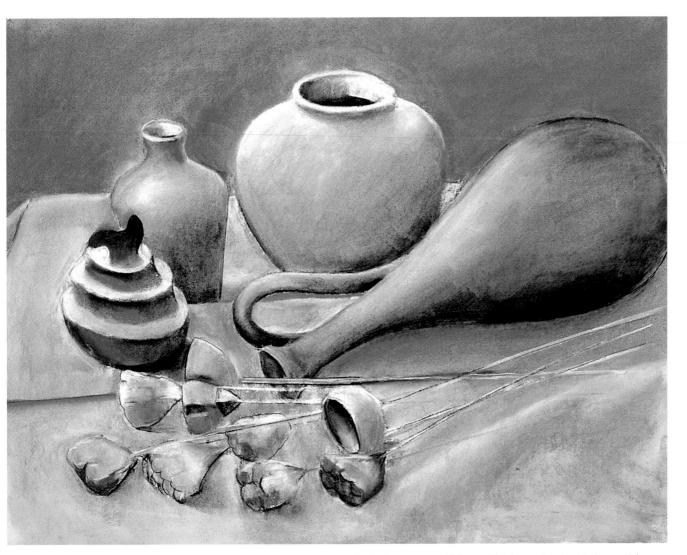

17. Finally, we have achieved both a rich and sober harmony at the same time. Each color incorporates a little gray that harmonizes it with the rest of the drawing. The work is somewhere between a monochromatic and a multicolored drawing.

Landscape

A pictorial effect in pastel can be achieved with very few colors. The rich chromatic qualities of a landscape can be obtained by heightening the range of a monochromatic drawing with two well-chosen colors. The work we are going to paint in this section is based on a combination of charcoal, light green, pale pink, and sky blue. The subject (a pathway through a park) has been chosen with a limited color range in mind. This is a landscape with a stark chiaroscuro in which the simple forms are outlined and create an attractive view in perspective. To highlight this effect, we will draw the picture on a sheet of dark green paper, a perfect background color for creating abrupt contrasts.

Parks offer the artist numerous interesting views. They combine regularity with diversity and the lines of their avenues and pathways arrange the richness of trees, flower beds, bushes, and plants in general.

BACKLIGHTING

The effects of backlighting in a landscape always produce a chromatic vibrancy by highlighting the contrasts of light and dark. The large masses of vegetation that look like columns lend steadfastness and solemnity to the composition, highlighting its volumes against a diffuse light of a cloudy day.

These are the tones chosen to draw with on this sheet of dark green paper. We can obtain intense natural contrasts, leaving areas of the background uncolored or only partially filled in.

1. The preliminary drawing can be drawn with pink or blue. The aim of these basic tones is to arrange the composition and center the point of view.

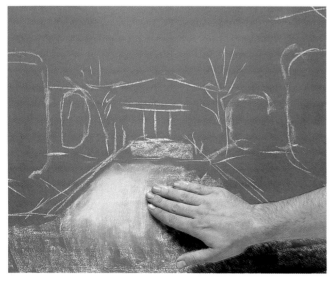

2. Light patches are spread over the paper and are then stumped in order to create the basic structure of the motif.

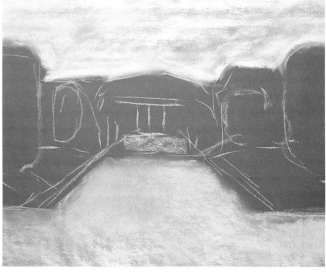

3. The large white areas of the ground and sky enclose the composition and ensure its symmetry and the characteristic order of the subject.

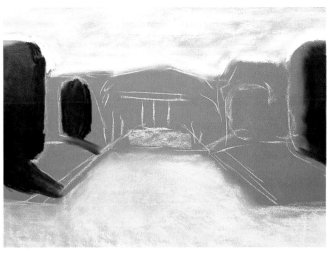

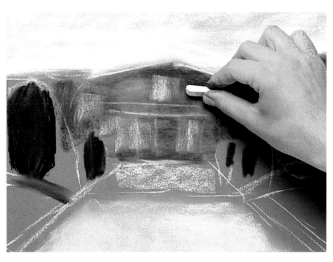

4. The color of the background provides an invaluable aid for drawing the volume of the bushes in few lines. The charcoal highlights the feeling of volume while barely introducing hues or alterations in the patches of color.

5. The facades in the background are blurred by the distance and the effect of backlighting. This can be drawn with gray tones that suggest the forms without including details.

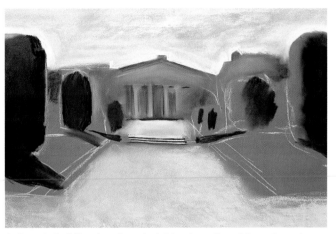

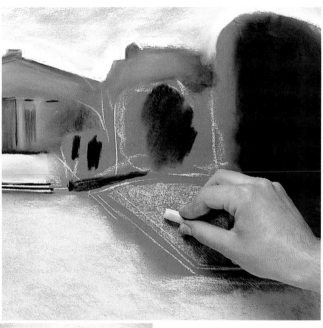

6. Once the buildings have been shaded in, the outline of the roofs are drawn in with pale blue lines that profile and give detail to the drawing. With this stage at an end, the sensation of space is much more elaborated.

7. The grass tones can be drawn as light green patches, while always respecting the outline of the bushes and the shadow they cast.

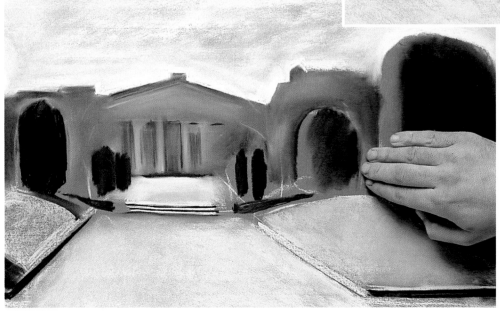

8. Now we have to create a natural connection between the foreground and the background by making the green tones of the grass penetrate within the dull gray tones.

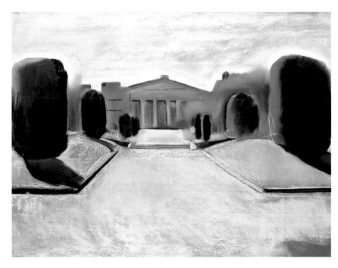

9. By this stage, the work contains numerous spatial suggestions. With a controlled use of the color and blended areas, we have achieved a good definition of distances and the positions of the elements of the landscape.

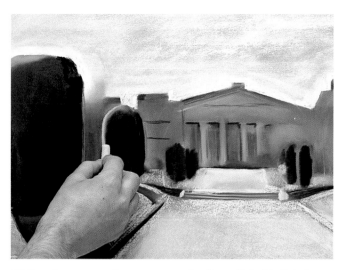

10. From here on, we will concentrate on the effects of light. The light forms clear outlines against the masses of vegetation in strong contrast with the depth of their darkest parts.

11. The shadows cast are lengthened over the ground. Their tone is created by blending strokes of charcoal. If the charcoal doesn't adhere well over the pastel, it can be erased in the areas where the shadows are lengthened.

12. The tone of the shadows must be uniform, without internal changes that can be interpreted as undulations over the ground. So, the artist must smooth these strokes in order to remove any trace of them.

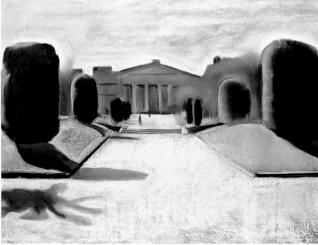

13. At this point, the work looks already finished, since all that remains is to add the trees that stand out against the winter sky.

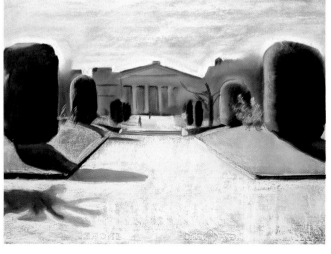

14. The trunks and branches of the trees are reference points that define the sizes and distances between the elements of the landscape.

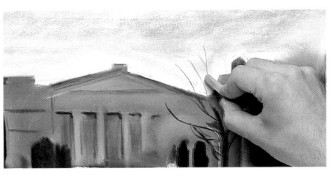

15. *It is important to study the shapes of the branches and the way each one of them is drawn. It is these kinds of details that can make a promising work lose all credibility.*

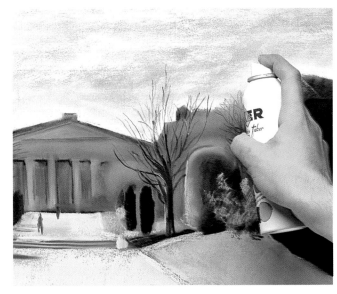

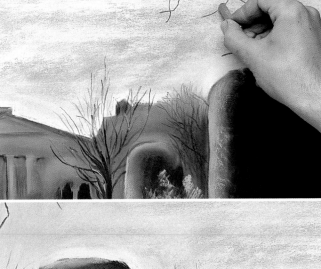

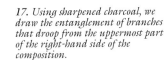

16. *In order to achieve precision in the branches, we should fix the background so that the different strokes do not blend together.*

17. *Using sharpened charcoal, we draw the entanglement of branches that droop from the uppermost part of the right-hand side of the composition.*

18. *The final detail: The corner of the grass in the lower right-hand corner of the paper highlights the foreground and rounds off the intense suggestion of the space within the work.*

Drawing with Ink

As a drawing medium, ink can be used in several ways depending on the instrument used to apply it. The nib is the most common of these, although it is also possible to draw with a reed pen, a brush, or any normal fountain pen. The result can range from a meticulously detailed work to spontaneous effects such as patches, washes, and lines. When applied with a fountain pen, ink is one of the simplest and cleanest media, ideal for drawing all kinds of sketches from nature. Its fine lines make it superior to any other medium for smaller formats, although this same property makes it unsuitable for larger works.

CONTROLLING THE STROKES

Whether you are drawing with a fountain pen, nib, or reed pen, the resulting strokes are much finer than with any other drawing medium. The strokes are also more permanent: With ink there is no place for approximate lines, trial strokes that will later be erased or covered with heavier final lines. As a result, ink strokes need confidence and control, which can only be obtained through continuous practice and a thorough knowledge of the possibilities and limitations of this medium. The first point that should be emphasized is that ink strokes vary only slightly in width. The width of the line does not depend, as with other mediums, on the pressure applied but on the type of nib or reed pen employed. In the case of nibs, the line keeps a constant width regardless of the amount of ink the nib holds, unless of course the nib is pressed so hard to the paper that the point opens up, with the resulting loss of ink. The same can be said of most fountain pens or other conventional writing pens. On the other hand, a reed pen can produce a line of variable width depending on which side of the point is pressed to the paper. If the reed pen is held like a fountain pen, it produces a thick, continuous line that can be varied slightly by increasing or decreasing the pressure. If the point is held to the side, however, the line is reduced to about half its usual size. The stroke is also less stable, since any change in the angle of contact results in a larger section of the edge coming into contact with the paper, with the resulting increase in width. This combination of thick and thin lines can alternate with another of the reed pen's characteristic features: blurred, semitransparent lines resulting from a lack of ink. Whereas a nib will suddenly stop drawing when the ink runs out, a reed pen leaves an increasingly fading line that can be used to produce certain effects. These include medium shadows resulting from an accumulation of parallel faded lines, sketched contours, and transitions between a blank section of a drawing and another dark section caused by an accumulation of bold strokes. This technique can be used whenever it occurs naturally, that is, when the pen begins to run out of ink, or it can be produced by using up the ink on a piece of scrap paper until it produces the desired effect. These properties make the reed pen one of the most versatile forms of ink drawing, especially well-suited to the techniques of the modern artist.

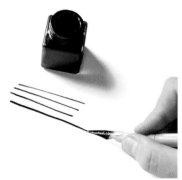

When held like a normal pen, the reed pen draws lines of a constant width, which varies depending on how sharp the point is. This width can be varied slightly by applying more pressure so that the tip opens slightly and lets more ink out.

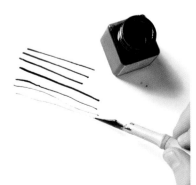

If the tip of the pen is applied sideways to the paper, the resulting line is finer. The width can be easily varied by changing the angle. The strokes can also be affected by the accumulation of dried ink on the tip, so it is a good idea to clean the point before using this technique.

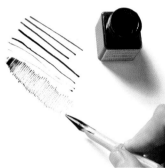

When there is little ink left on the pen, the lines begin to fade and lose covering power. The artist can use this circumstance to create shadows and gray areas. The ink can be used up on a piece of scrap paper, or the artist can wait for the process to occur naturally during the course of his work.

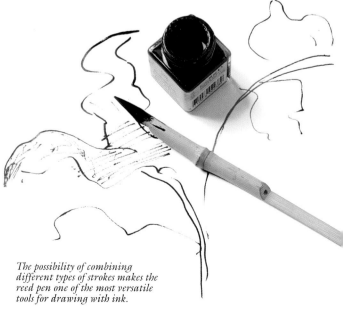

The possibility of combining different types of strokes makes the reed pen one of the most versatile tools for drawing with ink.

COLORED INK AND COMBINED TECHNIQUES

When used for drawing, colored ink has the same possibilities and limitations as India ink. Working with colored ink requires a more orderly approach, however. Although different color inks can be mixed, the results are not usually attractive, since the tones usually have a murky, messy appearance. The only really acceptable mixtures come from combining different colored strokes directly on the paper. In order to keep this process clean, it is essential to use at least two nibs, which can be used to switch between light and dark colors. Both nibs can be alternatively inserted into the same handle.

Using colored ink also permits the combination of

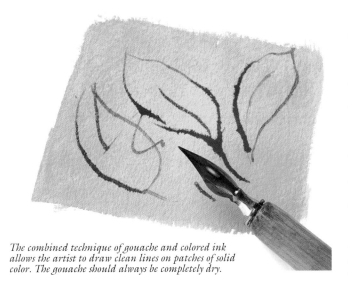

The combined technique of gouache and colored ink allows the artist to draw clean lines on patches of solid color. The gouache should always be completely dry.

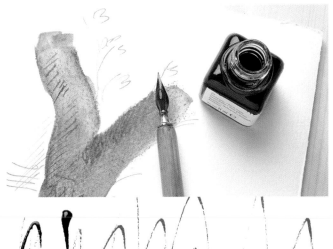

The combination of nib strokes and brush patches can give colored-ink drawings an appearance similar to watercolor.

lines and brushstrokes. The brushstrokes can use saturated colors directly from the bottle or ink that has been watered down. When applied with a brush, colored ink has a transparent quality similar to that of watercolor, but with much more tonal saturation and less resistance to light. The transparency of colored ink contrasts with the opacity of gouache, which can provide a colored base to work on with a nib and ink, sketching in details on colored blocks. Gouache can also be dissolved in water and used like ink by dipping a nib into the solution. Drawings that use this technique can be altered later by going over them with a brush dipped in water, which blurs the lines. A similar effect comes from drawing with a nib or reed pen on wet patches, or using brushstrokes of water on ink lines that are not completely dry. In both cases, the ink extends randomly, creating a misty, richly toned effect.

When the ink strokes are still wet, we can obtain a blurred, richly toned effect by passing over them with a brush dipped in water.

1. Gouache can be used like colored ink if it is dissolved in water until it is liquid enough to dip the nib in.

2. A drawing made with dissolved gouache can be retouched with a paintbrush dipped in water. The strokes will dissolve even if they are completely dry.

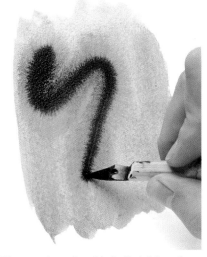

When a reed pen dipped in India ink is used on a patch of wet gouache, the ink spreads out to produce a spongy, gradated effect.

Drawing with a Reed Pen

Despite its rustic appearance, the reed pen is a highly versatile drawing tool. Its strokes are softer than a nib's, with more variety of line width. It also allows the artist to control the intensity of the strokes by using up part of the ink on a piece of scrap paper before starting to draw. Moreover, the greater width of the lines makes it easier to create black patches and to produce sketches that are considerably larger than those drawn with a metal nib.

BACKLIGHTING

Although any theme can be drawn with a reed pen, the special characteristics of this medium (like most of those based on India ink) make it especially suitable for essentially linear motifs, with clearly defined silhouettes. In a word, these motifs are more like drawings than paintings. Backlighting often favors these characteristics. In this subject, the leaves of the plants stand out sharply against the luminous background, and the stems create an interesting and attractive pattern of lines. This medium provides ample possibilities for this subject: lines of differing width, shading by lines, and solid black patches.

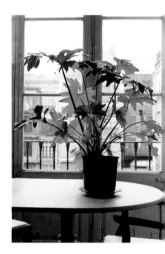

With the bright background of a window, the leaves of the plant are reduced to silhouettes of differing intensity; an excellent subject to draw by means of patches of shaded lines of varying intensity.

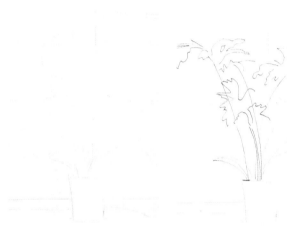

1. Before starting any ink drawing, it is essential to make a pencil sketch so that we are sure that the dimensions and proportions of the subject are correct.

2. The first stems and the outlines of the leaves are sketched in fine strokes with the edge of the reed pen.

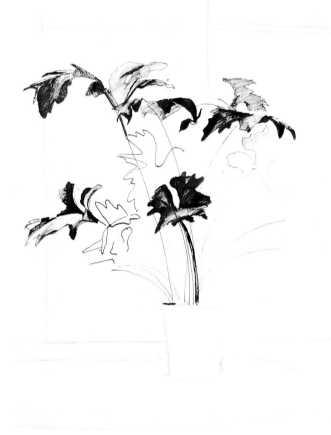

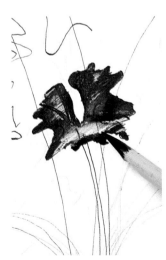

3. Once the outlines of the first leaves are complete, they can be shaded with strokes of varying density depending on the darkness of the silhouette.

4. The parts of the leaves facing the sun should be shaded in softly, using the edge of the reed pen to obtain fine lines.

5. As the shading of the first leaves nears completion, the outlines of the rest of the plant should be gradually added.

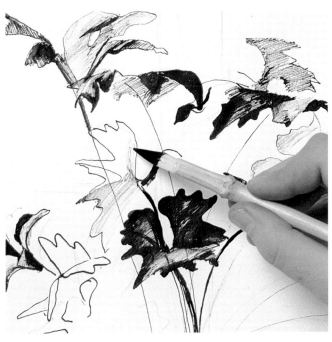

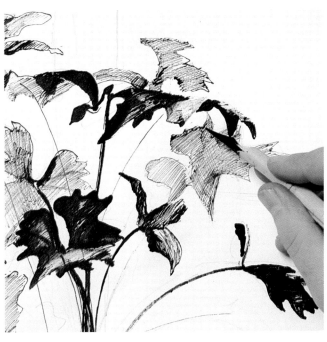

6. *Very soft shading can be obtained by previously using up the ink on a piece of scrap paper until the strokes become very light.*

7. *Some contours have a slightly darker appearance than the rest. This effect can be achieved by using the edge of the reed pen to produce an accumulation of fine strokes.*

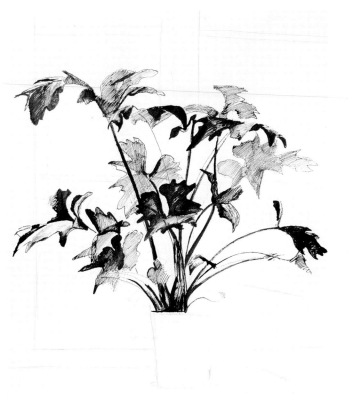

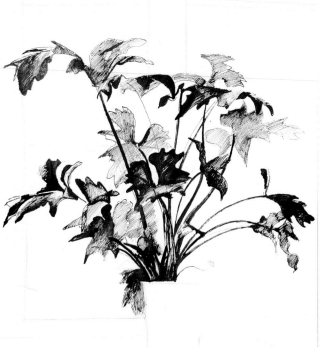

8. *Here the drawing already has a fairly finished appearance. Thanks to the constant variation in the intensity of the shading, the bunch of leaves takes on a three-dimensional aspect, with each leaf occupying a different position.*

9. *The remaining leaves at the base are located farther away than the rest, providing a chiaroscuro contrast with the closer leaves and stems.*

NOTE

After dipping the reed in ink, it is a good idea to try out a stroke or two on a piece of scrap paper. This will prevent spots on the drawing caused by excess ink or an accumulation of dried ink on the tip.

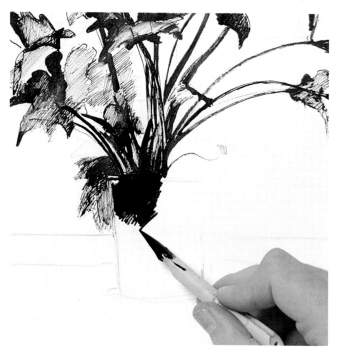

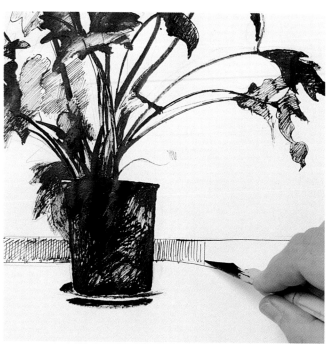

10. *The backlighting makes the flower pot look very dark, especially in the middle. This tone can be obtained by an accumulation of broad strokes with a lot of ink.*

12. *The table is a very light plane. We can make it stand out by darkening the surfaces that surround it.*

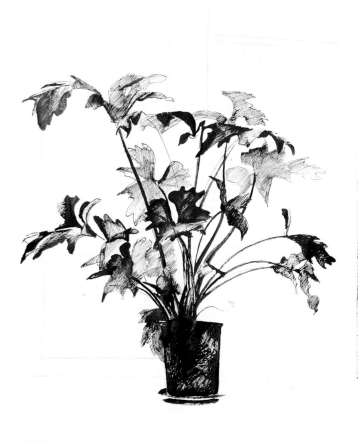

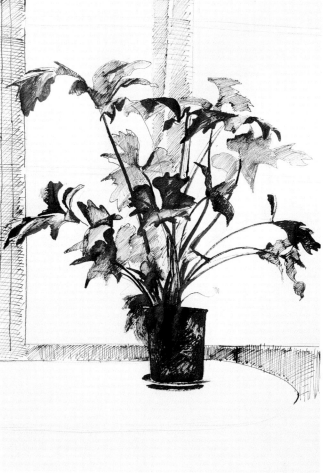

11. *The flower pot has not been turned into a completely black silhouette. The crossed strokes suggest its volume, much in the same way as the treatment of the group of leaves.*

13. *The window frame has been shaded in using loose, dispersed strokes. This element adds a certain spatial precision to the drawing.*

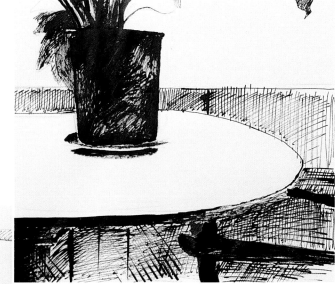

14. *This is the first stage of shading the lower part of the table. Crisscrossed, dispersed lines create the initial general shading.*

15. *Details like the legs of the chair stand out in black against the shadows of the lower part of the composition.*

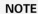

NOTE

During the drawing process, it may be necessary to clean the tip of the reed with a rag to remove the accumulation of dried ink, which can impede both drawing and absorbing ink.

16. *The final touches include finishing the shading of the window frame and sketching the railing of the balcony. Once this is done, the scene is completely drawn.*

Highlighting with a Nib

Drawing with a nib allows a wide range of combinations with other media. Although these combinations can be considered combined techniques, they do not require complex procedures or a detailed calculation of the desired effects. Watercolor and ink are related media that many artists combine in various ways. Here, watercolor is used as a background for the ink drawing, which is used mainly for highlighting and adding detail. Thanks to the watercolor base, the ink and nib work can be limited to its most essential use and exhibit the elegant properties it possesses.

LEOPARD

This animal was chosen mainly because of its coat. Its beautiful pattern of spots is enough to suggest its volume, the curved contour of its back, and the folds of its legs. If we pay attention to the distribution of these spots, we can create a complete image of the leopard without having to revert to shading or an accumulation of strokes. The simplicity and precision of the nib is suited to this purpose like no other medium.

Zoos are full of interesting subjects for the artist, but few other animals provide as many opportunities to take advantage of the precision available from a nib and ink. Here, India ink and sienna ink give expression to this fascinating subject.

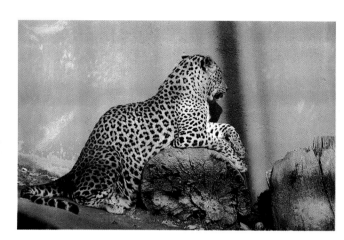

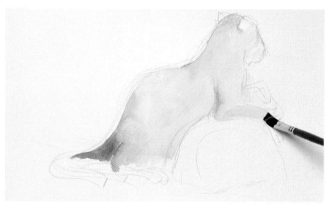

1. Although the previous watercolor wash is simple, it should be applied with care so that the varying intensities of color do not contradict the animal's anatomy. The color should be very watered down and should be applied without worrying about details.

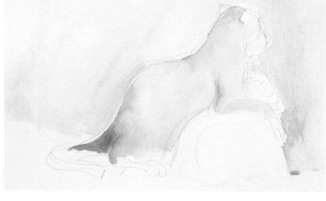

2. A second wash of bluish green surrounds the first, suggesting the animal's surroundings. Again, the color has been dissolved in a large amount of water to obtain a pale tone.

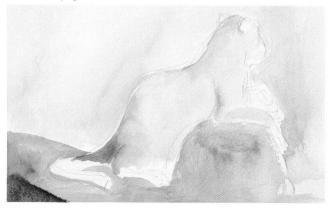

3. Another wash for the ground. Here the artist has used a sienna color slightly tinged with blue to create a shaded gray tone.

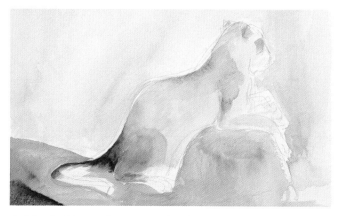

4. A few finishing touches to suggest the softness of its coat and prepare the base for the subsequent ink drawing.

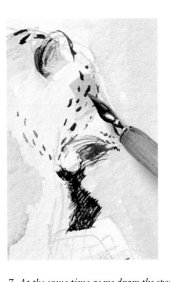

5. The first spots to be drawn are those on the leopard's head. This is a procedure, since mistakenly placed spots will distort the effect of volume.

NOTE

The nib highlights should only be added when the wash is completely dry. If the wash is still wet, the ink will spread, and the sharp point can easily tear the wet paper.

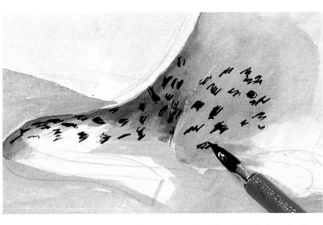

6. The next spots drawn are on the opposite end of the animal: the tail. The spots here are larger, although attention should still be paid to detail and location.

7. At the same time as we draw the spots, we can start to model this section of the body. The shaded parts are darkened with small strokes of sienna and black ink. On the feet, sepia-colored lines help define the position and shape of the claws.

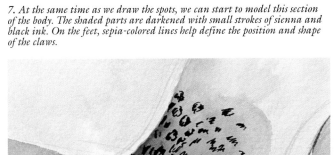

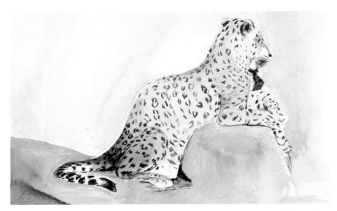

8. The combination of sienna-colored details and black spots rounds out the volume of the leopard's body. The ink-drawing has now defined the anatomy where the watercolor had only suggested the shape.

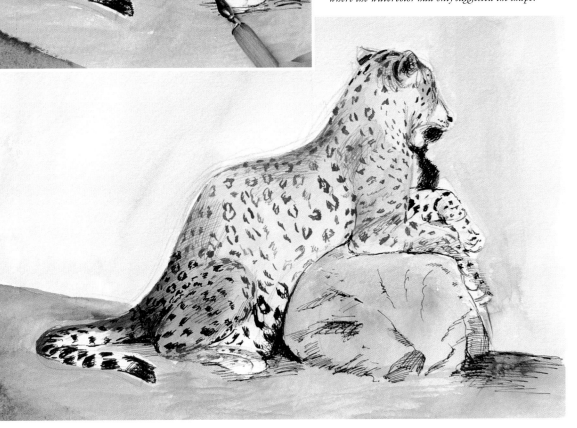

9. The final touches consist of adding definition to the tree trunk that the leopard is resting on. A few cracks and some shading are enough to give the scene its final form.

Combined Techniques: Ink and Gouache

Like watercolor, gouache combines well with ink drawing. While gouache is based on patches and flat colors, ink is a linear medium. As a result the two are complementary, and the only question is how each can bring its best to a drawing. Lines tend to delimit shapes, whereas patches tend to extend them past their boundaries. In this example of combined techniques, both of these factors are combined to create a work that is more illustrative than realistic. The style allows a freedom that owes a great deal to the techniques that are being combined. The result is a piece that is a free interpretation of the festive scene, rather than a rigorous reproduction.

Some themes require realistic treatment, while others seem more suited to other styles. The parade that inspires this drawing cries out for freer pictorial style. The color, movement, and charm of this scene would be lost if they were frozen within a conventional realistic style. This is an occasion that justifies artistic freedom, and the combination of gouache and ink is an ideal technique for trying out new approaches. The sketchy ink drawings center the attention on the motif, whereas the gouache creates small patches of color that contrast with the lines. No complicated media is necessary—only a reed pen, India ink, and three colors of gouache: blue, red, and burnt sienna.

Much of the vitality of this scene comes from the pronounced contrast between the foreground and the figures in the background. This kind of contrast is a dynamic element that the artist should take advantage of. The combination of grays and bright colors adds a chromatic liveliness that can be captured by correctly combining the two techniques.

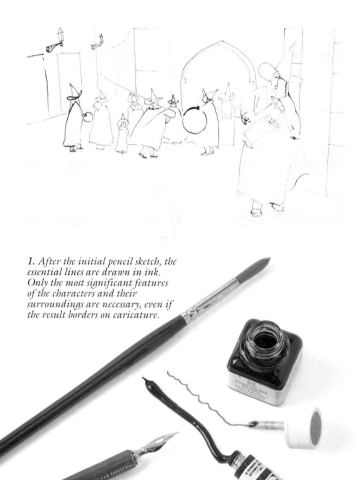

1. After the initial pencil sketch, the essential lines are drawn in ink. Only the most significant features of the characters and their surroundings are necessary, even if the result borders on caricature.

2. The red tone of the costumed child is the chromatic key to the scene. Painting it first gives us an important point of reference.

3. As a counterpoint to the red, the other characters' clothes are painted in saturated blue, which is slightly lightened at the parts that are more exposed to light.

4. The main figure has been drawn in an almost cartoonlike style. The proportions have been slightly modified to accentuate the carnival atmosphere of the scene.

5. The rest of the group is depicted in a more approximate style. A few patches of blue are enough to give an expressive contrast that suggests the movement of the tunics.

6. The background is done in a similar style to the supporting figures. The background color creates a setting that is not intended to be descriptive but to evoke an atmosphere.

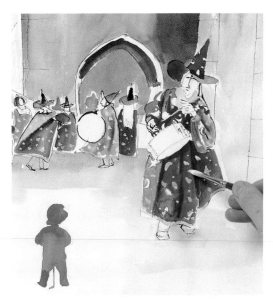

NOTE
When combining techniques, it is essential to allow the ink to dry before applying the gouache or watercolor. This keeps the lines from getting blurred, unless of course this is the effect you are looking for.

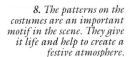

7. A light gray wash on the ground is necessary to give a reference point for distance. It also serves to unite the foreground and background in one plane.

8. The patterns on the costumes are an important motif in the scene. They give it life and help to create a festive atmosphere.

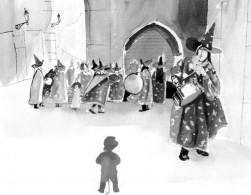

9. The figures are almost finished. The informal approach fits in nicely with the simplified representation of the surroundings.

10. The final touches focus on the pavement, with freely sketched paving stones and additional shading in the foreground. The brightly colored decorations carried by the characters in the background add a final festive touch to the scene.

Nib and Colored Ink

When ink is applied with a nib, it is exclusively a medium for drawing, relying completely on lines and combinations of strokes. By employing different colors of ink, we open up new possibilities of contrast, combination, and tone without leaving the field of drawing. While ink does not allow us to mix colors in the strictest sense of the term, it is possible to combine strokes in different colors to obtain similar effects. This drawing combines different colored inks with black ink, which is used to darken the shaded areas of the drawing and provide a contrast with the more colorful illuminated areas.

A CAFETERIA TERRACE

This theme is full of light and color effects, and the various contrasts and details make it an ideal subject for nib drawing. The surfaces consisting of one solid color have to be dealt with as combinations of lines, and the white of the paper can be used whenever possible to reproduce lighting effects. The slight shadows will play an important role, since they are especially well suited to line patterns. A gray wash of India ink can create a background which will serve to highlight the colors and shapes of the scene.

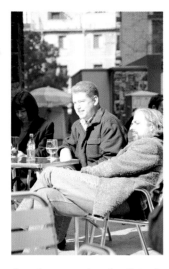

In order to reproduce the effects of shadow and light in the scene, certain areas of the paper should be left white. The sharp contrast between the direct light and the shadows in the background can be created by blank areas set against half-toned sections drawn with superimposed strokes of color and dark black strokes in the areas of deepest shadow.

1. The initial pencil drawing should be complete enough to avoid hesitation during the subsequent stages. The contours should be well defined and sufficiently detailed.

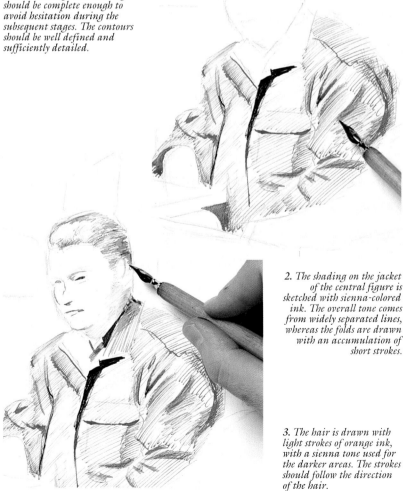

2. The shading on the jacket of the central figure is sketched with sienna-colored ink. The overall tone comes from widely separated lines, whereas the folds are drawn with an accumulation of short strokes.

NOTE

You should use more than one nib so that the colors do not mix with one another. Two nibs are usually enough: one for dark colors and another for light ones. The nibs can be inserted alternately into the same handle.

3. The hair is drawn with light strokes of orange ink, with a sienna tone used for the darker areas. The strokes should follow the direction of the hair.

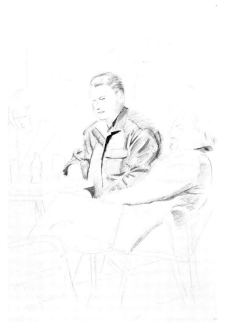

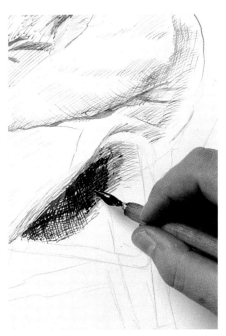

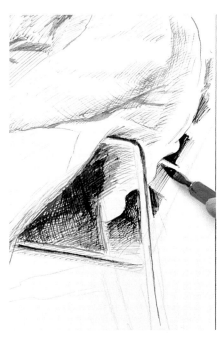

4. The jacket on the figure on the right is too light to be colored in completely. It will be enough to color in the shaded areas in green.

5. The dark shadow of the inside of the chair is drawn with a combination of green, blue, and black strokes to achieve a densely woven dark area.

6. The outline of the jacket (in half tones) is defined by darkening the contours. This shows the folds in the figure's back.

7. When shading in the figure on the left, the shapes of the glasses and bottle on the table have been left blank.

8. A wash of India ink that has been diluted in a great amount of water serves to highlight the outlines of the figures and add atmosphere. The wash has been applied with a synthetic-fiber brush.

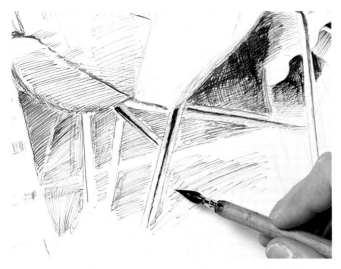

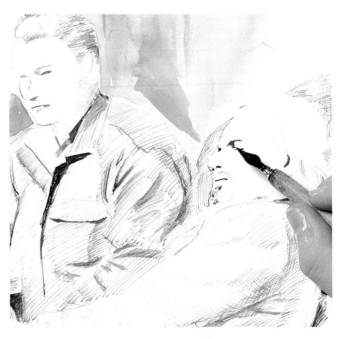

9. The shadows on the pavement are drawn with long strokes of black ink, leaving the more illuminated areas blank to take advantage of the white paper.

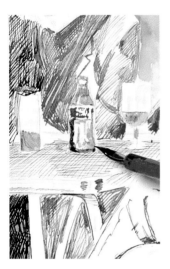

10. The features of the figure on the left take shape thanks to fine strokes of sienna-colored ink for the lips, nose, and eyelids. The beard is shaded in with very light strokes of the nib.

11. The glasses and bottle are completed using yellow, green, and sienna-colored ink spread out in small patches. The strokes are filled in and areas of solid color are created.

12. The light shape of the umbrella in the background is highlighted by darkening the outside of its upper edge with light strokes of black ink.

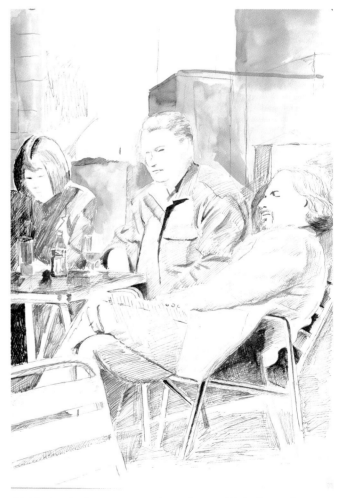

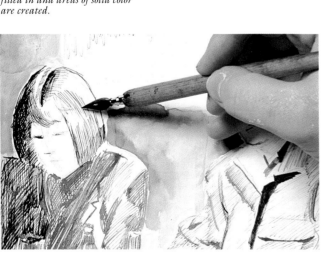

13. As with the central figure, the woman's hair is drawn with parallel strokes of black ink that follow the direction of the hair.

14. The drawing is now at a very advanced stage, with the figures almost completely defined. The surroundings have been highlighted with the transitions between light and shadow suggested by the use of washes and soft shading with black ink.

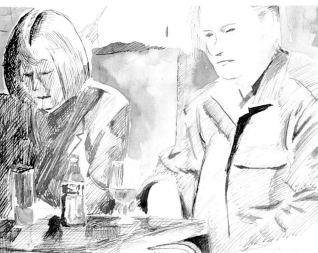

15. *The woman's features should be drawn in simplified form so as not to add too much detail to a drawing that is already fairly detailed.*

NOTE

Mistakes in ink drawings can be corrected by covering them with a piece of the same paper used for the drawing. The paper can be stuck on with glue and drawn on again.

16. *To fix mistakes like this one (the shadow between the backrest and the chair is too dark and messy) we can glue a piece of paper over it.*

17. *Now we can redo the part of the drawing, taking care to make the strokes coincide so that there is no noticeable break with the original.*

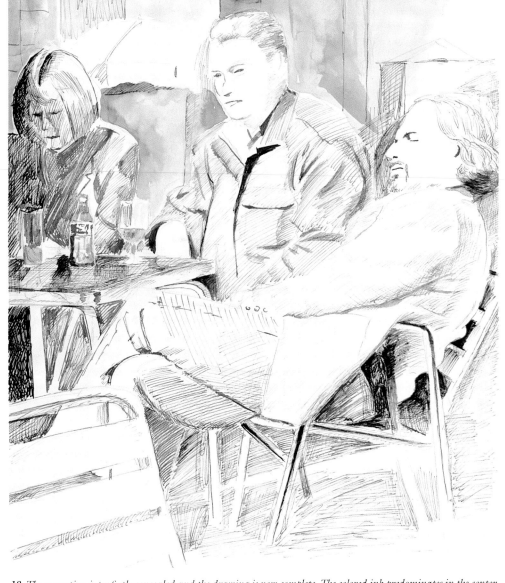

18. *The correction is perfectly concealed and the drawing is now complete. The colored ink predominates in the center of the drawing, whereas the surroundings are drawn in shades of gray from washes and strokes of black ink.*

Wet Techniques

Wet techniques is the frontier between drawing and painting. Wet techniques consist of any method that uses water as a solvent, such as watercolor, wash, or gouache, or combined techniques that use water solutions, such as drawing on a wash base or pastels dissolved in water. The brush is the most frequently used tool in these techniques. The reason for including these techniques in a book on drawing is that the brush is often used to define detail with lines and patches, and the work is usually based on black and white or only a few colors, characteristics that are typical of drawing.

SKETCHING WITH A BRUSH

The brush is especially well suited to drawing all kinds of sketches from nature. The lack of precision inherent in its strokes is compensated by the freshness of the result. Brush sketches possess an incomparably fresh and spontaneous feeling that is impossible to get from any other procedure. The flexibility of the tip gives the lines a variable width that allows us to speak of real brushstrokes rather than lines. Sketching with a brush requires economy and synthesis, since there is no possibility of correction, and an accumulation of lines would result in a messy, overcrowded look. The artist should strive to capture the essence of the subject quickly and directly, with only a few strokes. It is always possible to start with a pencil sketch consisting of a few light lines to ensure that the motif is correctly composed. However, once the brush sketch has begun, it should be quick and without hesitation. The density of the chosen medium will determine the fluidity of the strokes. An extremely fluid medium, like watercolor, allows the forms to take shape quickly, as the artist connects one stroke with another and reduces the shapes to spontaneous outlines in an almost cursive style. Denser media imply more separate strokes and a more sober, angular style.

SKETCHING WITH A BRUSH

SKETCHING WITH MONOCHROME WATERCOLOR

Brush sketching usually involves just one or two colors. Any more would provoke mixtures on the paper that would confuse the outlines of the shapes. The limited number of colors can be compensated for by tonal variations depending on how much water is used to dilute the color. Saturated colors are used for the outlines and shadows, whereas lighter contours can be sketched with colors that have been diluted to a point of near-

Subjects like this one are frequent in brush sketches: motifs that are like snapshots and make the artist look for synthesis. It is important to pick out only the most essential contours and lines of the scene.

1. The first strokes provide the basic outline of the main volumes: the boat and the two figures. The watercolor is heavily diluted, and the lines are fluid and light, which is the correct treatment at the initial stages of a sketch.

transparency. Each phase of this process should be carried out quickly and confidently. Between each phase, the artist can study the desired effects and try to predict the final result. It is essential to start with light shades before progressing to darker ones. The first strokes should be light and schematic, and then progress to more saturated tones. The shadows and contours, which should stand out more, can be added at the end.

2. Patches of highly diluted color are used for the lighter shadows. These patches shade in certain details without providing a detailed description of the scene.

3. The waves, plants, and general surroundings are sketched in quickly. This type of abbreviated work is typical of brush sketching, and is one of its main virtues. The work as a whole should maintain this synthetic look without corrections or excess detail.

4. The final touches consist of adding a few soft patches to define the contours. The background is limited to a few light washes of watered-down color to add depth to the scene.

SKETCHING WITH A BRUSH

LINES AND PATCHES

When sketching with a brush, the change from lines to patches is only a matter of changing hand gestures. With the tip of the brush, we can even draw fine lines that are almost comparable to those of an ink sketch. The harder the tip is pressed to the paper, the wider the line becomes, and the pressure brings more and more paint to the surface. The thick strokes that are created can be changed into patches by simply rubbing the brush against the paper. This almost immediate transition from lines to patches is one of the properties most characteristic of brush sketching and what makes it a borderline technique between painting and drawing.

The step from drawing to painting is immediate with brush sketches and wet techniques. Lines can be quickly changed into patches depending on the pressure applied to the tip. On the other hand, working with the tip of the brush, we can create lines that are similar to nib or reed-pen drawings.

SKETCHING WITH A BRUSH

DRY BRUSH

The dry brush technique consists of working with a brush containing a large amount of concentrated color to create an irregular effect that reveals the texture of the paper. Since this dry-paint effect is difficult to achieve with watercolor, gouache is the most common medium for dry brush drawing. Dry brush is usually employed to create details in gouache drawings when the work is nearing completion. Opaque touches are usually added over dried patches of color. However, it is also possible to make sketches directly with a dry brush, without any previous preparation. This results in an energetic and approximate effect that gives the drawing a rustic or primitive feel.

When using a brush with thick, concentrated color, the rough grain of the paper is revealed. The brush slides effortlessly across the paper, leaving a sketchy, rustic look.

GOUACHE

COVERING POWER

Along with watercolor, gouache is the most common medium for drawing with wet techniques. Unlike watercolor, however, gouache is an opaque medium with high covering power. Once dry, the patches and strokes of gouache can be completely covered with new patches and lines. To obtain a clean effect, the covering patches should not be excessively wet, because the water would dissolve the underlying patch. If we work with thick colors, we can be sure that each new layer covers the preceding one. It is essential to find the proper balance, however, since an excessively pasty patch of color may crack when it dries. Texture and thickness is impossible to obtain with gouache. In any case, it is difficult to obtain too much thickness with gouache, since it is a medium that doesn't have much body. This procedure should create a matte effect with clearly defined colors and little tonal variation.

Gouache is a medium with great covering power. Dry patches can be covered with new tones, and by using brushes of varying thicknesses you can obtain opaque, matte colors.

GOUACHE

COMBINED TECHNIQUES

Gouache is one of the most common mediums used in combined-technique drawing. Gouache colors can be mixed with almost any other drawing medium, both wet and dry. It is usually combined with pastels, since the rough surface of the gouache patches favors the adhesion of the pastel particles.

The inverse procedure is also possible: Extensive washes of watered-down color can allow the pigments of the pastels to mix with the gouache and meld the two media. Graphite pencils, colored pencils, charcoal, ink, and chalk can all be combined with various wet techniques, especially gouache.

Dry patches of gouache provide a good adhesive surface for pastel strokes. The combination of various background colors, painted in gouache as a subsequent base for pastels, is an extremely useful procedure, which explains why this combination of techniques is so common.

Sketching with a Brush

Brush sketching is the most common of the wet drawing techniques, and sketches from nature using washes represent one of the favorite uses for this type of drawing. The brush possesses an incomparable facility for quickly capturing the essence of a scene. It is a drawing tool that allows us to capture movement, light, and atmosphere simply, and with the fewest possible strokes. The result may appear sketchy, but it possesses a style that confers the air of a finished work of art in its own right. Brush drawing is also excellent practice for the artist. It exercises manual skill, observation, and retention and promotes the essential ability to see and understand shapes instantaneously and transfer them to paper.

CITY STREET

Streets are the main source of subjects for the artist looking for sketches from nature. The primary purpose of any sketch is to capture a moment of light or movement. The atmosphere of this street, however, cannot be captured in just a few well-placed brush strokes. The strokes must perform various functions: placing and clarifying the main shapes, establishing the distances of the scene, and suggesting light, among others. This cannot be achieved by forcing the medium to do what it is not intended to do, but rather by letting the brush move naturally and taking advantage of the random effects that may occur along the way.

This urban scene features backlighting, which is especially suited to brush work. The shapes can be reduced to silhouettes, and the dark and light volumes will be enough to complete the scene.

1. While a previous pencil sketch is not absolutely necessary, it always helps to place the figures correctly on the paper. Once the composition is clear, we can sketch the basic contours of each object in a diluted, neutral tone.

2. The dark silhouette of the main figure can be defined from the outset by means of a single patch of saturated color.

3. The rest of the silhouettes are filled in using the same color, which has been watered down to obtain a lighter effect. This makes them appear farther away.

4. These slight tonal changes already begin to suggest the space and atmosphere of the scene. The figures should not be made more precise, since this would destroy the atmosphere.

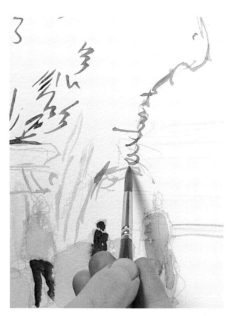

5. Using the tip of the brush, the contours of the leaves are sketched. Loose strokes are enough to suggest the shape without striving for a great deal of realism.

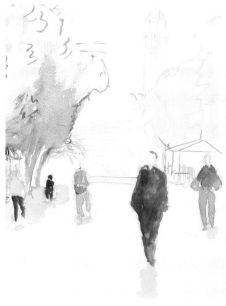

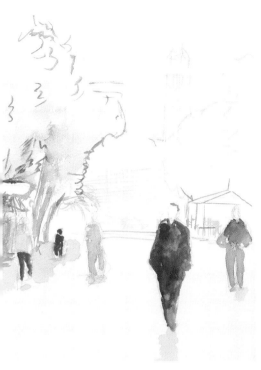

NOTE

When sketching using wash, it is essential to control the wetness of the color. Patches can only be defined if the brush has enough color to create the silhouette with one application. At the same time, the amount of paint should not be so much that the wash creates puddles.

7. The distant buildings should be sketched with very little detail and in lighter tones than the figures in the foreground.

6. The first patches should be done in a light tone in order to control the final effect of the composition.

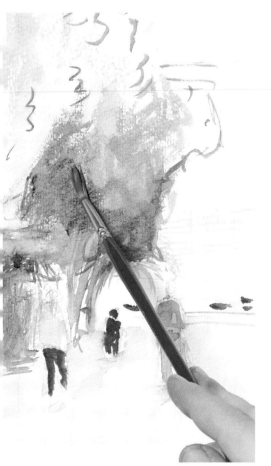

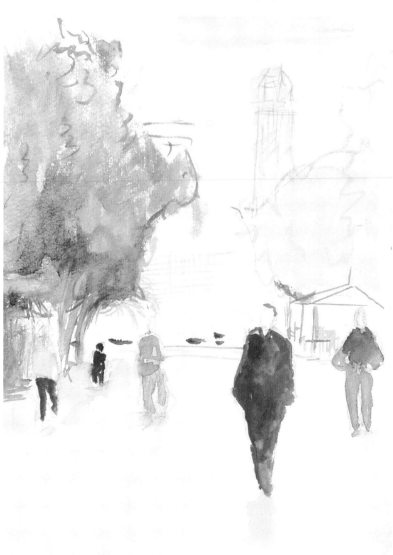

8. The trees are shaded in to create a screen against the sky. They are defined by contrast.

9. Just a few brushstrokes are enough to suggest the particular light of this day. This effect helps define the atmosphere surrounding the city street.

A Monochrome Wash

Although it is not exactly a drawing in the strictest sense of the term, this monochrome exercise, painted in wash, contains many drawing techniques hidden behind its more painterly appearance. The outlines, the tonal changes, and the composition comprised of simplified and detailed shapes are elements of drawing. A monochrome technique was chosen to study these elements. To transpose a motif from nature to a scale of grays is a process of abstraction. It is an abstraction of color as well as an abstraction of shape, which adapts to the tones and intensities that can be created using just black and white. A successful monochrome rendering emphasizes the principles of modeling and shading to define the forms in the composition.

LINES AND MASSES

Creating a monochrome drawing such as this one reveals the relation between the drawing of the outlines of forms and their volume or mass. Changes in tonality can not only define distances but can also be used to define outlines or, in other words, to draw. This subject has been reduced to outlines that define the contrasts between grays, whites, and blacks. The masses and volumes are defined by the hues of each of the painted areas or by their texture. These factors create the sensation of corporeality, and if they were to be omitted, this monochrome drawing would appear flat. The relationship between these factors reveals how to approach the subject, taking its light, shadows, and volume as a whole, and how to move away from a flat drawing to a subject conceived as an arrangement of volumes within a given space.

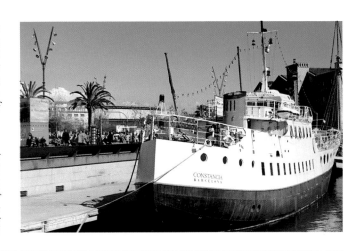

Thanks to the luminosity of this subject, it is possible to reduce the color to a limited range of grays. The basic contrast is produced by the hull of the boat, a contrast of black and white that can be developed in the other elements present in the motif.

1. The artist begins by using a fairly diluted, medium gray tone to situate the essential contrasts in the composition: the hull, its shadow on the water, and several other darker details.

2. In addition to the first contrasts, the most important outlines are defined by the boat and the shaded areas that appear in the background of the dock.

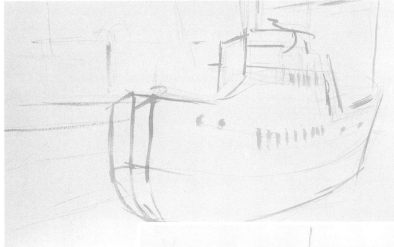

3. These initial stages already include the reflections on the water which help to define the spatial sensation of the composition.

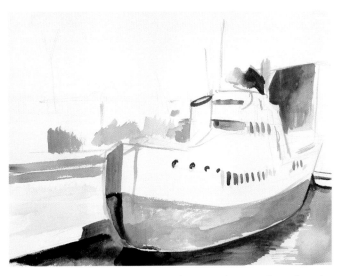

4. By intensifying the basic contrasts, it becomes easier to graduate the scale of grays to be developed later.

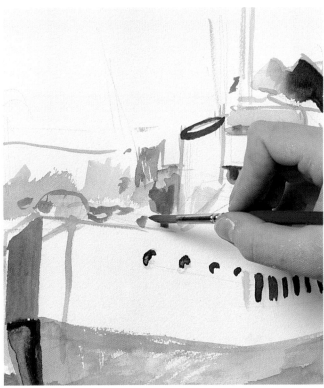

5. As more tones of gray are added, the first details can be defined.

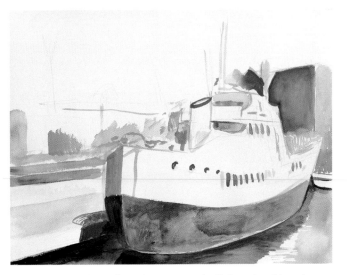

6. Shadows, details, new hues of gray are gradually introduced into the work, taking care not to clutter up the composition nor subtract from the contrast of black and white on the boat's hull.

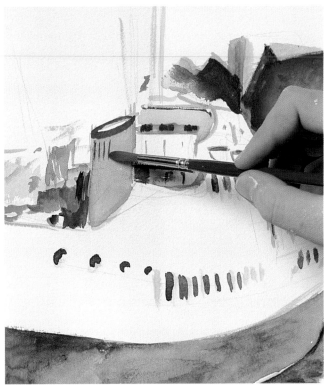

7. The red of the chimney can be expressed by this flat, plain gray tone, while its cylindrical shape is suggested by the dark ring of the neck.

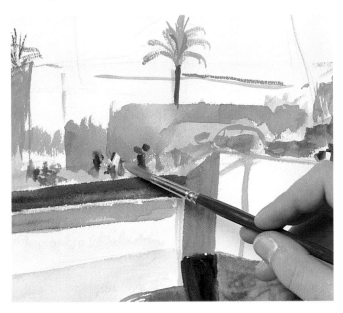

8. The buildings, trees, and other details that appear in the background create a black backdrop against which all the elements situated on the boat's deck stand out.

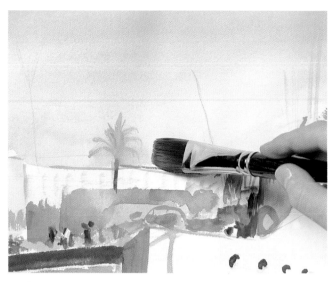

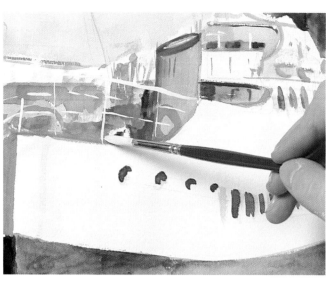

9. *The artist applies a pale gray wash over the entire sky area in order to highlight the tones of the composition. This wash should be uniformly applied, without any changes in tone or brusque transitions from light to dark.*

10. *The artist uses the tip of the brush to draw the lines representing the masts and rigging, with the hanging line of small lightbulbs and banners. The details of the handrail are also added.*

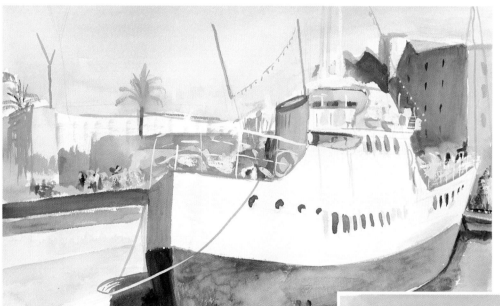

11. *The composition now reveals the tones. Gouache colors such as these can still be worked on, deepening the tones, overlaying details, and developing the work until it contains a large amount of detail. For this stage, the color should be applied more heavily.*

NOTE

Once you have begun to work with thicker colors, the density of the paint must be maintained. If diluted color is applied over a thick color (even when dry) the moisture will dissolve the gouache and cause it to mix with the new layer of paint.

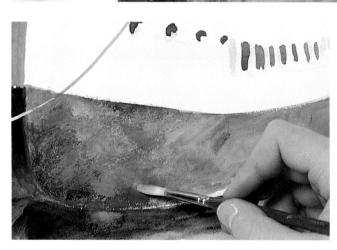

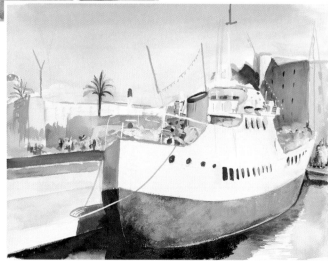

12. *In order to lend the boat body, thick gouache is added to the darker area, applying it with a dry brush. This creates a texture reminiscent of old metal.*

13. *The people strolling along the quayside are painted using small touches of thick color that conceal the previous colors and suggest movement and animation.*

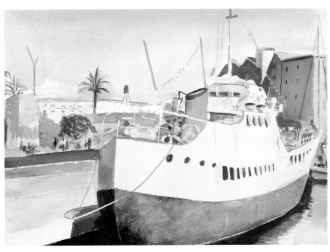

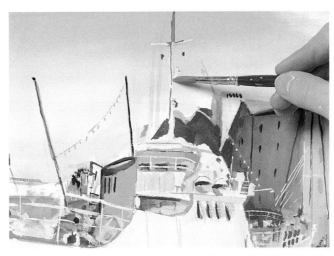

14. *As the artist develops the details on the deck, the shapes gain in definition and appear correctly situated.*

15. *The last touches are made to the decorations hanging from the masts of the boat, the handrails, the ropes, and other small details.*

16. *A final rectification: the white of the hull, which until now had appeared "flat," can be altered by applying broad brushstrokes of thick white paint.*

17. *Thanks to these white brushstrokes on the hull, the work possesses graphic strength while expressing the body and volume of the objects in the composition.*

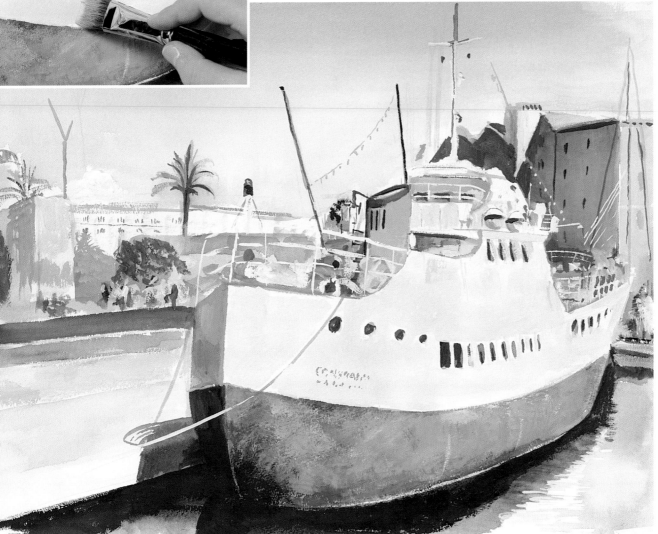

Combined Dry-Wet Techniques

Combined techniques are characterized by using different media. The combination of dry and wet techniques is a common one in contemporary painting, although there do exist many earlier examples of this method. This exercise is based on different versions of gouache and pastel: soft and hard pastels and pastel pencils. Gouache is used in a fairly diluted form so that it does not form lumps when mixed with pastel. Another interesting feature of this technique is to dilute pastel lines with water, which shows pastel's ability to adhere to a surface even when it has been diluted. The advantages of each medium are used to create a unified, overall effect.

RURAL LANDSCAPE

The chosen subject is a view of a rural village that has an interesting combination of architectural and natural elements. The planes and edges of the buildings combine with the irregularities of the tree branches, with the margins and the green of the wood. The tones are softened by the light that filters through the clouds. This calls for neutral colors, tending toward grays and earth tones. Sanguine, siennas, tile reds, greens, and grayish blues are the tones to be kept in mind.

The structure of this view comprises large vertical and horizontal masses, enlivened by the irregularities of the vegetation. The tones call for a soft, progressive treatment that develops from neutral grays to the most vivid colors.

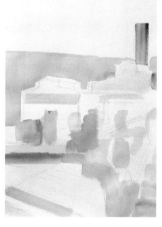

1. The overall layout is based on broad brushstrokes of diluted gray colors, which establish the overall chromatic orientation of the entire work.

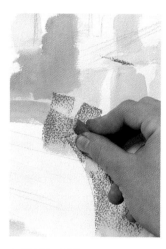

2. Thick pastel lines are superimposed over the preliminary colors. These are the green tones of the vegetation. The artist has chosen soft green tones with an earthy hue consistent with the planned chromatic layout.

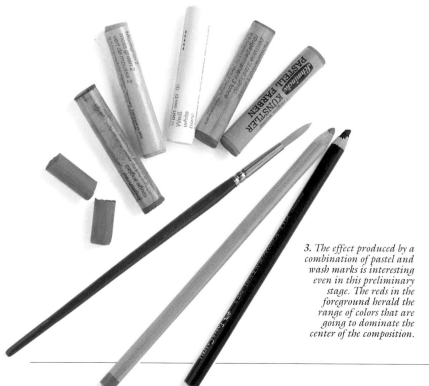

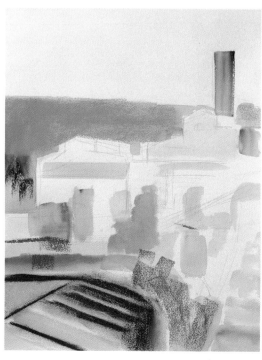

3. The effect produced by a combination of pastel and wash marks is interesting even in this preliminary stage. The reds in the foreground herald the range of colors that are going to dominate the center of the composition.

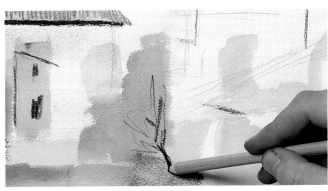

4. *Using a sepia-colored pastel pencil, the artist highlights the edges of the roofs and the tree branches that take up the center of the composition so as to better define the areas to be colored.*

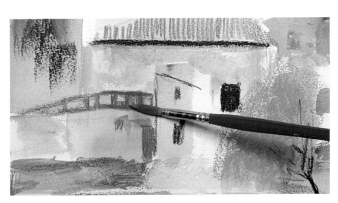

7. *This is a continuation of the previous stage: pastel lines, then diluted with the moistened brush so as to blend the color.*

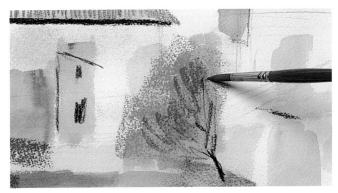

5. *After painting the central treetop in mauve, the pastel is diluted with light touches with a moistened brush so as to represent the tangled branches.*

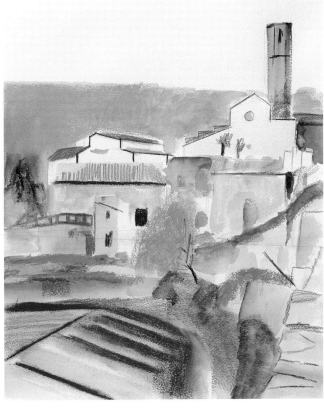

8. *The green pastel marks in the margin have been diluted to bring the tone closer to that of the herbs and bushes that grow at the foot of the wall.*

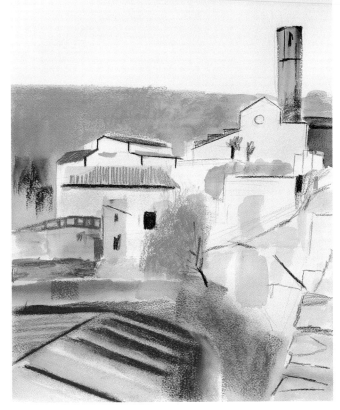

6. *As a result of the different colors and lines that the artist has included, the composition begins to become better defined: it now contains the basic indications for continuing the work of defining the forms through color.*

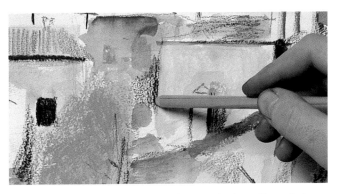

9. *After each dilution, it is necessary to define again the profiles and edges. This is typical of a combined technique: one technique enriches and modifies the other.*

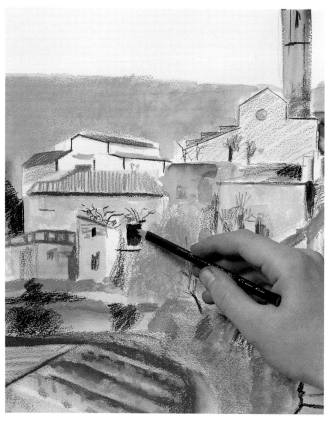

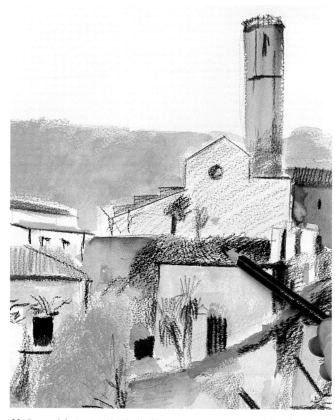

10. *The artist uses a charcoal stick to darken certain details so as to create contrasts that will break up the monotony of the gray tones.*

11. *Some of the treetops in the background are represented with a simple charcoal-pencil shading.*

12. *Charcoal pencil lines can also be diluted in water. In this case, the more visible lines of the treetops should be blended together to make them less distinct.*

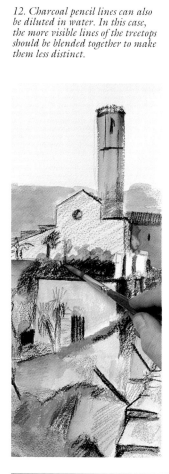

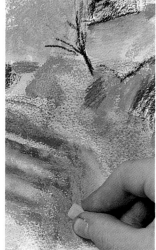

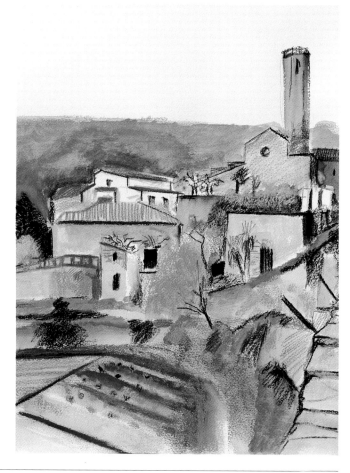

13. *After having intensified the colors and details of the houses in the village, it becomes necessary to intensify the tones in the foreground so that they are not lost in the contrast.*

14. *The landscape is almost finished and it now becomes obvious that the sky requires fuller treatment so as not to appear as a rough, white surface.*

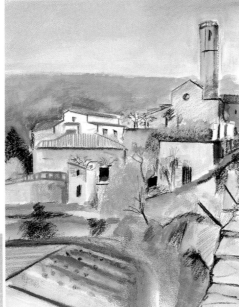

16. *Once the sky has been painted, the composition takes on a more unified harmony. The contrast between the many different hues in the sky lend the painting a more solid feel.*

15. *The artist covers the entire surface of the sky with a pale blue pastel, without pressing down too hard, which would produce too saturated a color. Using a flat, wide brush, he spreads water over the pastel painted area. This dilutes and softens the color.*

NOTE

Diluted colors should always be completely dry before charcoal, chalk, or pastel are applied over them; otherwise, the surface of the paper could be easily spoiled by the friction of the stick or pencil.

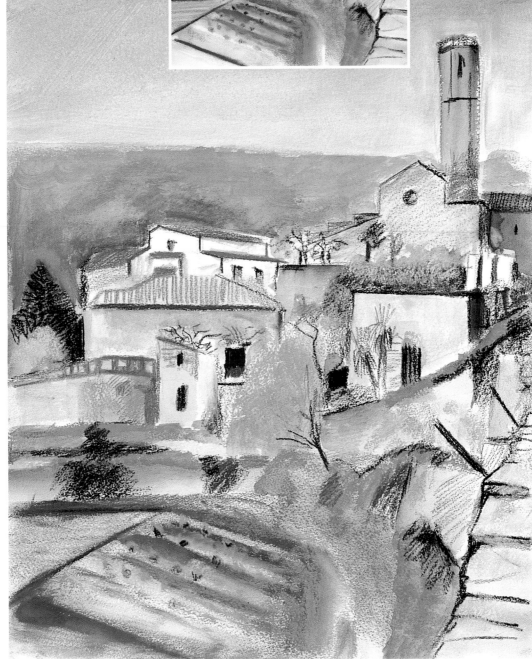

17. *The work is almost finished. The last touches have been added to the furrows in the foreground and to the vegetation.*

Oil-Based Media

Oil-based media are all those that are bound by organic substances such as wax or oil. Oils are the most well-known medium of this type; essentially a painting medium, it falls outside the scope of this book. The most common oil-based medium in artistic drawing is wax crayons, a medium halfway between pastel and oil. Wax crayons are a true drawing medium and have characteristics similar to those of pastel sticks or colored pencils. Wax crayons mix easily, are highly opaque, and their texture allows them to be modified after being applied to the paper. Like all oil-based media, wax crayons can only be diluted in organic solvents such as turpentine or paint thinner.

DRAWING WITH WAX CRAYONS

Colored wax crayons are usually considered school material, for they are easy to use and produce saturated colors. They are vividly colored sticks made up entirely of bound color, without any type of coating. But as with any other drawing medium, wax crayons can produce highly creative results when used with true artistic intention. Wax crayons are the most opaque of all common drawing media. Because they are bound with an oil-based substance, they contain a large quantity of pigment (provided they are quality crayons), produce strong color mixtures, and go further than most similar media, with the exception of high-quality pastels. They can be rubbed until all the tones have blended together entirely, and can be retouched and modified after being applied to the paper. All these characteristics, however, have their drawbacks. Wax crayons get dirty easily and require great care to keep the colors clean and uniform. In addition, they never dry out completely, so work done with these crayons must be protected by a special fixative.

DRAWING WITH WAX CRAYONS

MIXTURES

Wax crayons can be mixed in a wide variety of ways. When one color is applied over another, the colors blend sufficiently well so as to produce a clean color. Whatever color is applied over another, the result hardly varies: A light color drawn over a darker one produces approximately the same result as if they had been applied in reverse order. To produce even more homogenous mixtures, they can be smoothed with the fingers to produce a true blending of tones, not only as a result of the physical act of mixing them but also due to the wax being warmed by the friction. This can be done to produce continuous transitions from one color to another, without any sudden changes. When using this technique, be careful to clean your fingers before each mix so as not to smudge the resulting color.

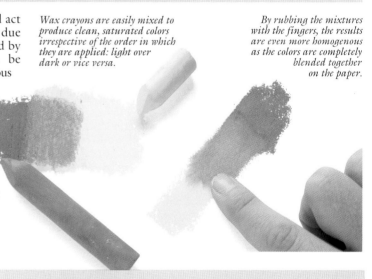

Wax crayons are easily mixed to produce clean, saturated colors irrespective of the order in which they are applied: light over dark or vice versa.

By rubbing the mixtures with the fingers, the results are even more homogenous as the colors are completely blended together on the paper.

DRAWING WITH WAX CRAYONS

DILUTIONS

As with all oil-based media, wax crayons can be dissolved in organic essences and solvents. To obtain the best results, these dilutions should be made on patches of thick color. If the layer of color is too thin, the solvent will affect the surface of the paper and stains may appear or the paper may start to rot over a long period of time. The most suitable brushes for dissolving wax crayons and oil-based media in general are bristle brushes, although softer-hair brushes can also be used. Synthetic-hair brushes, however, should be avoided.

After the color has been applied, it is rubbed with a brush dipped in turpentine so as to spread out the color and finally mix it in other areas of the drawing using the brush. The thicker the layer of color, the better the results.

DRAWING WITH WAX CRAYONS

COVERING ONE COLOR WITH ANOTHER

The highly opaque and oily nature of wax crayons make them capable of creating interesting effects when superimposed and scratched. After painting over a color with another tone until it is completely concealed, the second layer can then be scratched to reveal the base color through the scored lines. When attempting this effect, it is important not to press down too hard when applying the second color; otherwise, the colors would mix. The best results are obtained when a dark tone is applied over a light one, as dark colors tend to be more opaque.

1. When covering over a color, you must avoid pressing the crayon down too hard over the base color or both colors will be mixed. A good result is guaranteed if you apply a dark color over a lighter one.

2. The superimposed layer of color can be scratched with any pointed object to create a drawing or engraving that reveals the light, underlying color.

DRAWING WITH WAX CRAYONS

RESISTS

Not being water soluble, wax can be used to mask areas in water-based techniques such as watercolor or gouache. If a colored wash is applied over wax, the wax remains impermeable while the paper surrounding it absorbs the color. White wax crayons are generally used to create these effects, though any other colored wax can also be used.

When a colored wash is applied over white wax, the wax remains unchanged, like a white mask in the center of the color. To achieve a clean result, do not press too much over the wax with the brush to avoid the brush picking up any wax which would make it more difficult to apply the wash.

DRAWING WITH WAX CRAYONS

MELTING

Wax crayons melt so easily that they can be used to apply drops of wax on the paper. This method produces a wide variety of mottled effects. These effects can be explored further by drawing with the crayon on the hot wax or even using a hair dryer on the drops of wax to create different blends of color.

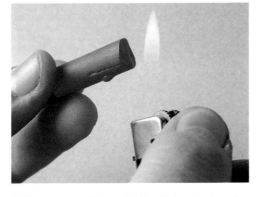

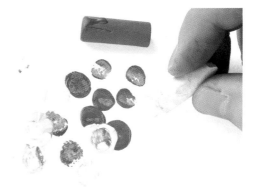

1. The crayon can be heated with a lighter. In just a few seconds it begins to drip. Care should be taken that the crayon does not melt entirely between your fingers.

2. The hot crayon can be applied to the drops of wax on the paper or they can be reheated using a hair dryer.

Drawing with White & Black Wax Crayons

Wax is a drawing medium that is better suited to working with masses of color rather than with lines. Lines drawn with a wax crayon are thick and uneven and are darkened when other colors are overlaid. Results similar to those of pastel drawing can be obtained when working in black and white: blended areas, continuous transitions from light to dark, superimpositions, etc. With wax crayons, tones can be blended until a perfectly homogenous mix is obtained. All these characteristics make wax crayons a quick, direct drawing medium. If the artist works only with black and white, these characteristics can be seen quite clearly.

The gentle transition from light to shadow on the vase and the table can be achieved quite easily by blending grays together. The darker tones of the leaves suggest a silhouette that contrasts sharply with the background, a contrast that, at the same time, contains different hues of gray and a certain amount of detail in the definition of the stems.

BRANCHES AND FLOWERS

The color of this subject is overshadowed by the clear contrast between tones. Indeed, the different greens of the leaves form a dark mass that stands out against the pale tone of the wall; the soft blue of the table and the vase are reduced to grays, altered by the effect of the shadows. Even the chair is a dark, almost black, silhouette. It is a subject that can be interpreted using a mixture of black and white, with transitions between grays and contrasts of chiaroscuro.

1. The initial layout is quite simple. It is an arrangement of outlines that bring these few elements of the composition into order: the outline of the table, the vase, the silhouette of the leaves, and the back of the chair.

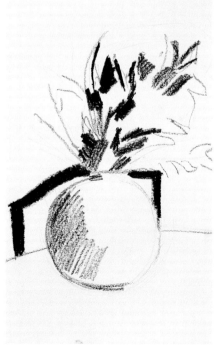

2. First, several black lines are applied to the darkest spaces in the composition. The backrest of the chair can be defined as a thick, sharp, deep black line.

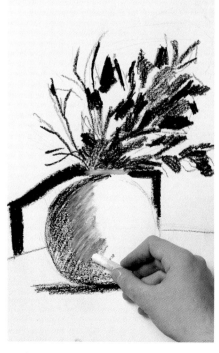

3. The grays are lightened slightly by adding white lines over the shaded areas, which are then rubbed to merge the tones together.

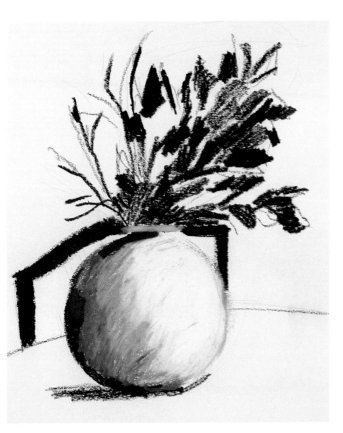

4. *By drawing over the black lines with the white crayon, the lines are blended to a certain extent to obtain a gradual transition from light to dark.*

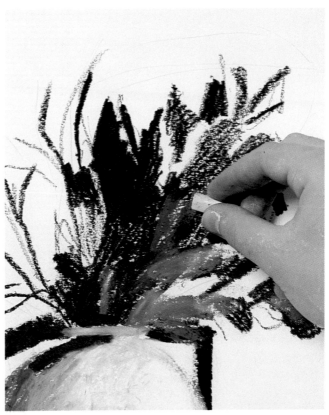

5. *The flowers are rounded white patches over the black lines. The mixture of the two creates a gray that, for the moment, is sufficient to indicate the position and form of each flower.*

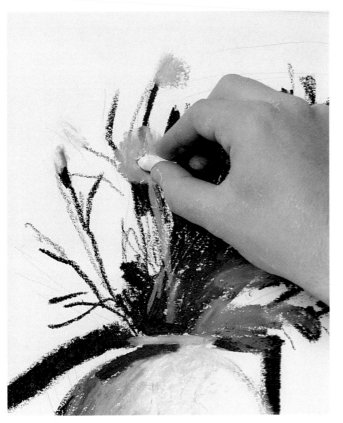

6. *In order to obtain different grays in the area of the leaves, the white crayon is rubbed flat on the paper and applied to the black area until lighter tones are obtained.*

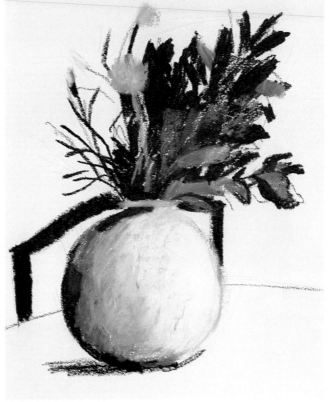

7. *Having reached this stage, the work now contains a fair amount of detail. The mass of leaves is better defined as a result of the gray and black tones that make individual forms stand out.*

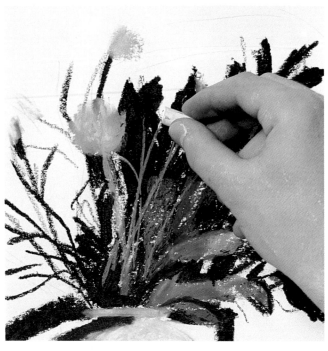

8. By drawing with the edge of the white crayon, the direction of the stems over the darker gray of the leaves can be better defined.

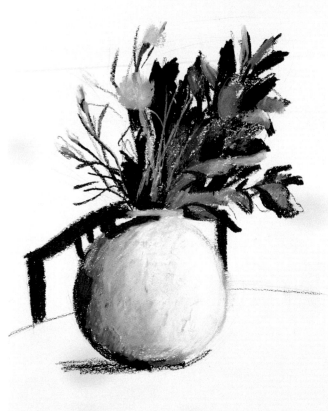

9. The group of leaves and flowers is almost finished; the rest of the composition now requires the same amount of detail to be added.

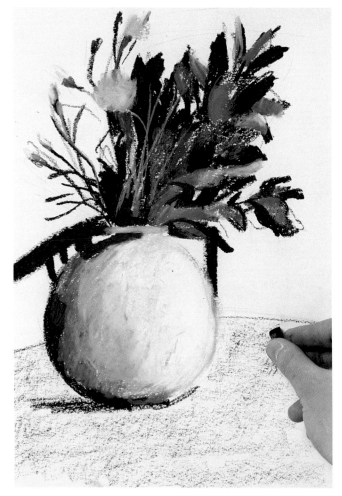

10. To obtain the right tone for the surface of the table, the artist starts by drawing soft patches of black crayon, gently rubbing the crayon flat on the paper until the entire area is covered.

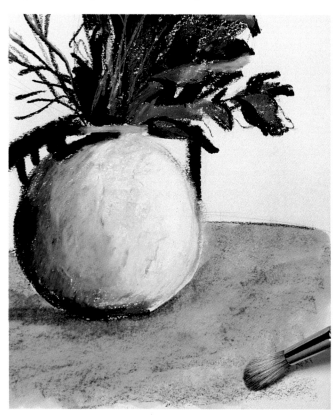

11. After rubbing the surface of the table with the black crayon, a brush dipped in turpentine is used to darken the area by spreading out the dissolved wax.

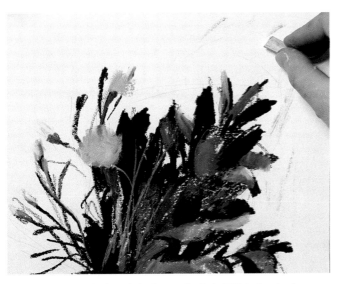

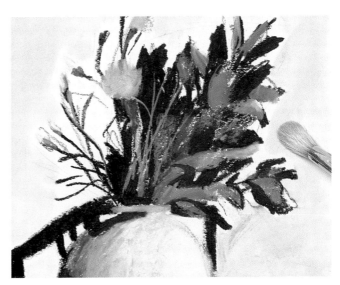

12. The artist now darkens the background a little. This is done in the same way as the table, though this time he uses the white crayon, applying it flat on the paper.

13. The white color is diluted with the brush dipped in turpentine. This darkens the background in keeping with the relationship of the tones in the composition.

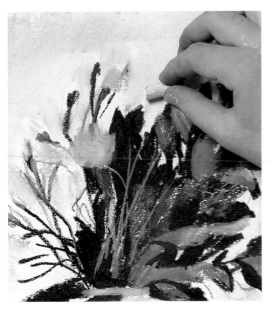

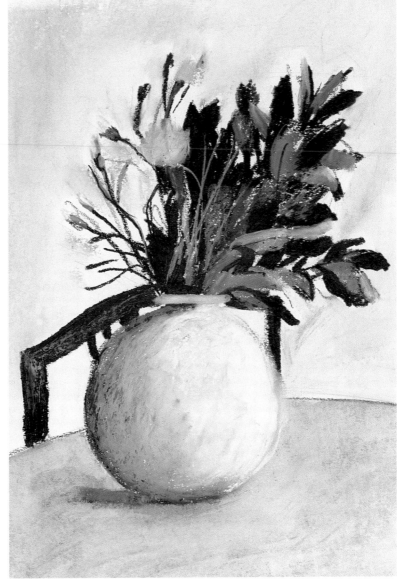

14. The artist then uses the white crayon to extend the background color until it covers the areas the brush cannot reach, rubbing over the spaces that appear between the leaves and the flowers.

NOTE

The potential for superimposing opaque colors has its limit: when the paper is completely saturated with color, new layers cannot completely cover the wax and the previous layers tend to merge together. This can smudge and dirty the tones of the composition and blur the profiles and outlines.

15. The result possesses a good finish, a unified whole thanks to the special texture of the wax, which is soft and lumpy at the same time. The tones have been easily achieved thanks to the enormous potential of wax crayons when blending and mixing colors.

Colored Wax Crayons

Colored wax crayons are the most painterly of drawing techniques. Given the way they are used, they should be included as a drawing medium, though the results obtained have the typical appearance of a painting. Wax crayons can be superimposed and mixed on the support in a similar way to oil paint. Blending and mixing colors are common techniques that help to lend the work a unified appearance, with its own oily and slightly lumpy consistency. Wax crayons are ideal for quick drawing as they require no solvents or special auxiliary materials, have no waiting or drying time, and mistakes can easily be corrected by simply drawing over the wrong tone with the correct color.

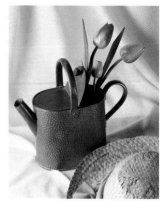

WATERING CAN AND FLOWERS

To show how easy it is to mix and obtain different tones when working with wax crayons, we will use just a few colors to draw this still life. All the color mixes are done directly on the paper, so it is advisable to test the effect first. This can be done by simply trying out the color mix on a separate sheet of paper before starting to paint. It is best to avoid mixing the more intense colors, those of the flowers, so as not to lose their clean tone.

This simple still life can be easily represented by using a few color mixtures and blends, in addition to a few touches of pure color, which are then slightly blended together.

These are the colors we are going to use. This range comprises primary and secondary colors plus a few other tonalities that can be used to obtain the muted colors of the watering can and the background.

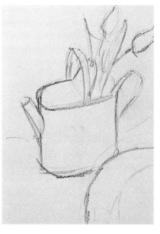

1. Using a violet-colored crayon, the artist draws in the general outlines of the subject. The lines should be faint so as not to dirty any subsequent layers of color.

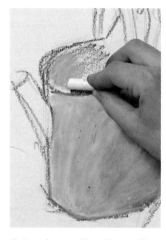

2. In order to achieve the metallic tone of the watering can, stripes of sienna and blue are gently superimposed without pressing down too hard on the paper. The tone is then unified by blending the previous lines with these white touches.

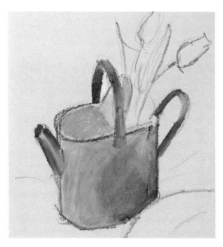

3. The darker parts contain a larger amount of sienna while white is the predominate color in the lighter areas, producing an overall coppery tone.

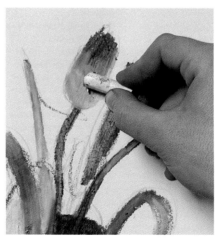

4. After painting the green of the stems, the artist again uses white for the flowers, so as to smooth and blend the pure tones and lighten the lower part of the flowers.

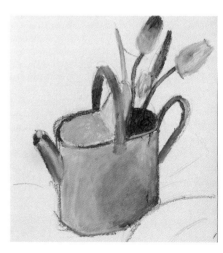

5. The process is very fast; wax crayons allow the artist to cover relatively large areas quite easily and cause no problems when mixed and superimposed. The artist will now continue to color in the background.

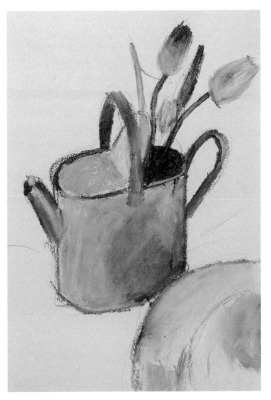

7. The pale background color can be obtained by combining gentle blue and red lines where the folds create shadows. Then, rub briskly with the white crayon to obtain a pale and gradated tone.

NOTE

During the mixing and blending of colors, wax crayons pick up other colors and need cleaning before reusing so as to avoid smudging any subsequent colors. To clean them, simply use a clean cloth that will also remove the typical shavings that appear on the tip of the crayon. If the drawing session is a long one, it is also a good idea to clean your hands to avoid dirtying the crayons with your fingers.

6. The color of the hat is achieved by adding a few touches of sienna to the darker areas and a superimposed yellow tone that covers the entire surface of the object. Both colors must be blended together until there is no sign of any lines.

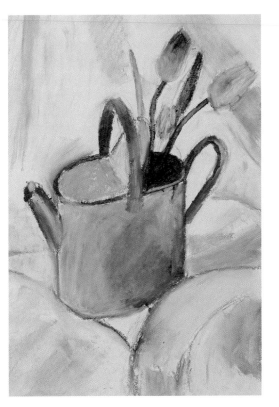

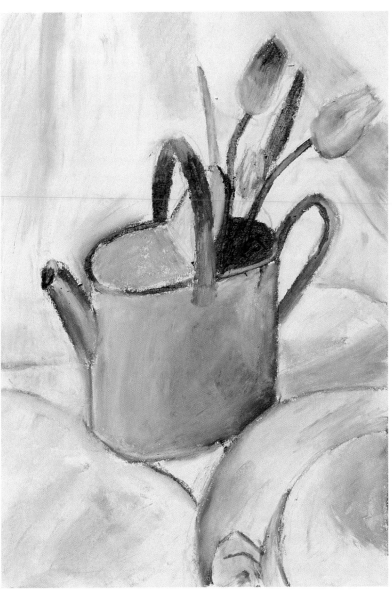

8. The shading on the cloth of the background shows which tones have been used. These different tonalities lend volume to the folds. To unify this volume, more white should be applied to blend the tones together a little more.

9. Once the background tone has been unified, this crayon drawing can be considered finished. It is both a drawing and a true painting at the same time, obtained by color blends and mixtures as well as the application of direct, dense, opaque tonalities.

Drawing with Felt-tip Pens

For those familiar with using colored pencils, drawing with felt-tip pens will not be an entirely new subject. Fine-tipped felt-tip pens, the most suitable for drawing, are instruments that can be used to accurately define outlines as well as to create effects of color and shading. Like colored pencils, felt-tip pens can be superimposed using lines or colored patches. Generally speaking, felt-tip pens cannot be overmixed unless they are watercolor pens that are diluted with brush and water. And even if this is the case, darker colors easily mask lighter colors when mixed. The artist must take this factor into account when trying to obtain precise hues by mixing two or more colors. Felt-tip pens, however, are easier and quicker to handle and produce stronger, saturated lines without having to press down hard on the paper.

FELT-TIP PEN TECHNIQUES

Working with felt-tip pens is similar to colored pencils, although there are some important differences that we shall deal with here. First, the preliminary drawing of the outlines must be done in the color of the forms being represented. If a general tone such as gray is used for this preliminary drawing, in certain light areas this color may be too strong and distort the final effect. This should be avoided unless the artist is deliberately seeking a carefree, sketchlike effect.

The initial layout is therefore in color. It is also advisable to follow the light to dark sequence, as light tones cannot mask darker ones. The tone of felt-tip pens is not affected by the intensity of the line, so each color can only produce one intensity; this means the artist needs ranges that are wide enough to include different hues of each color. The best results are obtained when different hues of each range are used to color in areas with a similar tone.

FELT-TIP PEN TECHNIQUES

DIRECT MIXTURES

Direct color mixtures are obtained by superimposing lines of one color over another. This technique is suitable when working with colors from the same range or when the artist wishes to darken a color. It is not suitable when the artist wants a homogenous mixture, that is, a mixture in which two superimposed colors blend to produce a third, pure color. Direct mixtures should not be used at the beginning of the process as they tend to darken and dirty the tonalities as the drawing develops.

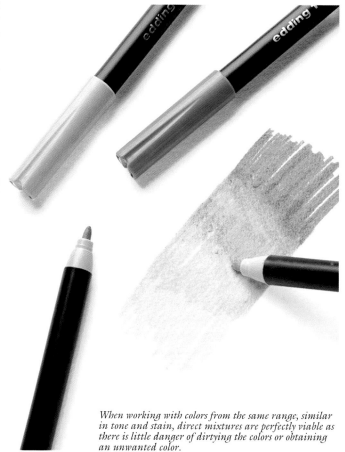

When working with colors from the same range, similar in tone and stain, direct mixtures are perfectly viable as there is little danger of dirtying the colors or obtaining an unwanted color.

Direct mixtures are a good technique to use when you wish to darken a color by superimposing another tonality, usually a darker one, which produces a more opaque hue.

FELT-TIP PEN TECHNIQUES

GRAY MIXTURES

As with colored pencils, felt-tip pen lines can be mixed until they almost disappear by rubbing over them with a light gray or any other pale and grayish color available. By tracing these lines over a color, the gray unifies the hues and blurs the outlines, compensating somewhat for the rather striking effect of a multicolor work drawn in felt-tip pen. This technique can only be used in small, specific areas, as it is impossible to obtain a complete blending of large areas of color.

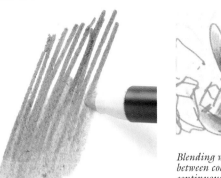

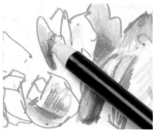

Light grays are very useful for creating blended areas to soften the characteristic outlines of areas colored with felt-tip pens.

Blending with gray blurs the limits between colors, to obtain gentle, continuous gradations.

FELT-TIP PEN TECHNIQUES

WATERCOLOR FELT-TIP PENS

Like watercolor pencils, felt-tip pens with soluble ink can be used to obtain results similar to those of watercolor. With felt-tip pens, however, the colors are much more intense and less transparent, and therefore also less suitable for creating wash effects. Dilutions can only be used in small areas and it is inadvisable to apply excess water in an attempt to spread out the color. You should concentrate on small areas, stumping, blending, and diluting the different hues. It is also not a good idea to blend the tones to such an extent that the marks of the lines disappear, as this clashes with the technique of felt pen drawing.

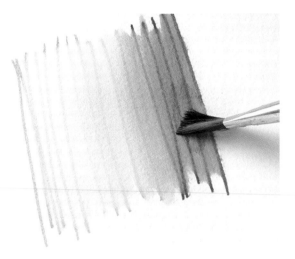

Watercolor felt-tip pens allow the artist to blend the lines together and unify the color over a given area. The brush should not be too wet so as to avoid leaving stains.

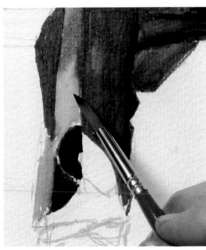

When used on small areas of the drawing, watercolor felt-tip pens enable you to obtain very similar results to those of watercolors. They become less interesting, however, when large washes of diluted color are attempted.

FELT-TIP PEN TECHNIQUES

RESERVES

Reserves are a common technique in defining and outlining light forms that are to contrast with a dark background. A reserve protects the delicate hues when using more transparent colors. This technique, of course, requires the artist to carefully plan his work, calculating the areas intended to be worked later with pale hues.

1. Reserving a form begins by darkening the color surrounding it. This darker color makes the outline of the form in question stand out.

2. Once the white form stands out against the dark background, different hues can be added in order to model its appearance.

A Sketched Figure

Felt-tip pens can be used both for sketches and for drawings with a high degree of precision and perfect finish. They are a good exercise medium that can also be used outside to draw from nature. It may be that watercolor felt-tip pens are best suited to this task. They can combine lines and patches, and can be used spontaneously, letting the lines run freely and later coloring in the spaces. This exercise is an example of the potential of this technique.

The figure stands out clearly against the dark background, so the artist needs to apply the technique of reserving. In addition, the contrast between the lights and shadows makes it inadvisable to work the lighter tones too much during the initial stages of the sketch.

FIGURE IN A PARK

A figure reading in a public park is the subject we have chosen for this sketch with watercolor felt-tip pens. We have chosen a limited range of colors for this exercise, comprising basically a pair of dark tones (blue and green) and a variety of sienna and pink tones to represent the lighter parts. This is an ideal medium for quickly sketching forms and modeling volumes with diluted colors.

2. The first lines are those of the warm tone of the jacket. The artist begins by shading small areas to check the initial effects of the color.

3. The previous lines are dissolved with a moist brush, spreading the color toward the other shoulder and over the entire area of the jacket. These few lines are enough to color the entire area.

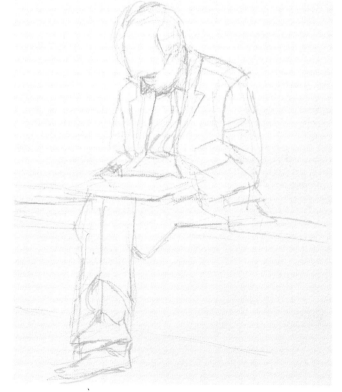

1. After a brief pencil sketch, the lines have been redrawn in a very light gray so that the basic forms of the figure can be seen clearly at all times.

4. After coloring the jacket, the wrinkles are shaded in using a felt-tip pen of the same range, though a little darker.

5. The colored lines are then spread out again with the brush to try to blend the two colors to form a common tone.

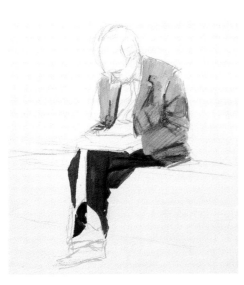

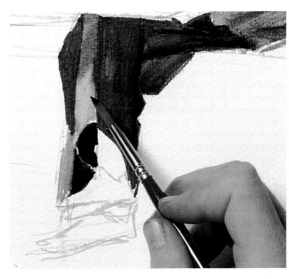

6. The blending of the colors of the jacket are made by applying a wash and including parallel lines that slightly shade in the light sienna, the first color to be applied. The artist now moves on to the trousers.

NOTE

The initial, thin colors should be used carefully so as not to dirty the final result. Only toward the end can the water be applied and spread out more freely, to get the desired effect.

7. After coloring the darker areas of the trouser with a solid blue, he extends this color over the lighted area, thinning it with a little water.

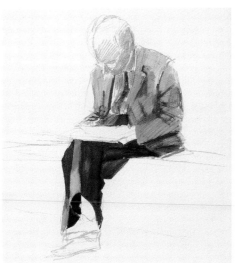

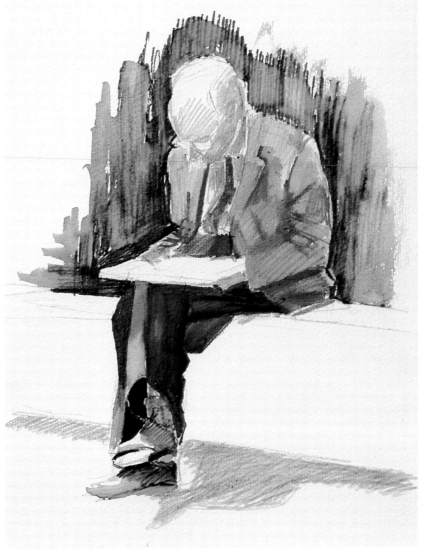

8. The thinning of the color of the trouser leg shows how useful this type of shading with water can be when working in small areas. The areas of the figure that were still white have also been colored.

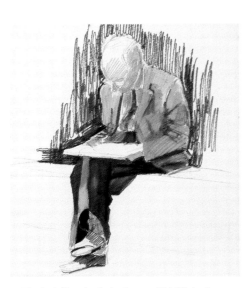

9. The dark lines in the background highlight the colors of the figure, lending greater expression to the illuminated parts that have been drawn with just a few, pale stripes.

10. The thinned background has softened the rather harsh effect of the dark green lines and has unified the illumination of the scene. As a final touch, a few shadows have been added under the ledge to create the tones for the ground plane.

A Full-Color Drawing

Professional ranges of felt-tip pens usually offer a great number of colors and a large assortment of hues of the same range. To make the most of this fact, you can choose motifs that offer chromatic variety and liveliness so as to take advantage of the full potential for contrast, harmony of color, and definition of forms when working with felt-tip pens. The characteristic chromatic intensity of this medium involves certain risks. These risks include the use of too many varied and dissonant colors and the smearing of colors due to excessive layering and color mixing. In order to avoid these risks, it is advisable to work in a certain method and to introduce neutral colors to compensate for any excess tonality.

FLOWERS IN THE SUNLIGHT

Few subjects are better suited to a full-color treatment than this. This counter in a street flower stall offers all the possible chromatic ranges and tones imaginable, from bold colors such as yellows, reds, and blues, to soft gray, green, and sienna hues. It is a question of finding the balance between these bold and soft colors so that they enhance each other and produce a result that is neither loud nor muddled. It is very important to follow the technique of working from the more intense tones to the softer tones.

The sharp contrasts between the colors are strengthened even further by the intense contrast between the lights and shadows. Light is expressed with color, and it is the most vivid tones and the contrasts between them that create this luminous effect.

1. After quickly sketching the composition in pencil, several outlines have been redrawn in the color of the flowers and the flowerpots. The outlines are not too sharp: they simply situate and box the volumes of the elements that make up the composition.

2. The artist reserves the white areas causing the nearest flowers to stand out, like a negative. This is the first stage in adjusting the colors and the outline of the silhouettes.

3. In the same way as the first flowers were reserved almost white, the bunch of yellow roses has its own color, chosen from the wide range of yellows available for this exercise.

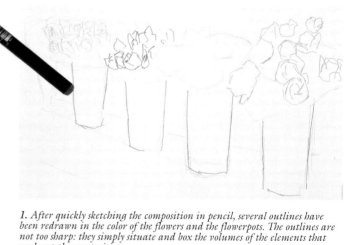

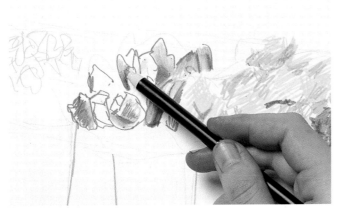

4. *The fuchsia-colored roses have been slightly altered with a strong pink, and these lines are now blended using a light gray felt pen.*

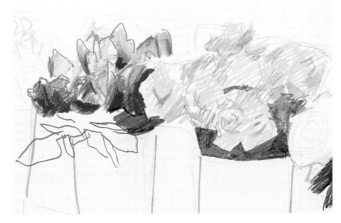

5. *The process consists of having certain forms limit and define others by pitting one color against another, like a screen on which the outlines stand out.*

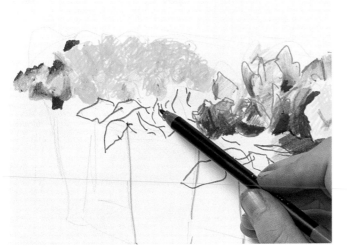

6. *For the next bunch of yellow roses, the artist has chosen a new hue that is more intense and saturated, and then altered with light orange-colored shadows. The artist merely outlines the leaves.*

NOTE
Felt-tip pens should not be pressed down too hard on the paper as this may cause the fiber of the support to rub off, resulting in small balls that are a great hindrance when working.

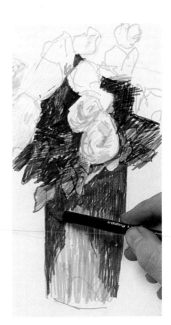

7. *The dark colors of the flowerpots admit a more direct, bold approach: A tile red color is applied over the sienna cross-hatching so as to define the area in shadow.*

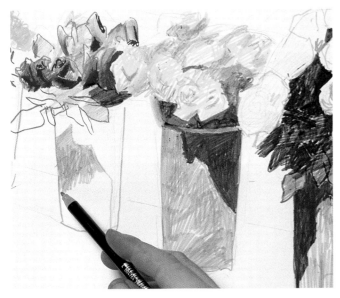

8. *Shadows should be defined first using outlines, as if they were simply another object. The illuminated areas are painted in a golden ochre color.*

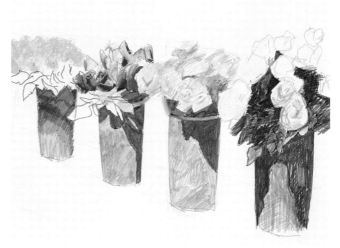

9. *The most colorful stage of this exercise is revealed in this composition of contrasting forms and colors.*

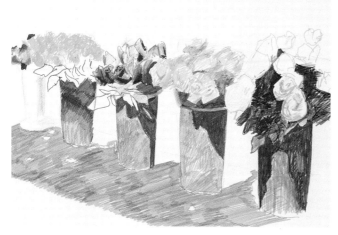

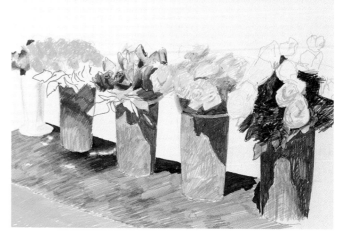

10. *To define the plane of the table, felt-tip pen lines are very useful. The inclination of the lines determines the position of the support and its relationship with the flowerpots.*

11. *A new, strong contrast is added to the previous ones: The yellow in the foreground intensifies the large blue rectangle on which the shadows of the flowers and pots are cast.*

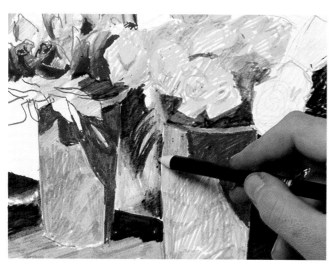

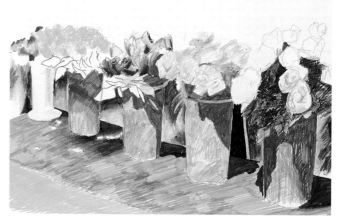

12. *After creating all the strong color contrasts, it is now time to paint the shaded background. The artist chooses a range of grays that includes pale tones with which to blend the lines.*

13. *When only a small part of the shaded areas has been covered, the harmonic effect of the grays in contrast to the brilliant coloring of the flowers is already apparent.*

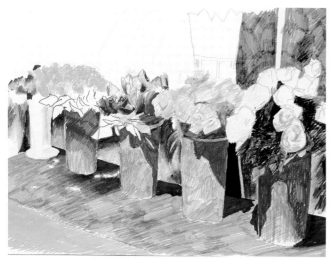

14. *In order to cover the background, the artist uses short lines to form a kind of mosaic to suggest the undefined forms in the shadowy background.*

15. *The airy effect on the left of the composition was obtained by applying a light gray immediately after applying other tones of gray.*

16. *The treatment of the background has taken into account the large number of flowers, though the artist has not attempted a realistic representation. Instead, the background is simplified entirely in shades of gray.*

NOTE

When drawing with felt-tip pens, the direction of the line can help to define the forms and surfaces. It helps to think about this before coloring.

17. *The pale orange color of the flowerpot in the shade adds a chromatic note that enlivens and lends depth to the grays.*

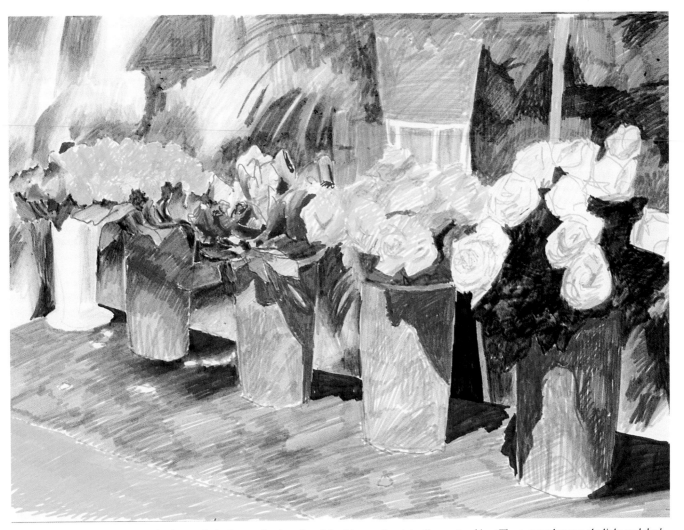

18. *Thanks to the treatment of the background, the flowers that have been left white require virtually no retouching. The contrast between the light and dark tones has lent form and luminosity to the foreground and has left the background as a neutral counterpoint to the rich chromatic arrangement of the subject.*

ALL ABOUT TECHNIQUES IN DRAWING

Topic Finder

MATERIALS AND TOOLS

Graphite6–7
Composition.............................6
 Origins...............................6
Hardnesses and Qualities7
• Graphite in Leads7
• Graphite in Sticks7
• Watercolor Graphite7

Colored Pencils................8–9
Composition.............................8
 Characteristics.....................8
Varieties and Presentations.........9
• Colored Leads9
• Watercolor Pencils9
 Qualities9

Charcoal10–11
Composition............................10
Varieties and Presentation10
• Compressed Charcoal
 and Binder.........................11
• Charcoal Pencils11
 Characteristics....................11
• Powdered Charcoal11
 Origins...............................11

Pastel and Similar
 Media12–15
Pastel, a Drawing Medium..............12
Composition............................13
 Characteristics....................13
 Origins...............................13
Variety and Presentation14
• Pastel Pencils14
• Watercolor Pastels14
• Types of Boxes14
• Special Assortments15
• Chalks15
• Sanguine15
• Conté Crayons15

Ink.......................................16–17
Composition............................16
• Reeds16
• Ink in Tablet Form16
 Origins...............................16
• Colored Inks17
• Inks for Washes17
• Pens and Nibs17
• Writing Tools17
 Characteristics....................17

Other Media18–21
Mixed Techniques18
• Drawing and Painting..............18
Water-Based Media19
• Watercolor and Gouache19
• Latex and Acrylic Paint...........19
• Water-Based Oils19

Oil-Based Media20
• Oil Sticks..............................20
• Wax Crayons20
• Solvents and Mediums20
 Characteristics....................20
Felt-tip Pens21
• Variety and Presentations21
• Water Based21
• Alcohol Based........................21
 Characteristics....................21

Brushes22–23
An Introduction to Brushes22
• Sable Brushes22
• Other Natural Hairs23
• Hog's Hair23
• Synthetic Hair23
• Japanese Brushes23

Drawing Papers24–27
Drawing with Pencil and
 Charcoal24
Drawing with Felt-tip Pens24
Drawing in Ink25
• Rice Paper25
• Drawing Pads25
Drawing with Pastel..................25
Paper for Wet Techniques26
• Handmade Paper26
• Other Papers27

Other Supports................28–29
Canvas28
Cardboard29
Preparation29
Polyester Paper29
Wood......................................29

Complementary
 Material30–33
Erasers30
Pencil Sharpeners.....................30
Fixatives..................................31
Cloths.....................................31
Clips and Thumbtacks31
Scissors and Utility Knives31
Stumps31
Boards31
Cotton....................................31
Paper Towels32
Glues......................................32
Metal Rulers32
Containers32
Alcohol and Solvents32
Sponges32
Pans.......................................33
Palettes33
Palette Knives33
Portfolios.................................33
Additional Material33

GRAPHITE

Graphite Techniques.........34–35
Drawing with a Graphite Pencil.
 How to Hold the Pencil..............34
Drawing with a Graphite Pencil.
 Blending34
Drawing with a Graphite Pencil.
 Erasing...............................35
Drawing with a Graphite Pencil.
 General Cleanliness35

Graphite Techniques.........36–37
Graphite Techniques.
 Gray Background36
Graphite Techniques.
 Textured Background...............36
Graphite Techniques.
 Direct Blending....................36
Graphite Techniques.
 Shadows on Watercolor Paper37
Graphite Techniques. Blending........37
Graphite Techniques. Turpentine37
Graphite Techniques.
 Dissolved in Water37

Value and Modeling..........38–41
Notion of Value38
Notion of Modeling38
Light and Shadow38
Simple Shapes38
Value and Modeling. A Sphere........38
Value and Modeling. A Cylinder39
Value and Modeling. A Jug............40
Value and Modeling. Drapery40
Value and Modeling. The Whole41

Perspective42–43
Perspective. Linear Perspective.........42
Perspective. Intuitive Perspective......43

The Value of the Line......44–45
The Value of the Line.
 Shading by Strokes.....................44
The Value of the Line.
 Modeling45

The Sketch........................46–47
The Sketch.
 The Linear Technique46
The Sketch. Sketching Volume47

Drawing with a
Range of Grays...............48–51
Pictorial Effect.........................48

COLORED PENCILS

Colored Pencil
 Techniques52–53
Drawing with Colored Pencils.
 Lines and Colors52
Drawing with Colored Pencils.
 Color Mixtures.....................52
Drawing with Colored Pencils.
 Blending Gray and White53

Drawing with Colored Pencils.
 Color Reserves53
Drawing with Colored Pencils.
 Mixing with Watercolor
 Pencils.......................................53

Tones54–55
Tones. Orange Tones.......................54
Tones. Red Tones............................55

Solid Colors56–57
Solid Colors. Fruit...........................56

Color by Strokes58–59
Plumage and Water.........................58

Color Drawings60–61
Botanical Garden60

**Drawing and Color
 Ranges**62–65
An Olive Tree62

CHARCOAL

Drawing with Charcoal ...66–67
Drawing with Charcoal. Blending....66
Drawing with Charcoal. Erasing66
Drawing with Charcoal.
 Masking with Paper......................67
Drawing with Charcoal. Textures.....67
Drawing with Charcoal.
 Fixing Charcoal...........................67
Drawing with Charcoal. Natural
 and Compressed Charcoal...........67

Blending and Strokes68–69
Blending and Strokes. Landscape68
Blending and Strokes. Figure69

Modeling...............................70–71
Modeling. Torso.............................70
Modeling. Head.............................71

Surfaces................................72–77
Surfaces. A Shiny Surface72
Surfaces. Old Metal74
Surfaces. Chromium-Plated
 Surface76

Seascape78–81
The Sea and the Rocks78

Still Life82–85
Arabesques82

PASTEL AND SIMILAR MEDIA

Drawing with Pastel86–87
Drawing with Pastel. Blending.........86
Drawing with Pastel.
 Working with Color87

Drawing with Sanguine ...88–89
Drawing with Sanguine.
 Two Figures.................................88
Drawing with Sanguine.
 Combinations89

Drawing with Chalk90–91
Drawing with Chalk. A Statue90
Drawing with Chalk. A Musician91

Still Life................................92–95
The Range92

Landscape96–99
Backlighting96

INK

Drawing with Ink100–101
Controlling the Strokes.................100
Colored Ink and Combined
 Techniques.................................101

**Drawing with a
 Reed Pen**102–105
Rural Landscape102

**Highlighting with a
 Nib**106–107
Leopard ..106

**Combined Techniques:
 Ink and Gouache**108–109
Carnival ..108

Nibs and Colored Ink ..110–113
A Cafeteria Terrace110

WET TECHNIQUES

Wet Techniques..............114–115
Sketching with a Brush114
Sketching with a Brush. Sketching
 with Monochrome Watercolor ...114
Sketching with a Brush.
 Lines and Patches.....................115
Sketching with a Brush.
 Dry Brush115

Gouache. Covering Power115
Gouache. Combined Techniques ...115

**Sketching with a
 Brush**..............................116–117
City Street116

A Monochrome Wash...118–121
Lines and Masses118

**Combined Dry-Wet
 Techniques**122–125
Rural Landscape122

DRAWING WITH WAX CRA-
YONS

Oil-Based Media............126–127
Drawing with Wax Crayons126
Drawing with Wax Crayons.
 Mixtures126
Drawing with Wax Crayons.
 Dilutions126
Drawing with Wax Crayons. Covering
 One Color with Another127
Drawing with Wax Crayons.
 Resists127
Drawing with Wax Crayons.
 Melting......................................127

**Drawing with White and
 Black Wax Crayons** ...128–131
Branches and Flowers128

Colored Wax Crayons...132–133
Watering Can and Flowers132

FELT-TIP PENS

**Drawing with
 Felt-tip Pens**134–135
Felt-tip Pen Techniques134
Felt-tip Pen Techniques.
 Direct Mixtures..........................134
Felt-tip Pen Techniques.
 Gray Mixtures135
Felt-tip Pen Techniques.
 Watercolor Felt-tip Pens.............135
Felt-tip Pen Techniques. Reserves ..135

A Sketched Figure136–137
Figure in a Park136

**A Full-Color
 Drawing**138–141
Flowers in the Sunlight138

We wish to thank the following firms for use of their material:
Papeles Guarro Casas; Talens, departamento técnico; Faber-Castell; Gigandet;
Escoda

Original title of the book in Spanish: *Todo sobre la técnica del Dibujo.*

© Copyright Parramón Ediciones, S.A. 1998—World Rights
Published by Parramón Ediciones, S.A., Barcelona, Spain.
Author: Parramón's Editorial Team
Illustrators: Parramón's Editorial Team

© Copyright of the English edition 1999 by
Barron's Educational Series, Inc.

All inquiries should be addressed to:
Barron's Educational Series, Inc.
250 Wireless Boulevard
Hauppauge, New York 11788
http://www.barronseduc.com

International Standard Book No.: 0-7641-5163-0
Library of Congress Catalog Card No.: 99-14655

Library of Congress Cataloging-in-Publication Data

Todo sobre la técnica del dibujo. English.
 All about techniques in drawing / [author, Parramón's Editorial
 Team ; illustrators, Parramón's Editorial Team].
 p. cm.
 Includes index.
 ISBN 0-7641-5163-0
 1. Drawing—Technique. 2. Drawing materials. I. Parramón
 Ediciones. Editorial Team. II. Title.
 NC730.T5813 1999
 741.2—dc21 99-14655
 CIP

Printed in Spain
987654